100

PLACES TO GO BEFORE THEY

DISAPPEAR

CONTENTS

Climate Change Is Already Happening!

100 PLACES TO GO BEFORE THEY DISAPPEAR is, in my opinion, an excellent concept to make people fully realize the extent of the damage that climate change can do. By bringing this to the attention of the public and highlighting 100 places that the world holds dear, this whole project is turning attention to something that hopefully will bring about decisions that might actually protect these beautiful, valuable and precious places on the Earth.

In the context of this project, there are places that are very vulnerable and in danger in a number of respects. There are problems where sea level rise is threatening small island states, low-lying areas and coastal areas in some parts of the world. There is also the threat to ecosystems. We have assessed that if temperature rise exceeds 2.7–4.5°F (1.5–2.5°C), then 20–30% of the species we in the IPCC have looked at are under threat of extinction. Take, for example, the coral reefs. These beautiful ecosystems that we have all over the world are clearly going to be affected. There are lots of places all across the globe that will vanish if the climate is not stabilized.

Apart from the natural attraction of these places, there are also going to be major economic losses, because most of the food grains that we consume and most of the medicines and drugs that we have in our modern system have been derived from biodiversity. If that biodiversity is damaged, we are limiting economic opportunities for future developments and for the needs that might arise in the future, both for food grains and for drugs and medicines.

I think people have to be informed, not only about those very pristine places on this planet, which we have always valued and cherished for their natural beauty, but also about the economic risks for the future.

Let us look at the melting of the glaciers. In some parts of the world, people depend on the streams that come from the glaciers for their water supplies. If those glaciers melt away, then those streams are obviously going to decline. For instance, in the Indian subcontinent we are very vulnerable. The northern part of the subcontinent, especially, could suffer from a serious reduction of water availability, because all the reserves in that region originate in the Himalayan glaciers. If they are reduced, it will have a major economic impact.

When it comes to agricultural food grains, we will see a decline in yields in several parts of the world because of the impacts of climate change. If we have to develop new strains and species that are resistant to the new climate, we will have to do it on the basis of nature's wealth of biodiversity. But if the species themselves are threatened, then it clearly restricts our ability to come up with new forms of agricultural crops that can thrive under the new conditions.

The public has to be told that this is not something that is going to happen in the future. It is already happening. If we don't do something about the problem, then this treasure that the human race and all living species have could be damaged and could vanish forever.

Dr. Rajendra K. Pachauri
Chairman of IPCC, United Nations'
Intergovernmental Panel on Climate Change

Climate Change Is the Biggest Threat

If so many of us care about nature, why is our impact on the Earth accelerating? Why is there such disparity in living standards? Why do some have so much and others so little?

Climate change is the biggest threat facing humanity at the start of the 21st century. We are already seeing its impacts—from melting Arctic sea ice to flooding and droughts. And it is often vulnerable communities from developing countries such as South Africa that are affected the most. 90% of natural disasters happen in the global south and only 3% of the people are insured, compared to the global north, where only 10% of the disasters happen, but 95% of the people are insured.

OUR DISCONNECTION FROM NATURE

We, as humanity, face a conundrum. Very few among us wilfully advocate the extinction of species or the suffering of our fellow humans. Yet we face rampant environmental destruction that is imposing hardship upon millions of those who cannot escape it.

If so many of us care about nature, why is our impact on the Earth accelerating? Why is there such disparity in living standards? Why do some have so much and others so little?

We have developed a temporal and physical disconnection from the resources that sustain us, and from our impact on them. Our forefathers had a direct, visceral connection to nature. Meat had to be caught, and killed, carried, then skinned, a taxing business. Fruit and vegetables had to be sought out growing in the wild or carefully tended. That effort caused our ancestors to waste very little. Modern life has removed that connection and the realization of our impact on the earth. Supermarkets and packaged foods hide the processes involved in feeding us. In short, the consequences of our actions are delayed or hidden, so we assume they are waived.

WE HAVE TO ACT INDIVIDUALLY AND COLLECTIVELY

So how does humanity reduce the sting to come? We simply have to act individually and collectively to reduce our impact on the world. There's no shortage of information on how to do that. It just needs to be done by enough people. And acting on it must be impressed upon the government leaders who will meet in Copenhagen later this year to devise the next generation of guidelines on limiting carbon emissions and fighting climate change.

It is heartening to see that organizations such as Care International and its partners are spearheading the cause of the poor and taking a leading role to improve the livelihoods of the poor through various programs and projects throughout the world. It is important to note that poverty is a cause and an effect of environmental degradation. The equitable, efficient, and productive use of natural resources offers important opportunities for sustainable livelihoods which can contribute to reducing poverty.

Desmond Tutu

South African cleric and activist. Archbishop Emeritus of the Anglican Church of South Africa. Received in 1984 the Nobel Peace Price for his active and nonviolent struggle against the apartheid government in South Africa.

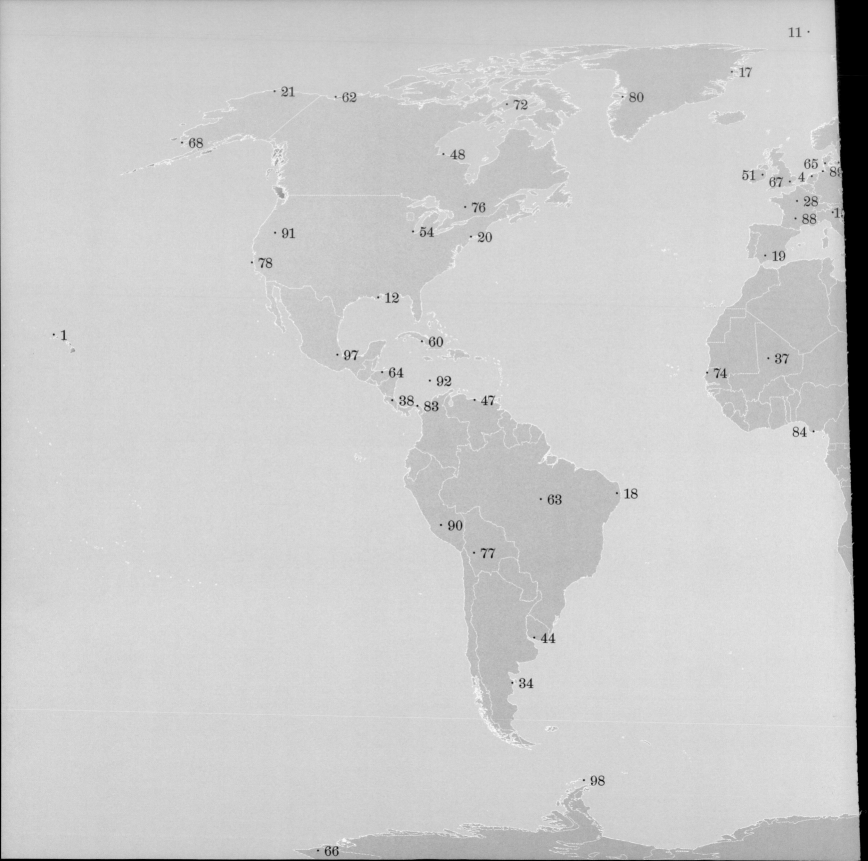

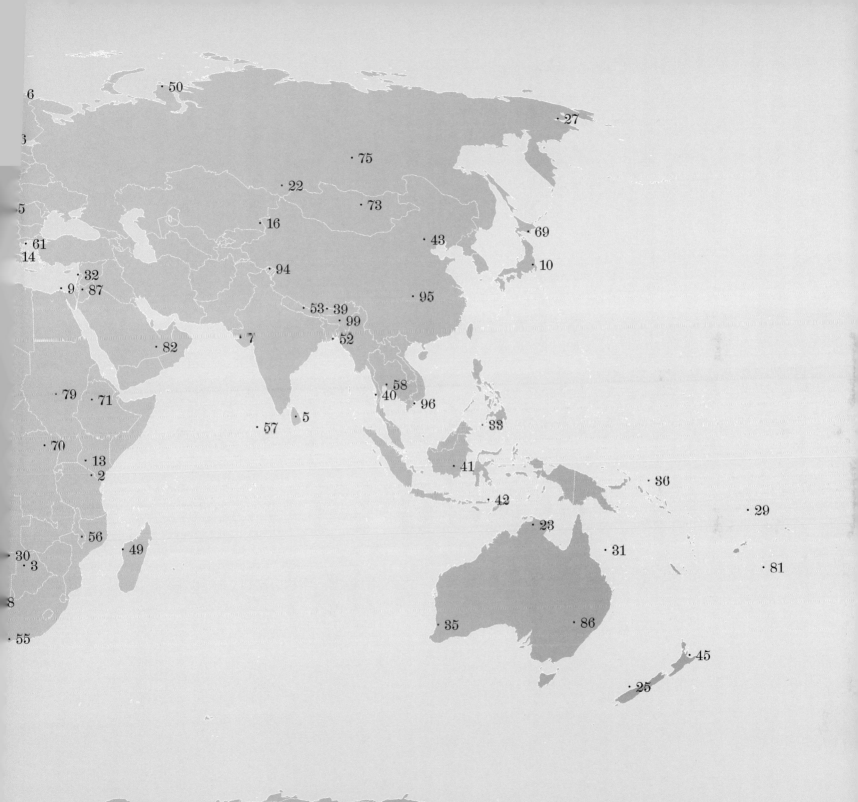

Hawaiian Honeycreepers Hiding in the Clouds

Kauai, the fourth-largest Hawaiian island, is one of the wettest spots on Earth, with an annual average rainfall of 460 inches (11,700 millimeters). Large parts of the mountainous island are swathed in cloud. Moist trade winds from the Pacific sweep across the rugged landscape, and clouds settle in the mountain saddles, creating lush and mossy forests.

High in the cloud forests, where the climate is cool, live the beautiful and colorful Hawaiian honeycreepers. These rare birds use their long, downward-curved bills to sip nectar from flowers, hovering like hummingbirds and emitting a variety of sounds, from nasal squeaks to clear, flutelike calls.

The species of honeycreeper that is endemic to Hawaii lives at an elevation above 4,900 feet (1,500 meters) where the climate is too cool for mosquitoes to survive. Most of the Hawaiian honeycreepers are only 4–5 inches (10–13 centimeters) long and weigh no more than eight grams. They are extremely vulnerable to diseases like avian malaria.

The Hawaiian cloud forests make up one of the ecosystems that are most at risk due to climate change. Relatively small shifts in patterns could cause major local changes, putting the islands' distinct ecosystems under pressure.

Deforestation and non-indigenous species like pigs and goats have decimated the honeycreeper's habitat in recent years, and it is now an endangered species. With the projected rise in temperatures, mosquitoes are likely to gain a foothold at higher elevations in the Kauai mountains, slowly driving the honeycreeper to extinction.

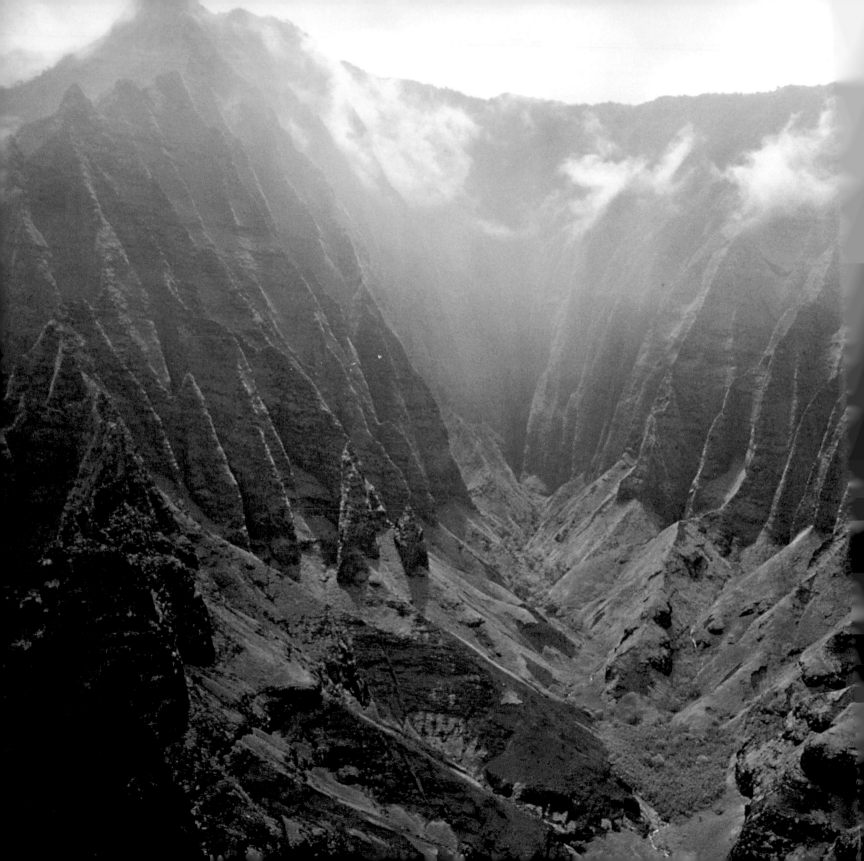

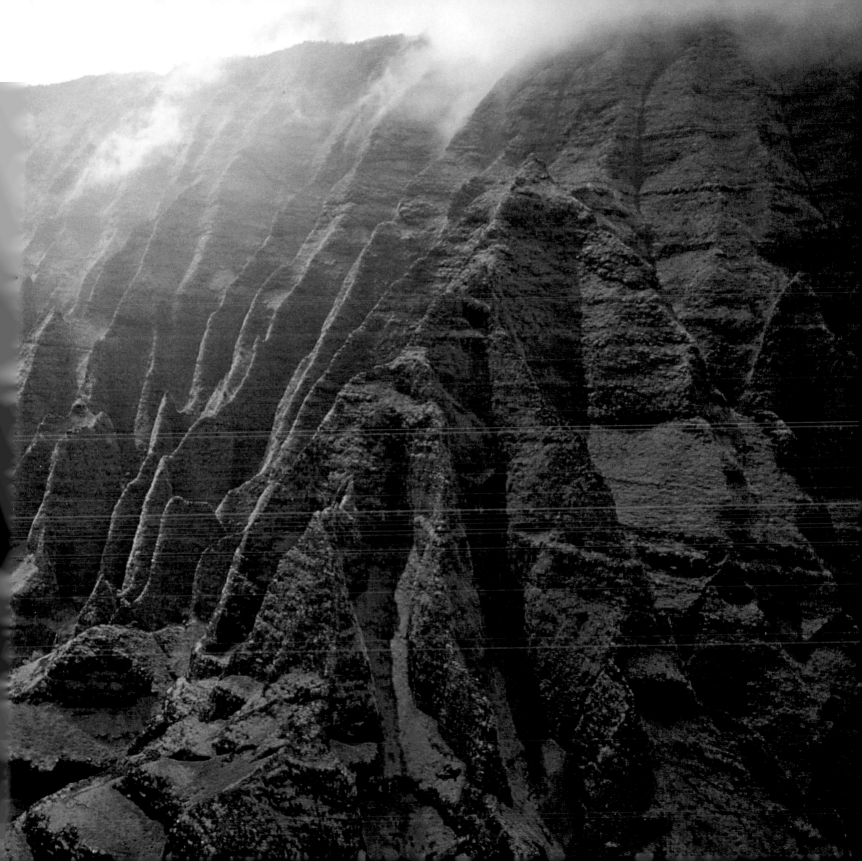

White Snows in the House of God

When Ernest Hemingway's novel The Snows of Kilimanjaro *was published in 1936, it made the snow-capped East African mountain famous and turned it into a legend.*

For the local Masai tribes living on the plains beneath it, the mountain had already been a living legend for centuries. To them, it is Ngàja Ngái—"The House of God."

Seen from the plains below, Kilimanjaro's peak emerges from a ring of fog and cloud that shrouds its forest-covered lower slopes. When Hemingway first described the mountain, its snowcap was already melting slowly. Between 1912 and 2003, climate change led to the loss of about 80% of its ice fields, and the remainder of the snowcap is expected to disappear by 2020.

In itself, the loss of the snow on top of Kilimanjaro will have a limited effect on the ecosystem, as it feeds only a few minor brooks. However, the symbolic effect will be enormous, as an illustration of the speed at which the global climate is changing.

Farther down the mountain, the heavy clouds whose vapor and precipitation irrigate the "Cloud Forests" and feed the rivers have already diminished, due to the rise in temperatures and decrease in atmospheric moisture. This trend is projected to continue and has already increased the frequency of forest fires.

Combined with human-induced deforestation, it will further reduce precipitation. This would have a devastating effect on the woodland, as well as the water supply for the million people of the Chagga and Masai tribes who inhabit the flanks of Kilimanjaro.

Federico Veronesi/Getty Images

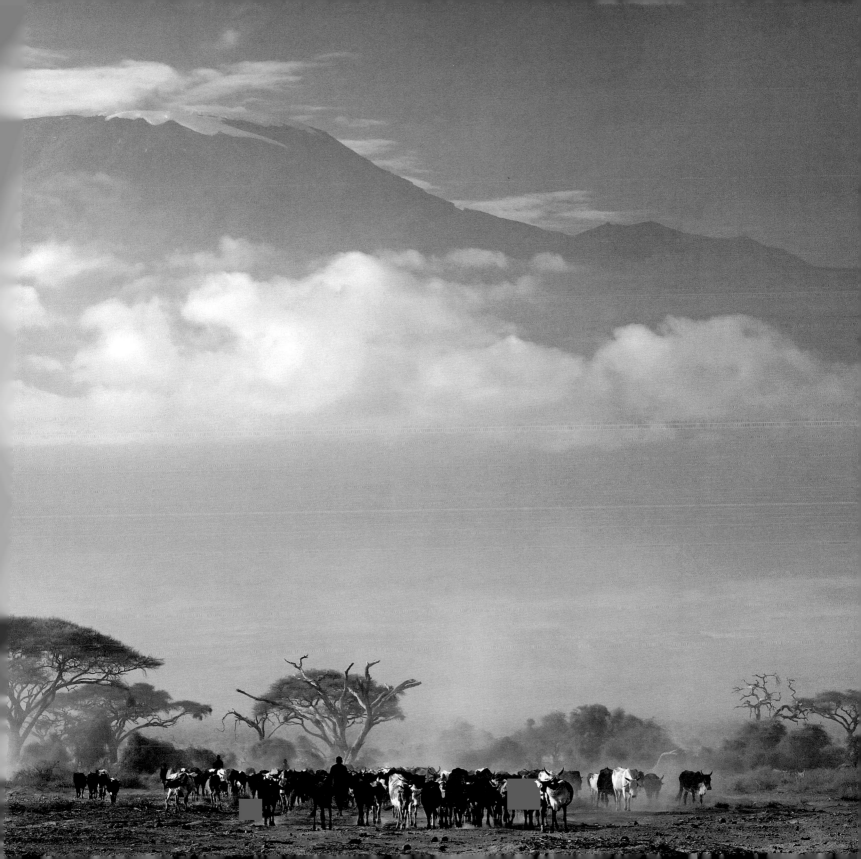

An Oasis of Wildlife, Above and Below

The Bayei people, one of several tribes dwelling in the Okavango Delta, use a poem to teach their children about the delta: "I am the river. My surface gives you life. Below is death."

The "death below" refers to the crocodiles that inhabit the region and are a threat to the people and animals of the delta. From space, the delta resembles a bird's footprint. It forms a labyrinth of lakes, lagoons and hidden channels covering an area of over 5,790 square miles (15,000 square kilometers), making it the largest inland delta in the world.

The Okavango Delta is trapped in the parched Kalahari Desert with no permanent outlet to the sea, and is a magnet for the wildlife that depends on the delta and its seasonal flooding. Each year, 390,000 cubic feet (11 cubic kilometers) of water reaches the delta, water that is unusually pure, thanks to the absence of agriculture or industry along the adjoining rivers.

Five ethnic groups, each with its own identity and language, live around the delta. This is one of the world's richest areas in terms of wildlife and they share the land with countless species such as elephant, buffalo, hippopotamus, wildebeest, giraffe, lion, wild dog, antelope, zebra, ibis, and many more—including the crocodile.

Precipitation is expected to decrease because of climate change, while the temperature is projected to rise. This will cause the delta's enormous peat bogs to dry out, with a risk that the peat will catch fire, releasing massive amounts of greenhouse gases.

The tribes who live around the delta could be forced to find new homes elsewhere and, at the very least, they will have to adjust their lives in order to survive, which would have a negative impact on the unique culture of the people of the Okavango Delta.

Bobby Haas/Getty Images

900 Years Behind Dykes, Dams and Barriers

With more than half their city lying below sea level, the people of Rotterdam have lived behind dykes and dams to protect them from the sea, storms, and flooding for almost 900 years.

In fact, 55% of the whole of the Netherlands is below sea level. At 22.17 feet (6.76 meters) below sea level, the country's lowest point is just east of Rotterdam's center, so the city is extremely sensitive to storms, floods and any rise in the sea level.

The shipping trade has been Rotterdam's principal economic asset since the 1350s. Today, the city is the largest port in Europe and one of the busiest in the world, accounting for 25% of the Netherlands' total emissions of CO_2.

In the late 1990s, a storm-surge barrier, the Maeslantkering, was constructed to protect the city and its surrounding areas from rising sea levels and flooding. Its two huge gates, each the size of the Eiffel Tower, allow the inlet to be closed to the harbor and its hinterland. The barrier is one of the largest moving structures on Earth, and is designed to resist a 16-foot (5-meter) rise in the water level. It closes automatically when the water level is forecast to rise to 10 feet (3 meters) above normal. According to Dutch prognoses, this should occur only once every 10 years, and once every 5 years from 2050.

In November 2007, 10 years after it was inaugurated, the barrier closed for the first time. Just a few years earlier, a flood had fallen a mere centimeter short of the threshold. During a major storm in 1953, a level of 12.63 feet (3.85 meters) was registered.

Although Rotterdam seems safe for the time being, climate change could cause a further rise in sea levels, extreme storms, and flooding.

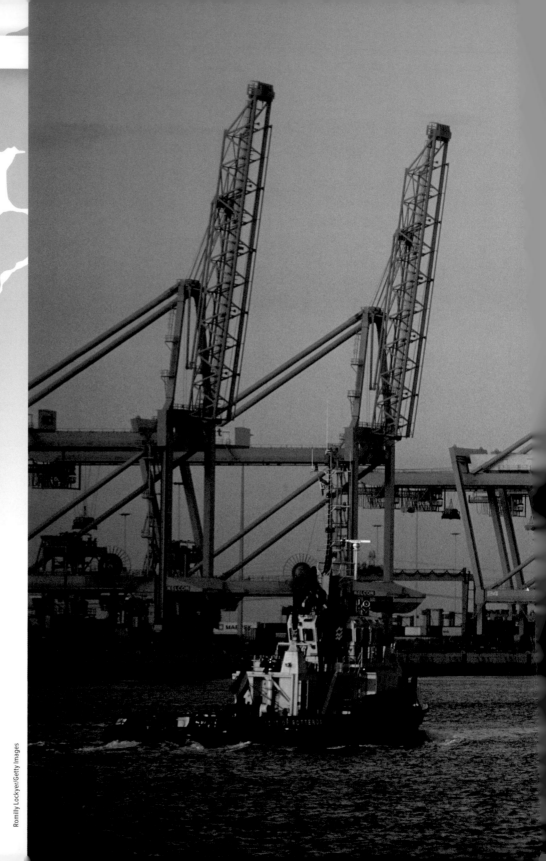

Romilly Lockyer/Getty Images

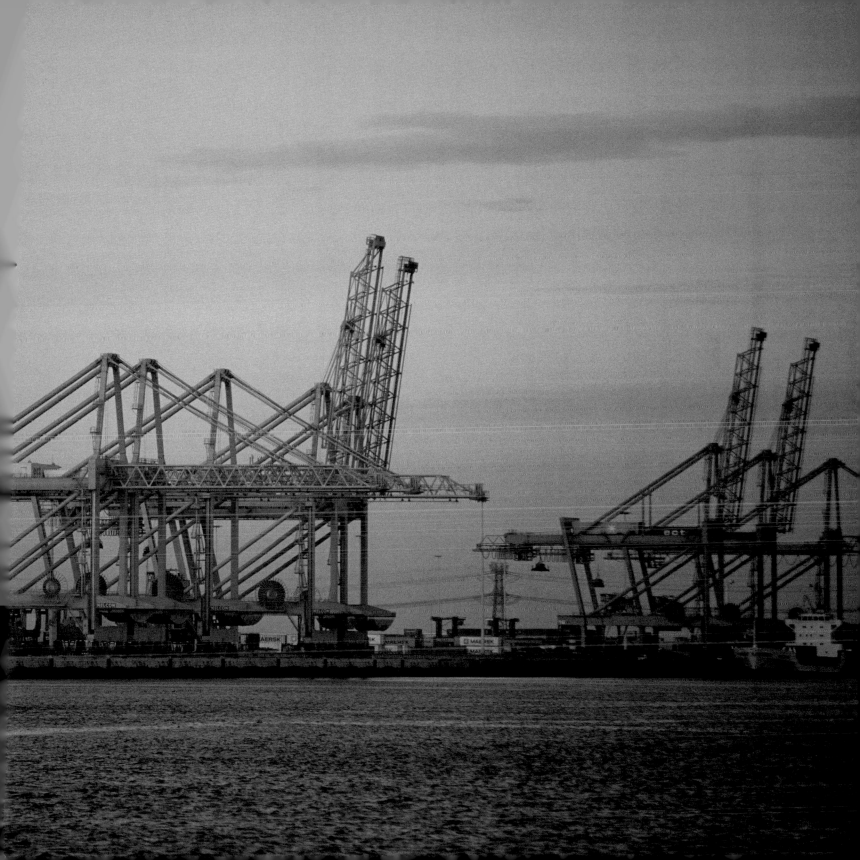

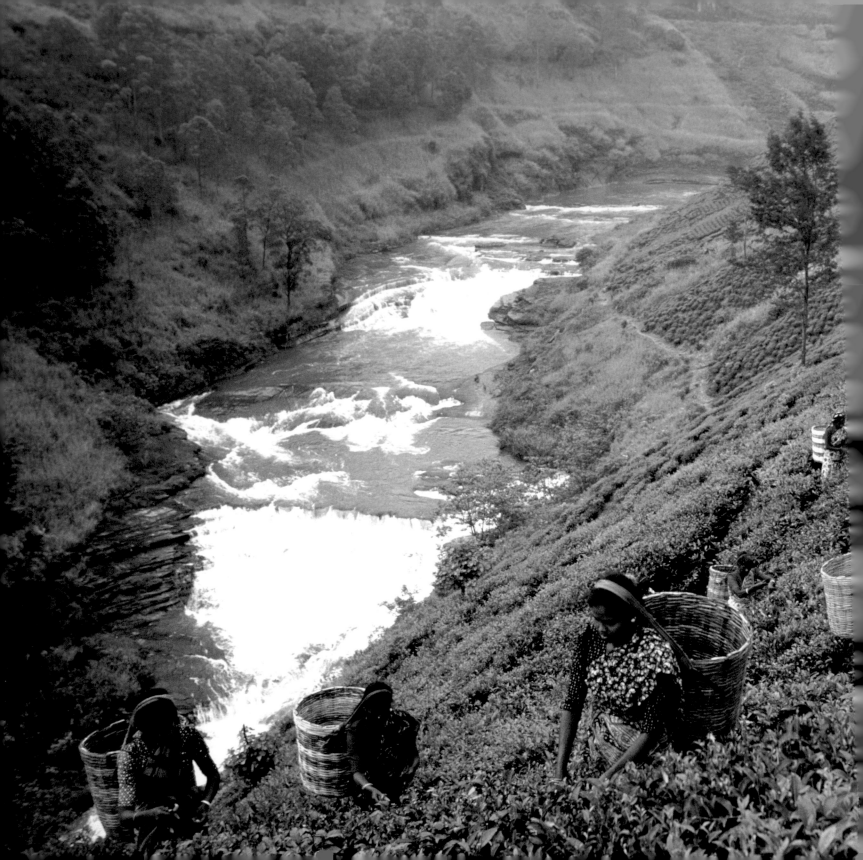

A Quality Brand Supporting 700,000 People

Tea originated in China, where it has been drunk for several thousand years. According to legend, a Chinese emperor discovered the beverage in 2737 BC when some tea leaves accidentally blew into a pot of boiling water.

Tea became popular in Europe in the 1600s, but commercial cultivation only commenced when British colonists established tea plantations in India and Ceylon (now Sri Lanka) in the 1800s.

The first tea estate was established in Ceylon in 1840. Today, Sri Lanka is the third-largest tea-producing country in the world and the trademark "Pure Ceylon Tea—Packed in Sri Lanka" is recognized everywhere as a sign of quality. Tea is the country's main net foreign exchange earner. More than 700,000 workers and their families are dependent on the tea industry, which is composed of large, state-owned but privately managed plantations operated on a profit-sharing basis and of many private smallholders. The latter own 44% of the plantations yet account for 58% of the annual production of 33,000 tons (300 million kilograms) of black tea.

Most Sri Lankan tea is grown on the hillsides of the central and southern highlands, at altitudes of between 2,500 and 5,300 feet (760 and 1,600 meters). The highlands of Sri Lanka are perfectly suited for growing tea, which requires an even distribution of rainfall throughout the year, temperatures of 64–77°F (18–25°C) and a sunny climate.

Global warming could wreak havoc on tea production over the next 60 years. Higher temperatures and drier weather are very likely to create droughts that will reduce the yield and eventually damage many of the plants. Heavy periodic rainfall will cause soil erosion and landslides on the steep hillsides and growth conditions will deteriorate as heavy cloud cover blocks the sunlight.

Martin Puddy/Getty Images

A People Without Borders

In the cold, barren tundra in the northern stretches of Scandinavia live the Sámi people, nomadic reindeer herders whose lives are shaped by the movement of the reindeer, which in turn is determined by snow and wind conditions. The Sámi spend up to nine months of the year in the mountains.

Believed to be one of the last indigenous groups in Europe, the Sámi inhabit the vast region of Sápmi, which transcends the borders of four nation states, stretching from central Norway to Sweden across northern Finland to the eastern end of the Kola Peninsula in Russia.

Their numbers are uncertain but 60–70,000 Sámi are estimated to live in Sápmi, most of them in Norway.

The Sámi have more than 400 words for reindeer, denoting their gender, age, color, shape, etc. Although relatively few Sámi still lead a traditional lifestyle, reindeer herding remains an essential part of their culture. The herders possess invaluable knowledge of the mountains and snow-covered landscapes of the Nordic countries.

Due to climate change, this knowledge is no longer as reliable as it once was. Rising temperatures and mild winters have made the ice unsafe and forests have encroached on reindeer pastures. Rain falls instead of snow in winter, posing new problems for the Sámi and their herds. When the rain hits the cold ground it forms an extra layer of ice, preventing the reindeer from reaching the food beneath it. The Sámi are already living with the challenges thrown up by global warming. The projected rise in global temperatures represents a serious threat to the reindeer and to Sámi identity

Kenneth Garrett/Getty Images

Gandhi's Birthplace

The most western state in India, Gujarat is the nation's largest producer of cotton and salt, and the birthplace of Mahatma Gandhi, the political and spiritual leader of the Indian independence movement.

Gandhi was born under the British Raj in the seaport of Porbandar. As a child, he witnessed locally grown cotton being shipped to Britain, only to return to India as finished garments. He understood how this kept the Indian people in a state of poverty, and later encouraged his fellow countrymen and women to boycott imported British clothes and make their own instead. To set an example, he began spinning cotton in public, made the spinning wheel a symbol of independence, and was only ever seen in a homespun Indian dhoti.

In 1930, Gandhi launched a campaign against the British salt tax, which had made it illegal for Indians to produce their own salt. He led the famous Salt March for 250 miles (400 kilometers) through Gujarat to the coastal town of Dandi, where, flouting the law, he picked up a handful of salty mud and declared, "With this, I am shaking the foundations of the British Empire."

India finally gained its independence in 1947. The following year, Gandhi was assassinated. By then, production of salt, cotton, and many other agricultural products from Gujarat rested in Indian hands. India is now the third-biggest cotton producer in the world after the USA and China, and the majority of its cotton comes from Gujarat. The state also produces 140,000 tons of salt a year.

In the summers of 2005 and 2006, heavy monsoons caused severe flooding in Gujarat, destroying thousands of homes, killing more than 1,000 people, and devastating both infrastructure and agricultural production.

Global warming is projected to intensify this climate pattern. If this happens, Gujarat will experience much heavier, more unpredictable monsoon rains and floods, which would deal a severe blow not only to the infrastructure and to millions of people and their homes, but also to the very pillars of the state economy—salt, cotton, and agriculture.

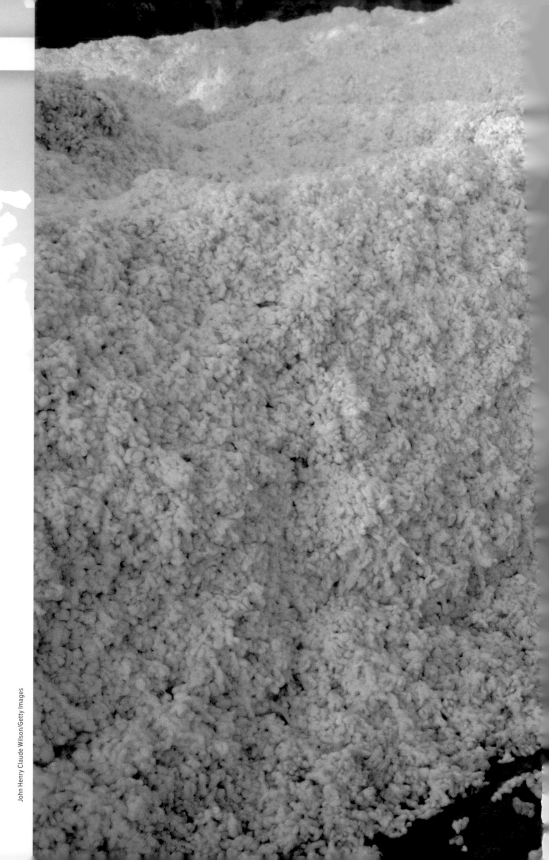

John Henry Claude Wilson/Getty Images

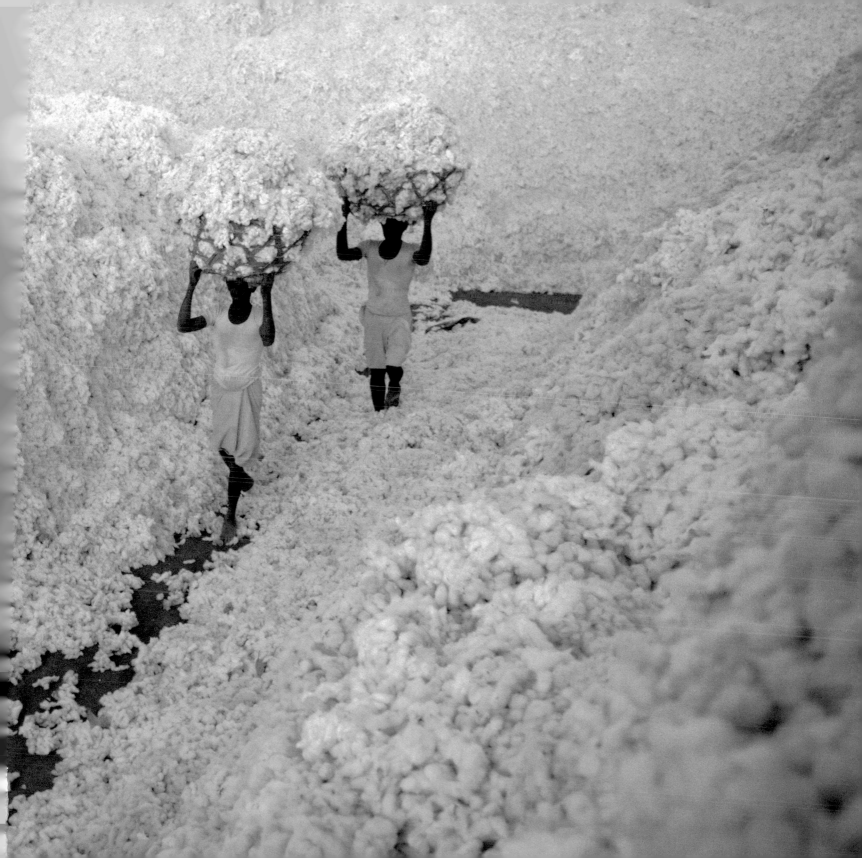

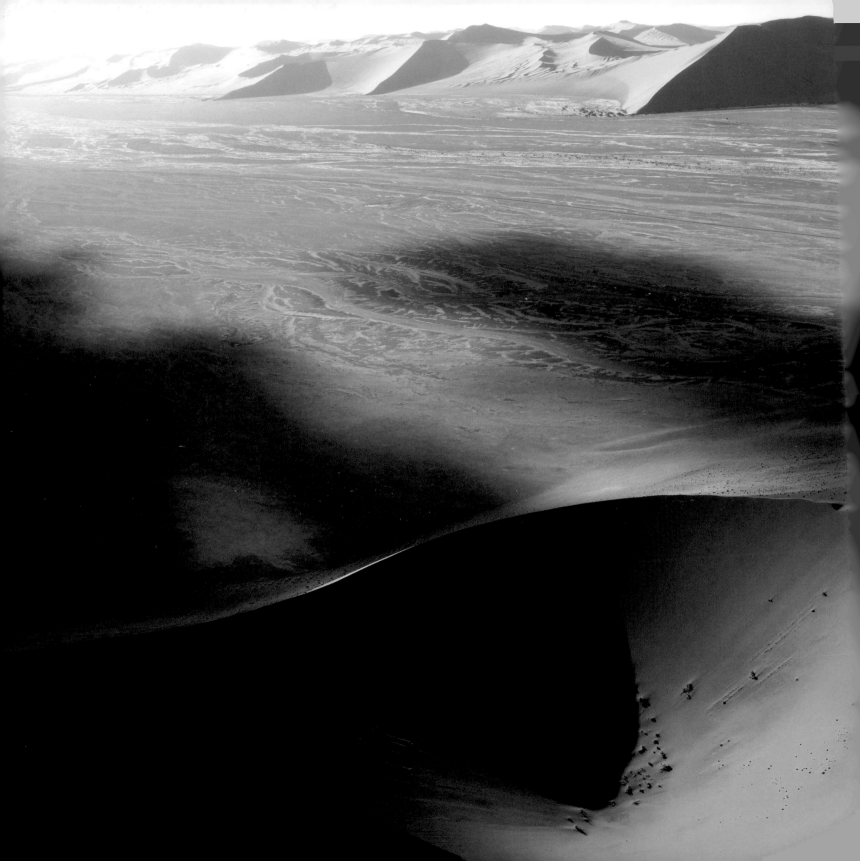

Land of Open Spaces

The Namibian Desert is believed to be the oldest desert in the world. Straddling the Atlantic coast of southwest Africa, it is home to the biggest migrating dunes in the world. Shaped by the west wind from the Atlantic, they reach heights of 980 feet (300 meters). Namibia means "land of open spaces," and is named after the desert.

The dunes move at a speed of about 65 feet (20 meters) a year. Farther inland, they merge with a landscape of bush and savannah, rich in grass, scattered trees, and a wealth of rare plants and animal species unique to the region. Ancient nomadic tribes have roamed here for centuries, searching for pastures to feed their cattle.

Moisture from the sea in the form of fog and rain carried on the westerly wind is crucial for the sparse flora and wildlife, and indeed for all life in the bush and savannah.

Climate change is expected to increase the strength of the Atlantic winds and induce more frequent droughts in the Namibian Desert. In turn, this will lead to a dramatic increase in the number of migrating dunes, which will travel eastwards across the land at a faster rate, threatening the vegetation, wildlife, and traditional way of life of the nomads.

It is estimated that a temperature rise of 3.8°F (2.1°C) would wipe out 41–51% of Namibia's unique flora and wildlife. Within the next 80 years, temperatures are projected to rise by up to 6.3°F (3.5°C).

Michael Poliza/Getty Images

The Gift of the Gods to the Egyptians

For millennia, the Nile Delta has been providing food for the many cultures that inhabit Egypt. For more than a thousand years, traditional Arab boats, known as dhows, have transported agricultural produce from the fertile delta.

The Nile, the longest river system in the world, originates from two sources, the White Nile rising from Lake Victoria at the Equator and the Blue Nile from Lake Tana in the Ethiopian Highlands. The Nile has been the country's lifeline from time immemorial—and the pharaohs believed it to be a gift from the gods.

After traveling more than 4,040 miles (6,500 kilometers), the river passes the Egyptian capital, Cairo, then opens into the Nile Delta. Covering some 7,720 sqaure miles (20,000 square kilometers) , the delta stretches along the Mediterranean coast from Alexandria in the west to Port Said in the east.

People still farm the land beside the river and in the Nile Delta as they have for more than 5,000 years. The river and its delta are crucial to Egypt. Without their water and fertile soil, the country probably would not exist, at least not as we know it.

The delta is extremely vulnerable to climate change, however. Rising sea levels will cause coastal erosion and inundate valuable agricultural land and ground water with saline seawater. By 2050, the rise in sea levels could have displaced more than a million people. Changing patterns of rainfall and higher levels of evaporation are also anticipated. Combined with an increasing population, this is very likely to put severe stress on Egypt's freshwater resources.

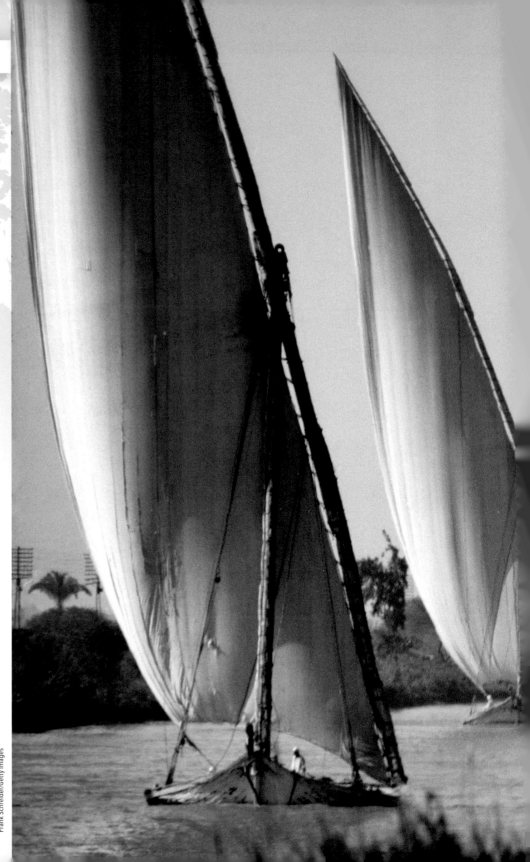

Frank Schreider/Getty Images

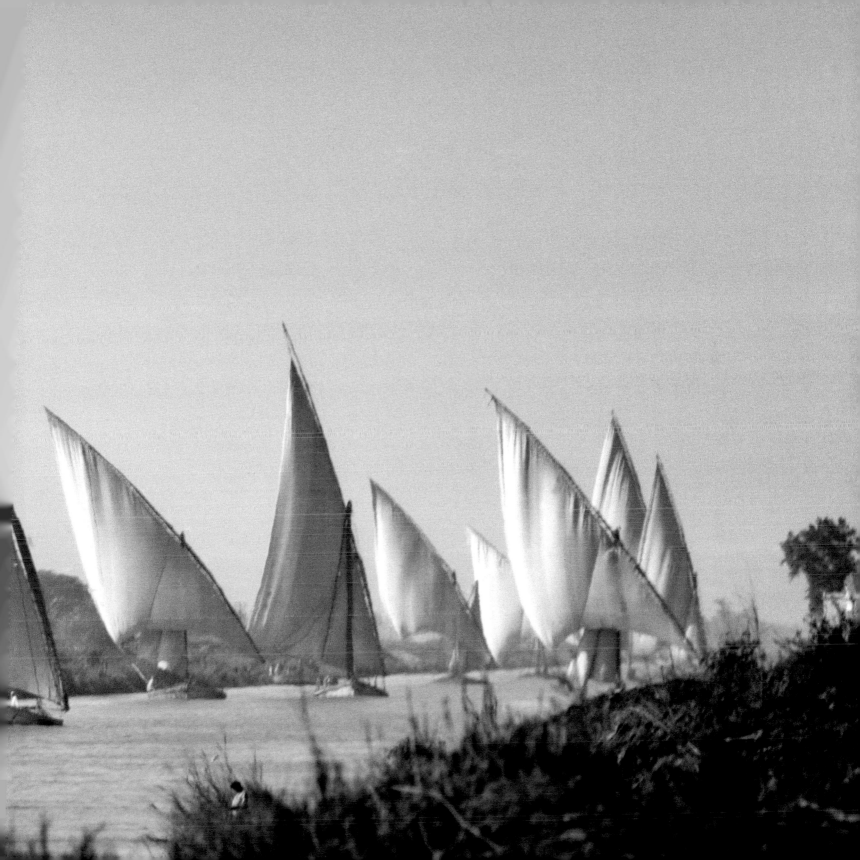

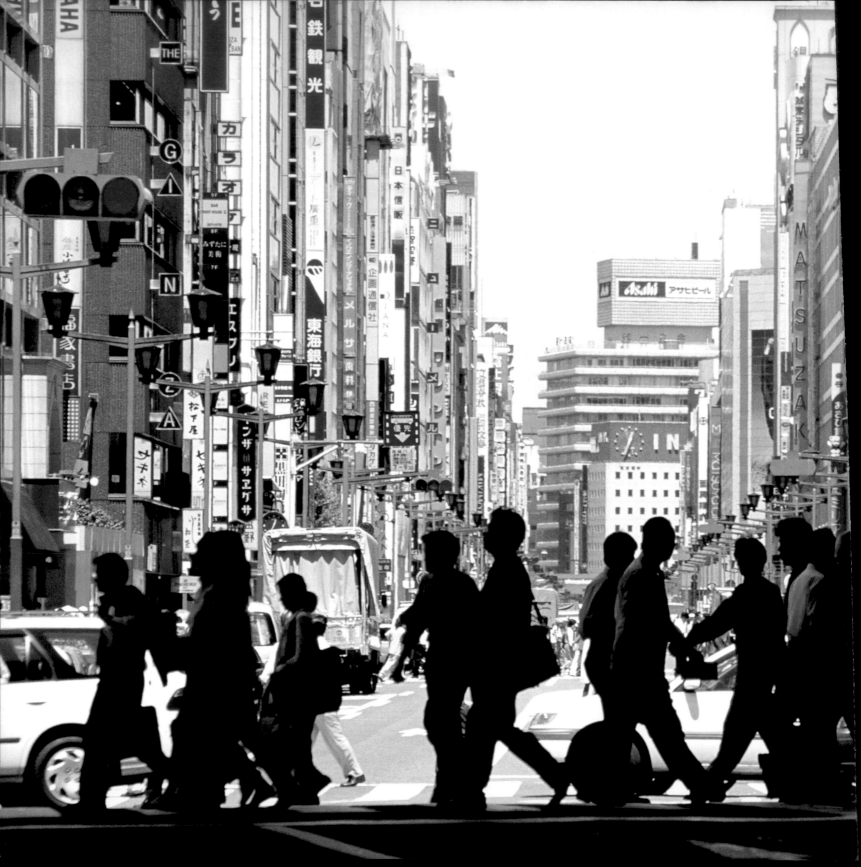

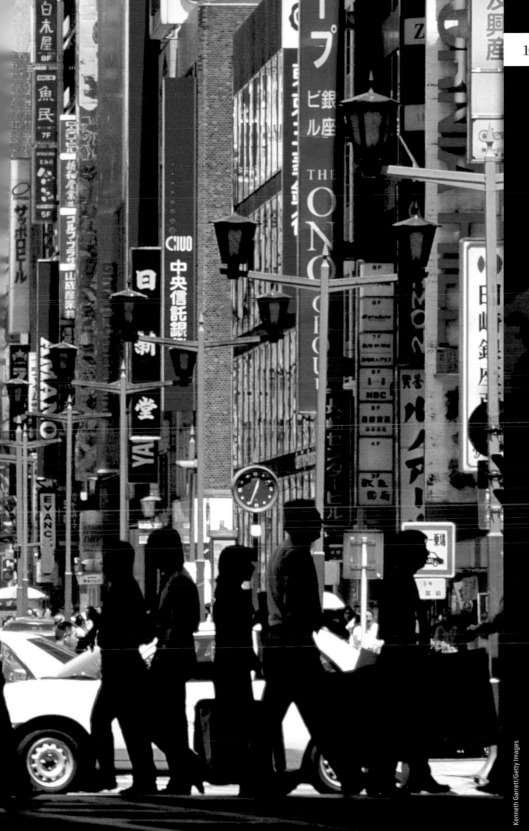

A Rush Hour Like No Other on Earth

Japan is one of the great economics of the world, Tokyo one of its great metropolises. For millions of Japanese, the backdrop to daily life consists of glass skyscrapers, jam-packed streets full of colorful banners, neon signs, and huge screens blasting out music videos and commercials.

Around 8.6 million people live in central Tokyo. Every weekday, the number is boosted by 2.5 million commuters hastening from the suburbs to work and school in the city. The subway and one of the busiest and most efficient commuter rail networks in the world make sure they get there on time.

The fast-moving city stops for a break every spring, when thousands of cherry blossom trees burst into bloom. Japanese companies close down at midday to throw hanami parties, picnics beneath the snow-white and soft-pink cherry blossoms. The startling beauty of the flower lasts less than two weeks, and it dies in its prime. To the Japanese, the cherry blossom is a reminder of the transience of life and beauty.

Global warming is now changing life even faster. Tokyo suffers from a phenomenon known as "heat islands," a characteristic of megacities where artificial heat from car exhausts and factory emissions create a local greenhouse effect. In the last 100 years, temperatures in Tokyo have increased five times faster than global warming.

A century ago, Tokyo experienced five tropical nights a year at most. The figure is now 40, while temperatures on winter nights rarely fall below 32°F (0°C). Leaves now start changing color in mid-December instead of late November, and cherry blossoms start to bloom earlier every year.

With the projected rise in global temperature, the heat in big cities like Tokyo will continue to increase. This will lead to more people suffering from heat stroke and respiratory disease, and will change both the seasons and the way of life in the city.

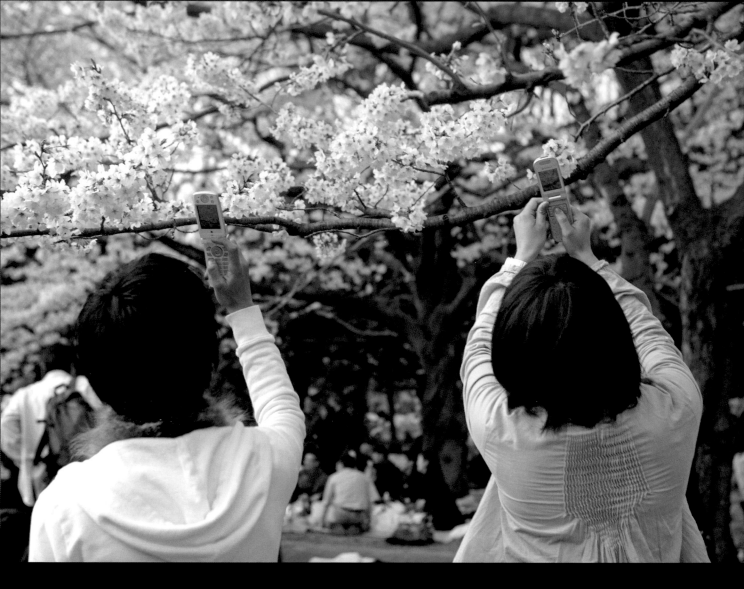

DESPITE THE STRIKING ANNUAL SPECTACLE of flourishing cherry blossoms, there is very little greenery in Tokyo. Only 14% of central Tokyo is occupied by green spaces—less than New York, London, and Berlin. In this densely packed city, the Japanese have resorted to an unconventional solution: rooftops.

In recent years, there has been a boom in roof gardens in Tokyo. From 2001, by law, at least 20% of the roofs all new medium-sized buildings must be given over to a garden. The high-rise plants cool the temperature and offer Tokyo's residents the scent of soil and fresh grass. In some cases, vegetables and crops like sweet potato are grown on the tops of the tall buildings, giving rise to a whole new urban farming sector.

11. The North Pole |
The Arctic Ocean

Greetings from the Top of the World

Until relatively recently, the Arctic Ocean remained unexplored. The lack of knowledge about what lay north of the shifting barriers of ice led to conjecture and speculation, nourishing persistent myths about an "open polar sea." However, as explorers inched farther and farther toward the pole, it became obvious that the ice cover was in fact massive and permanent all year round.

Occupying an almost circular basin of about 5,427,000 square miles (14,056,000 square kilometers) at the top of the world, the Arctic Ocean is surrounded by the land masses of Eurasia, North America, and Greenland, as well as several smaller islands.

The Norwegian explorer and scientist Fridtjof Nansen was the first person to cross the Arctic Ocean. He spent more than three years there, from 1893 to 1896, but never reached the North Pole—latitude 90° north—getting only as far as latitude

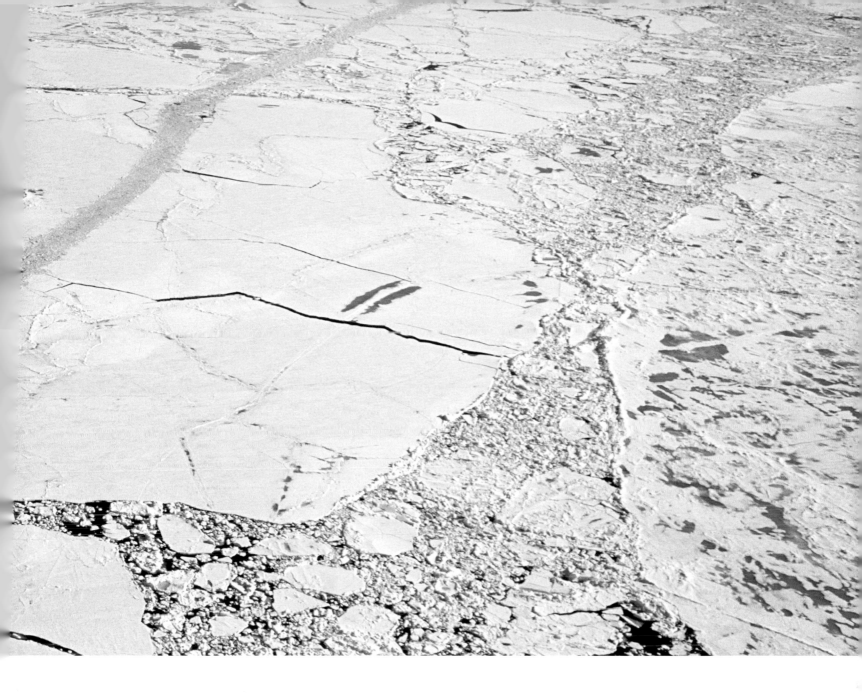

86°14′ north. At the time, this was farther north than anyone had ever been before. More than 70 years would pass before a dog sled expedition led by the British polar explorer Sir Wally Herbert crossed the entire frozen Arctic Ocean from Alaska to Svalbard and, in April 1969, reached the northernmost point on Earth. This epic crossing of more than 3,600 miles (5,800 kilometers) is considered the "last great journey on Earth."

Every summer, the Arctic sea ice breaks up and partially melts. In the last decade, global warming has caused the summer melting of the North Pole to break all records, and the sea ice cover has retreated much faster than had previously been predicted. If the trend continues at the same rate, it is thought summers at the North Pole could be completely ice-free by as early as 2013.

Currently, none of the five countries surrounding the Arctic Ocean—Russia, Norway, Denmark/Greenland, Canada, and the USA—owns the North Pole region. The area is believed to hold significant reserves of oil, gas and minerals. As the sea ice melts and the underground becomes accessible, disputes will arise over who is entitled to its resources, disputes that could trigger confrontations.

The Natural Barricades of Louisiana

From its source at Lake Itasca in Minnesota, the Mississippi River flows southwards for more than 2,300 miles (3,700 kilometers) until it reaches Louisiana, where it runs into the Gulf of Mexico.

This is the Mississippi River Delta—a humid, subtropical landscape with around 9,650 square miles (25,000 square kilometers) of rivers, fresh- and saltwater marshes, and low-lying barrier islands that provide a habitat for many species of birds, fish, shellfish, and small mammals. Some 1.2 million people live in New Orleans on the banks of the Mississippi. On average, the city is 1.5 feet (.5 meter) below sea level. The rich delta is of huge commercial importance to New Orleans—the region is ranked second in the United States for fishery production and also provides 16–18% of the nation's oil supply.

At the rim of the delta, at the state of Louisiana's easternmost point, the Chandeleur Islands form a chain in the shape of a crescent moon. These islands change shape to reflect the wind, tropical storms, and tidal action, creating a dynamic landscape that is home to endangered species such as the brown pelican.

Along with the delta wetlands, the Chandeleur Islands form a buffer zone against hurricanes and storm surges for the densely populated regions of Louisiana. The ferocity of storms along the Atlantic and Gulf coasts of the United States has already increased, almost certainly as a result of climate change. In 2005, Hurricane Katrina reduced the Chandeleur Islands to half their size and large tracts of wetland and marsh were also lost. Storms and hurricanes are expected to grow even fiercer in the future.

The rise in sea level caused by global warming has slowed down the rate at which it is possible to regenerate coastal areas, leaving the mainland of Louisiana even more exposed to flooding, with potentially catastrophic consequences for the ecosystems and for the people of the state.

Tyrone Turner/Getty Images

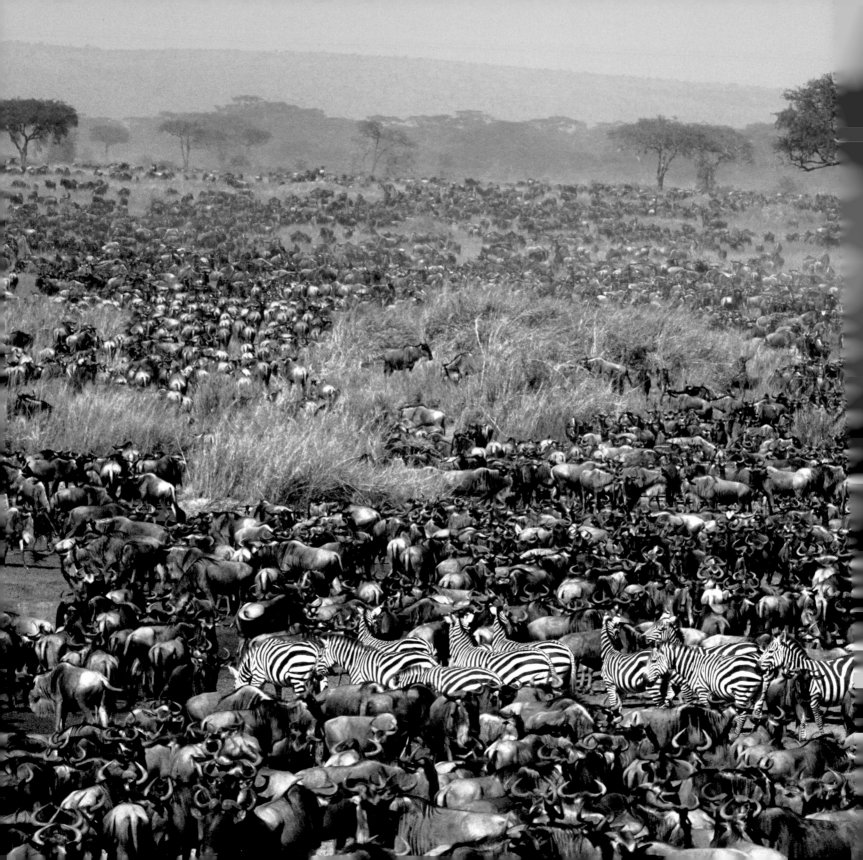

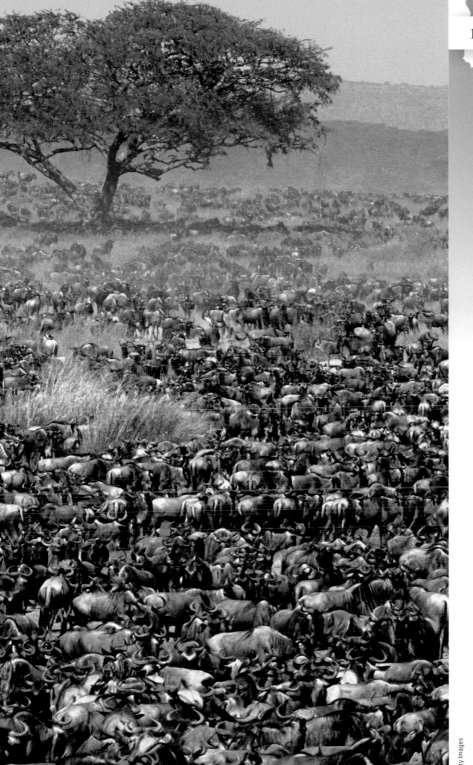

Anup Shah/Getty Images

Home to the Longest and Largest Migration in the World

The Masai Mara savannah in Kenya and the Serengeti in Tanzania cover a combined area of some 9,650 square miles (25,000 square kilometers) and form a unique ecosystem. The Serengeti Mara Ecosystem is the site of the longest, largest, and most diverse migration of grazing animals in the world, including 1.3 million wildebeest.

Every July, the wildebeest, accompanied by large herds of zebras and gazelles, migrate north from the plains of the Serengeti to the fresh, green pastures of the Masai Mara. The huge blue wildebeest provide protection against the kind of hungry predators—lions, cheetahs, and leopards—that inevitably prey on such a heaving mass of herbivores. Hyenas, marabou storks, and other scavengers also forage for scraps.

In October, led by the wildebeest, the whole caravan of migrating animals turns around and heads south again toward the Serengeti savannah.

Serengeti Mara is now a national park. It is surrounded by urban settlements and privately owned farmland, so expansion is not an option.

The green pastures depend on seasonal rainfall, and the current outlook for climate change indicates that precipitation patterns in the region will change. It is impossible to say with certainty where rain will fall in the future, but it seems likely that much of it will be outside the boundaries of the protected area of Serengeti-Mara. Any change of this nature would pose a serious threat to the ecosystem and to the survival of the migrating animals.

A Place Where Gods and Athletes Meet

The ruins of impressive temples scatter the Greek landscape, evidence of the preeminence of Ancient Greece. On the Peloponnese Peninsula in the south of the country lies the valley of Olympia, a haven for religious buildings and athletic facilities, and the site of the original Olympic Games.

The earliest evidence of building on the site is the Temple of Hera, honoring the wife of Zeus, which dates to around 600 BC. The golden age of Olympia was during the 5th and 4th centuries BC, when the impressive Temple of Zeus was built. The base and columns of both temples, which now lie in the shade of olive, pine, and poplar trees, have been restored along with Olympia's ancient baths and stadiums.

The first Olympic Games are believed to have been held here in 776 BC. The Games were dedicated to the gods, and athletes were immortalized for their ability to move the crowds with their great sporting deeds. The Games continued for nearly 12 centuries until the Christian emperor Theodosius I decreed that all such "pagan cults" be banned in 393 AD. The Olympic Torch is still lit at the Temple of Hera before being relayed to the host city for the modern version of the Olympic Games.

In recent years, extremely warm and dry summers have increased the number of wildfires in Greece. The damage was particularly bad in 2007, when three prolonged heat waves caused devastating fires that destroyed forests and agricultural land, razed villages, and killed 64 people.

The area surrounding Olympia was severely damaged in 2007 but, for the time being, the archaeological site itself remains intact. With temperatures projected to rise and rainfall projected to decline, global climate change raises the spectre of an increase in the frequency and ferocity of wildfires. The question is: How much longer will one of the most important cultural heritage sites in the Western world remain standing?

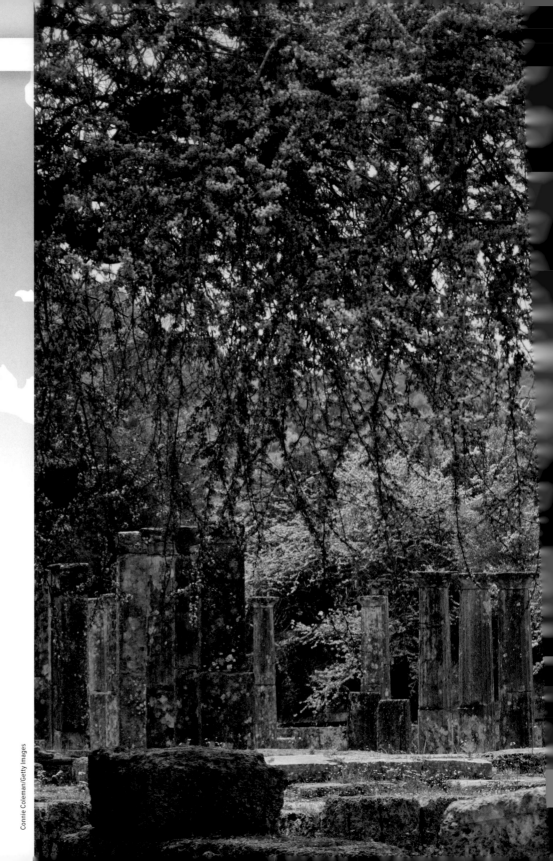

Connie Coleman/Getty Images

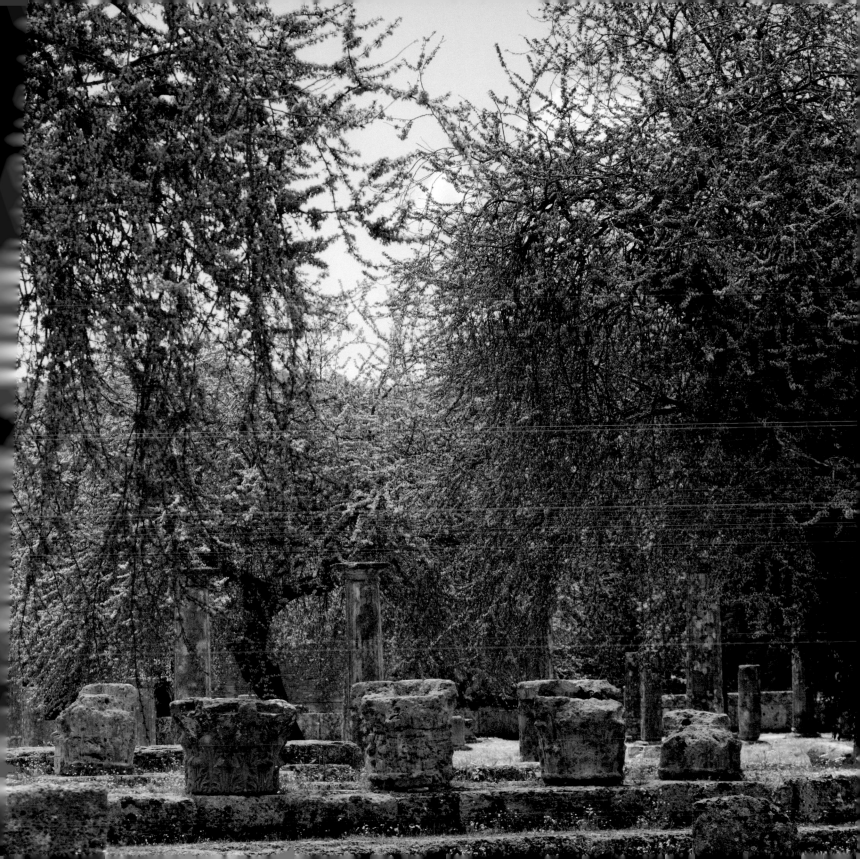

15. Principato di Lucedio | *Upper Po Valley, Italy*

The Cradle of Italian Rice Production

The vast Po Valley in northern Italy has been cultivated since ancient Etruscan and Roman times. Fed by Alpine glaciers, the mighty Po River and its 25 tributaries irrigate the huge, flat plain of the valley, known as the breadbasket of Italy.

Since medieval times, an extensive irrigation system made up of canals has rerouted water from the rivers, spreading it over most of the valley.

Italy is the largest rice producer in Europe and rice is a prominent crop in the valley, where local people are more likely to eat risotto than pasta. Other local crops include soya beans, corn, and wheat.

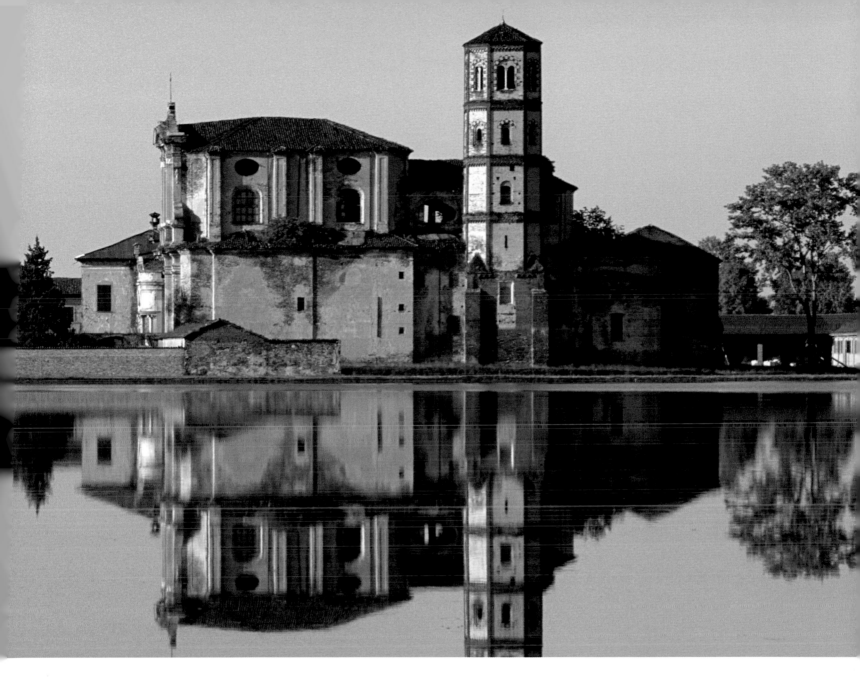

Lucedio Abbey—founded by Cistercian monks in the Upper Po Valley region of Piemonte in 1123—is the cradle of Italian rice production. This is where the crop was introduced to the country in the 14th century. The original octagonal bell tower, dating from around 1200, is still found on the site of the old abbey beside the Renaissance and baroque structures that are reflected in the reservoir, formed by dams on the river to provide water for modern rice production.

For more than two centuries, the estate has been in the hands of various Italian aristocrats, among them Napoleon's brother-in-law, Prince Camillo Borghese. It is now called Principato di Lucedio (The Princely Estate of Lucedio).

Rice production in the Po Valley is heavily dependent on water. Alpine glaciers are predicted to shrink, annual average rainfall to fall, and temperatures to rise, which could potentially disrupt the flow of the Po River and its tributaries and endanger the production of rice and other vital agricultural crops in the valley.

The Ancestral Home of the Apple

Farmers and cattle-breeders on the northern plains at the foot of the Tian Shan mountain range in Kazakhstan have been dependent on meltwater from Central Asian glaciers for 3,000 years.

In the 10th century, the settlement of Almaty was founded on the northern leg of the ancient network of trade routes, the Silk Road. Almaty derives from the Kazakh word for "apple" and, with its wide diversity of wild varieties, this region is thought to be the ancestral home of the modern domestic apple.

Almaty is the largest city in the Republic of Kazakhstan, with a population of 1.3 million. The Almaty region is also the economic powerhouse of the nation, accounting for 20% of total industrial production and 30% of its agriculture. The water supply for the whole area stems from glaciers in the 1,240-mile (2,000-kilometer) northern Tian Shan mountain range and is shared by Kazakhstan, Kyrgyzstan, and China. Millions of people in the three countries depend on the glacier melt-off for drinking water, irrigation, and industrial production.

In the last 50 years, the glaciers have lost about 36% of their mass due to a small but pervasive rise in mean annual temperature. With temperatures projected to increase further due to global warming, this grim trend is expected to accelerate. In the long term, it will result in a severe decrease in meltwater from glacial runoff.

At the same time, demand for water is growing fast in this rapidly developing area. Any reduction in the available supply would not just jeopardize Kazakhstan's agricultural and industrial development. Many of the dwindling rivers and glaciers cross state frontiers, so competition for declining resources would intensify and could eventually imperil the political stability of the whole region.

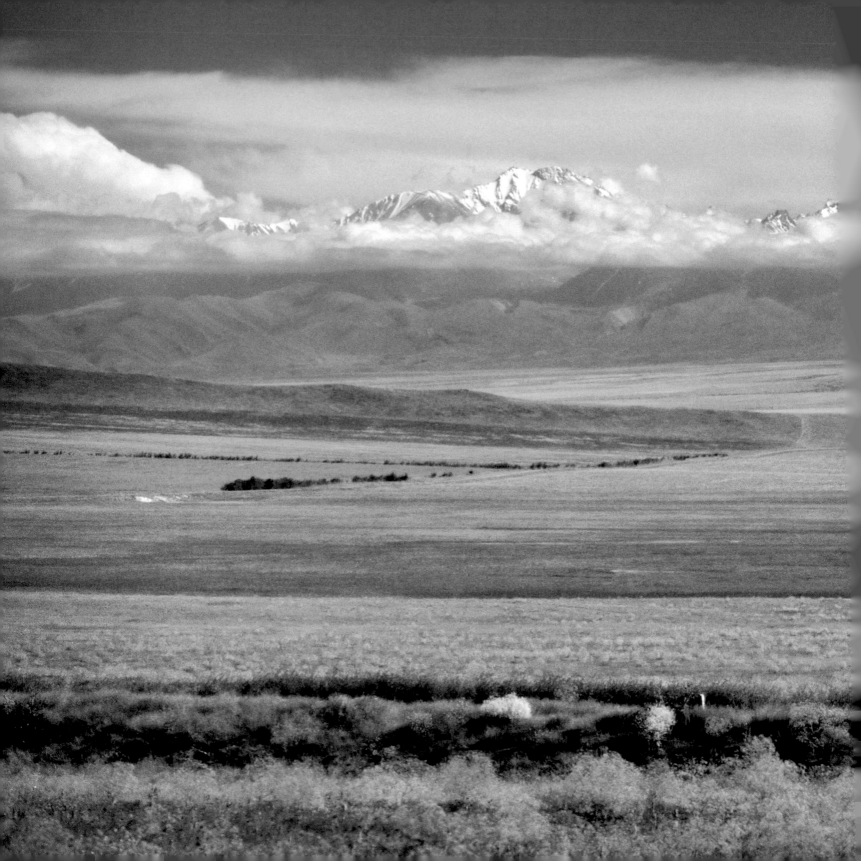

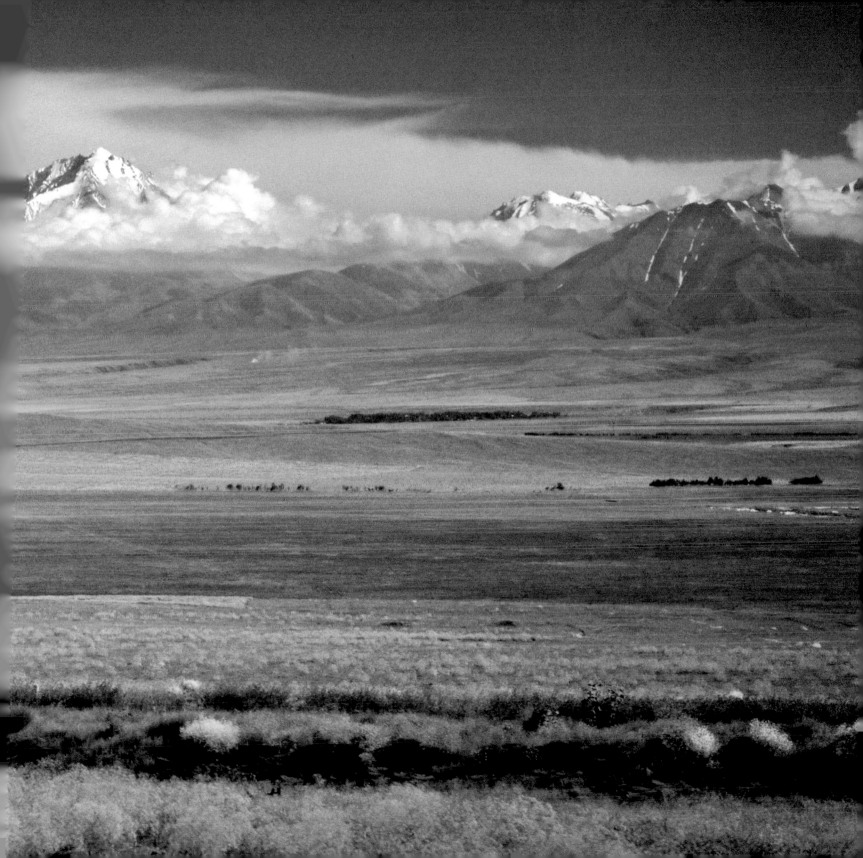

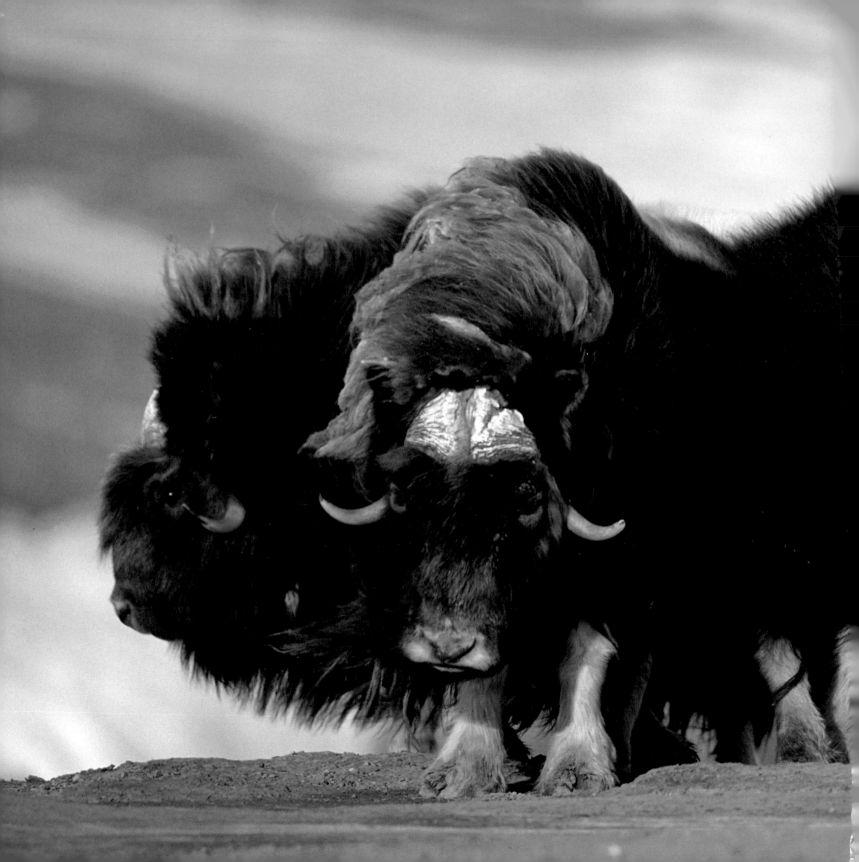

The Home of a Living Prehistoric Animal

Far to the north, in the High Arctic, lives one of the planet's oldest existing mammals, the musk ox.

More closely related to the sheep than the ox, its Latin name is *Ovibus*, meaning "sheep-ox." In Greenland, it is known as the *Úmimmak*, "the long-bearded one," because of the rich layers of wool that protect it from the wind and cold.

The musk ox is indigenous to the region and lives in groups. When threatened, the animals form a circle to protect themselves and their calves, and to scare off intruders. They feed on the sparse vegetation that grows to a height of 2–2.5 inches (5–6 centimeters) in the summer season, when temperatures can peak at about 50°F (10°C). In winter, with temperatures down to −31°F (−35°C), the musk ox uses its hooves to scrape through deep snow and access food.

Climate change is likely to cause the temperature to fluctuate even more and add to the number of ice layers covering vegetation during spring and autumn.

Higher temperatures could induce an annual rise in precipitation of 20%, even reaching 30–50% in the winter, which would make the snow 10–25% deeper.

Deeper snow and added layers of ice will make it extremely difficult for the musk ox to find food. Larger volumes of snow could also delay the start of the growing season and make vegetation even sparser.

A Cultural Melting Pot

Close to the Equator, the coastal city of Recife enjoys a year-round warm climate and gentle trade winds from the Atlantic Ocean. As well as being the commercial center of northeastern Brazil, Recife is also a prime tourist destination, thanks to its pleasant weather and 116 miles (187 kilometers) of white beaches.

The city's past as one of the first Portuguese colonies in Brazil and a main port for the slave trade has left an indelible mark on Recife. Nowadays it is a cultural melting pot with an ethnic mix of Indians, Europeans, and Africans. African culture is particularly visible in the local religion, music, dance, and cuisine. When the Dutch took control of Recife from 1630 to 1654, it also became home to the first Jewish community and synagogue in the Americas. Some of those early Jewish settlers later fled to North America, founding the first Jewish community in New Amsterdam—now known as New York.

A line of coral reefs protects the shoreline of Recife and gives the city its name, which is Portuguese for "reefs." Water covers the reefs at high tide but at low tide, natural pools form along the shoreline. Inland, Recife is full of waterways due to its location at the point where the rivers Beberibe and Capibaribe converge and flow into the ocean.

Due to its low-lying coasts and dense coastal development, Recife—like Rio de Janeiro and Buenos Aires—is highly vulnerable to rising sea levels and extreme weather events such as cyclones and storm surges. Any rise in sea surface temperature, combined with the increasing acidity of the ocean, is likely to damage Recife's natural barriers—the coral reefs—leaving the city even more exposed to flooding.

Andy Caulfield/Getty Images

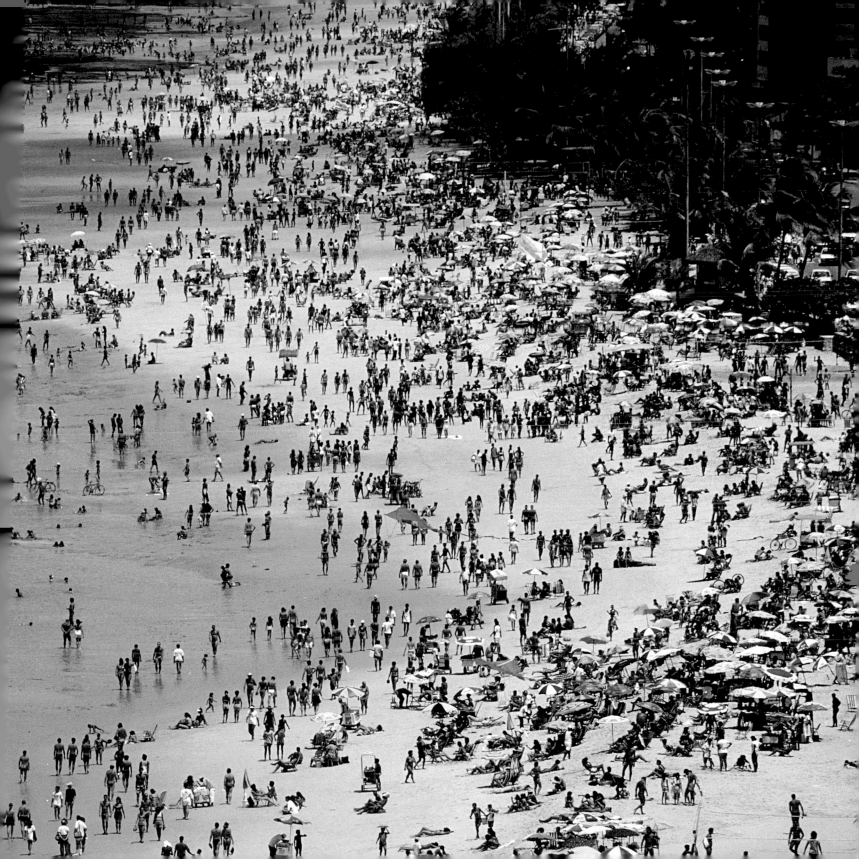

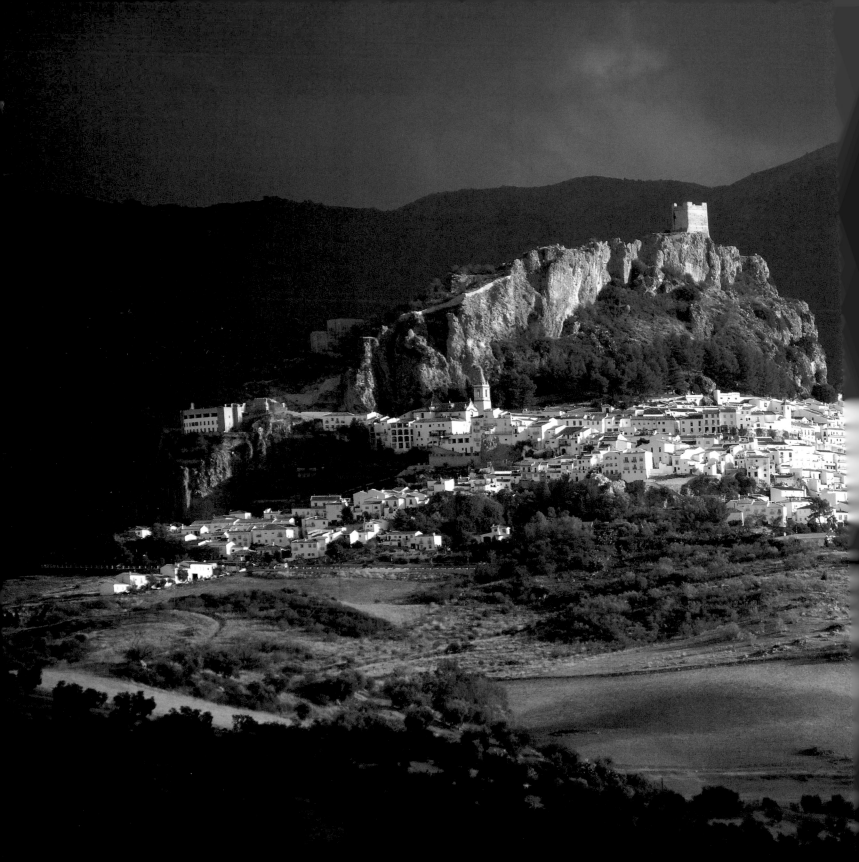

Olive Orchards in a Moorish Landscape

Below the remains of a medieval Moorish castle in the southern Spanish county of Andalusia, surrounded by fertile green pastures and olive orchards, lies the small town of Zahara de la Sierra, one of Andalusia's famous pueblos blancos *or "white towns."*

Olives are the most important crop in the region, covering 1.6 million hectares of land in the valleys and on the hilly slopes of the mountainous landscape.

The forests and mountains are rich in animal and plant life, including many rare species, and the area has been inhabited by man since the dawn of recorded history, as witnessed by the famous cave paintings at Pileta.

Due to global climate change, annual rainfall in the south of Spain is projected to fall by up to 40%, while the temperature is projected to rise by up to 7°F (4°C) by the end of the century. In other words, Andalusia and other parts of the Iberian Peninsula face a significant risk of decertification, with olive orchards disappearing, green pastures degenerating into bleak deserts and agricultural production dwindling.

The Birthplace of New York

New York City is located in a low-lying tidal area where the Hudson River flows into a natural harbor before reaching the Atlantic Ocean. Its near-coastal location has played an enduring role in the city's growth and economy.

The southern shoreline of Manhattan Island, known as the Battery, has been a popular promenade since the 17th century. The name comes from the artillery battery stationed there by the Dutch and British to protect the harbor in its early days.

The Battery is the largest public space in downtown New York. More than 280,000 people work within walking distance of it, and over 36,000 residents live in the surrounding area. It is home to the charming Battery Park.

About every 100 years, the area experiences extreme flooding that reaches heights of up to 10 feet (3 meters). Climate change will increase the frequency of winds and hurricanes from the northeast and cause sea levels to rise. According to the worst-case scenario, extreme events could occur every four years by 2080, with floods raising water levels by 11–14 feet (3–4 meters) and paralyzing the whole Manhattan infrastructure.

Michael S. Yamashita/Getty Images

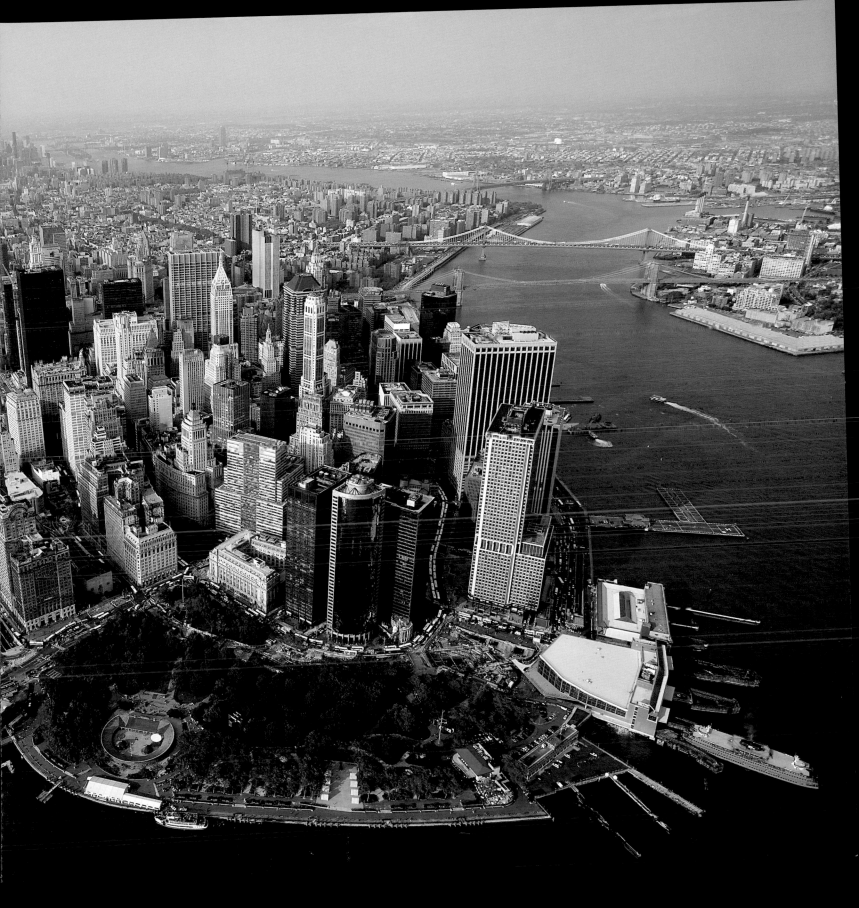

NEW YORK CITY is one of the world's major financial, commercial, and cultural centers. The city's growth exploded after the end of the Civil War in 1865, when New York became the first port of call for European immigrants arriving in search of a better life. To this day, this diverse and most cosmopolitan of cities teems with people of all nationalities and ethnicities.

New York has the largest subway system in the world in terms of track mileage and number of stations. The people of Manhattan are famous for using public transport in preference to driving. While only 5% of Americans nationwide use public transport to travel to work, 72% of Manhattan residents take the subway or other public transport. In 2000, more than 75% of Manhattan households did not own a car.

A Vulnerable Area of Thawing Permafrost

The North Slope region consists of a huge expanse of permafrost in the most northerly part of Alaska. Forest and tundra cover the region, with winding rivers running from the Brooks Ranges to the Beaufort Sea in the Arctic Ocean. Despite being almost as big as Great Britain, the permanent population numbers a mere 7,300.

As well as magnificent scenery and wildlife, including caribou, polar bear, and arctic fox, the North Slope is also home to the biggest oilfield in North America. Five thousand migrant workers are employed at Prudhoe Bay on the rim of the Beaufort Sea, producing 650,000 barrels of oil a day. From Prudhoe Bay, the Trans-Alaskan Pipeline transports the oil across the Alaskan state to the Port of Valdez in the south.

The thawing of the permafrost now poses a serious threat to the area. The "active" layer of permafrost—the part that freezes in winter, thaws in summer and sustains vegetation—ranges from a few inches to a few feet deep (from 100 millimeters to a meter). In the last quarter of a century, rising temperatures have made the active layer deeper. It now encroaches into the permanently frozen deposits of ice, soil, stones, and organic material that form the foundation for the physical stability of the whole area.

A further increase in temperature due to global warming is expected to make the active layer even deeper and slowly dissolve the permanently frozen soil. If this happens, it would gradually undermine the forests as well as man-made structures.

As the deeper layers of permafrost thaw, organic material that has been frozen for millennia will thaw too, potentially releasing greenhouse gases into the atmosphere and further fuelling climate change.

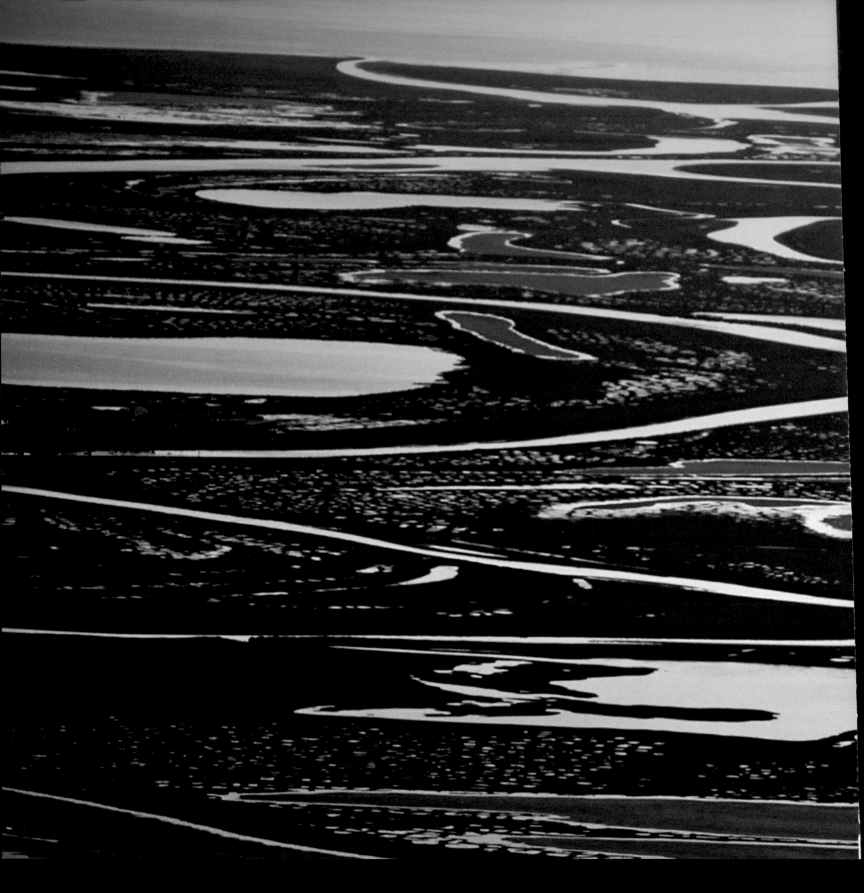

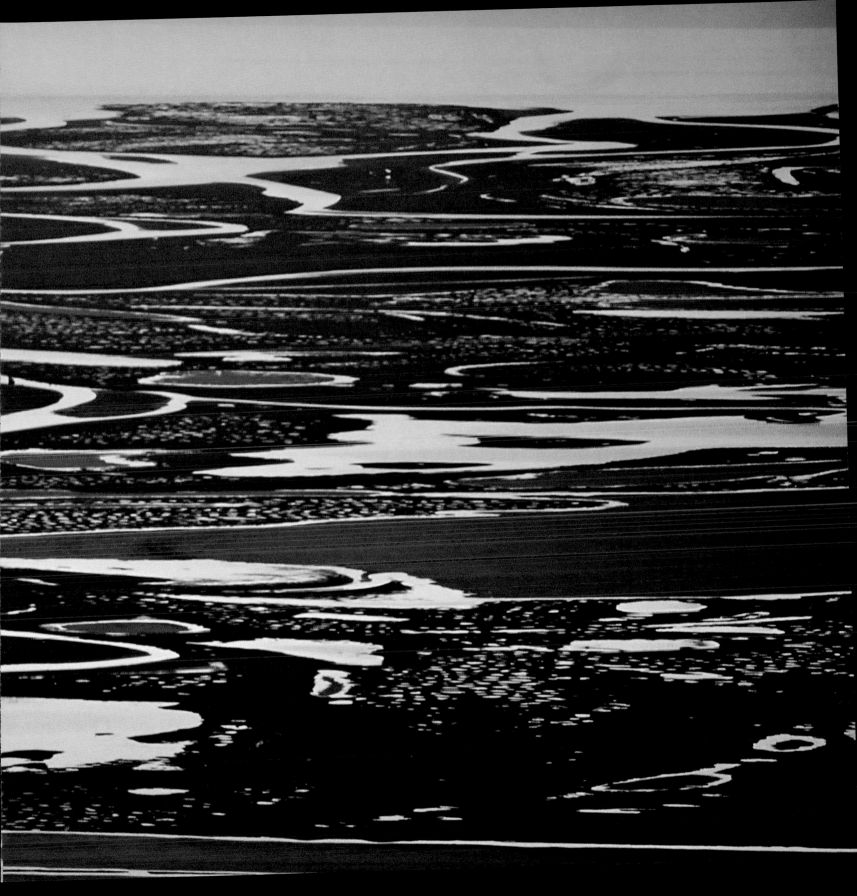

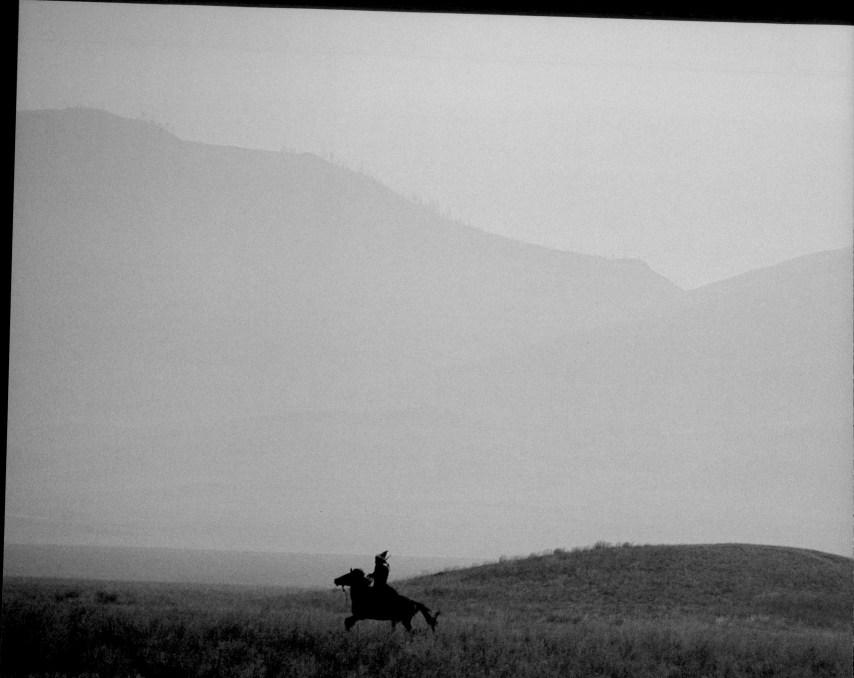

The Frozen Past of the Golden Mountains

In the Altai Mountains in Central Asia, burial mounds (kurgans) rising 65 feet (20 meters) extend along the southern Siberian steppe. The world's only frozen tombs, the kurgans have been preserved in their original condition by permafrost, bearing witness to the Scythian tribes, a nomadic, horse-riding people who dominated the Eurasian steppes during the first millennium BC.

The Altai Mountains rise where Russia, Mongolia, China, and Kazakhstan converge. The Russian section of the mountain range is on UNESCO's World Heritage List because of its diverse vegetation, which varies from steppe to mixed forest to alpine vegetation. *Altai* means "golden mountain"—an apt name, given the priceless nature and culture of the region.

Occupying lands stretching from the Black Sea to the Mongolian Plain, the Scythians were herdsmen and warriors, fighting rival tribes with barbed, poisoned arrows. Women, probably young and unmarried, fought alongside the men and dressed in similar clothes.

Examinations of the kurgan tombs have revealed gold artifacts, weapons, and animal (and sometimes human) sacrifices, all in perfect condition. Even organic material such as silk, wool, and leather has survived intact, along with mummified human bodies. In one kurgan, archaeologists discovered the beautifully tattooed corpse of a woman wearing a silk blouse, who was later given the name "The Ice Maiden."

The key to Scythian culture lies in the frozen tombs of the Golden Mountains. Many of the kurgans are located in an area where the permafrost is inconstant, making them extremely vulnerable to rising temperatures. In the last 100 years, temperatures have risen by 3–4°F (1– 2°C and a significant reduction of the permafrost is predicted to take place in the middle of this century. As the permafrost melts away, so too will a unique natural habitat and its distinctive cultural heritage.

Sisse Brimberg/Getty Images

A Living Cultural Landscape

Aboriginal clans have occupied the land of Kakadu in the north of Australia for more than 40,000 years. Kakadu National Park is famous for its unique interaction between culture and nature, as exemplified by its 10,000-year-old stone paintings and the remarkable variety of wildlife made possible by the diversity of its tropical climate.

The lush, green wetlands of Kakadu support more than 60 species of water bird and, at the end of the northern summer, the wetlands attract about 30 species of migratory birds that have flown south to these warmer climates from their breeding grounds in Siberia and China. Along the flood plains of the wetland lie paperbark forests that sustain honeyeaters, lorikeets, and other nectar-feeding birds.

Paperbark trees are vital to the Aboriginal peoples, who produce canoes from them by folding a single, large piece of bark.

The Kakadu National Park is home to about 500 Aboriginal people, who live according to the principle that has always governed their lives: caring for the land. They are highly dependent on the large number of people who turn up every year to visit the lily-carpeted waterways.

Climate change now presents a serious challenge, both to the livelihood of the Aboriginal people and to the rich natural environment. Rising sea levels are causing saltwater intrusion that threatens to destroy the paperbark forest and turn a major part of the fertile wetlands into salty mudlands. If this happens, tourism will decline and many of the distinctive birds will abandon the park, with a devastating effect on the wildlife of the wetlands.

Belinda Wright/Getty Images

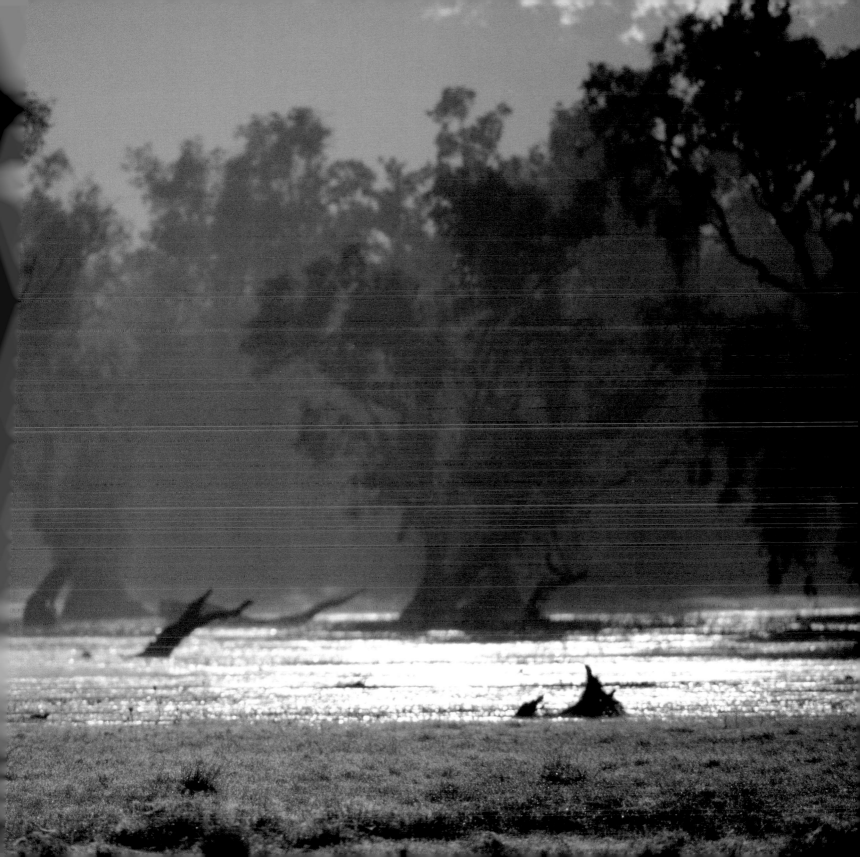

City on the Water

Packed with Gothic, Byzantine, and Renaissance palaces, Venice is an artistic and architectural masterpiece, famed as one of the most extraordinary and beautiful cities in the world.

Founded in the 5th century, Venice is spread over 118 small islands in a marshy lagoon in the northeastern corner of the Adriatic Sea. In the early Middle Ages, Venice evolved into one of the world's greatest maritime powers and wealthiest city-states.

The city prospered on trade with the rest of the world for centuries. As evidence of its vast wealth, works of art by great masters adorn even the smallest of the palaces along the canals.

Venice was built on wooden poles hammered deep into the muddy ground. The network of picturesque canals earned it the sobriquet "the city on the water." By its very nature, Venice has always been extremely vulnerable to flooding.

Over the centuries, the city has been slowly sinking—by 9 inches (23 centimeters) in the last century alone. In November 1966, the worst flood in recorded history raised the water level 6.36 feet (1.94 meters) above the norm and caused widespread damage to many historic sites.

To avoid similar incidents in future, a barrier comprising a number of mobile floodgates is now under construction. Known as MOSE (a play on *Mosè*, the Italian for Moses, who parted the Red Sea), it is designed to withstand a maximum flood of 10 feet (3 meters) and to safeguard Venice from storms and rising sea levels until the end of the century. At that time—or sooner if climate change accelerates faster than predicted—new measures will have to be taken to protect this Adriatic gem.

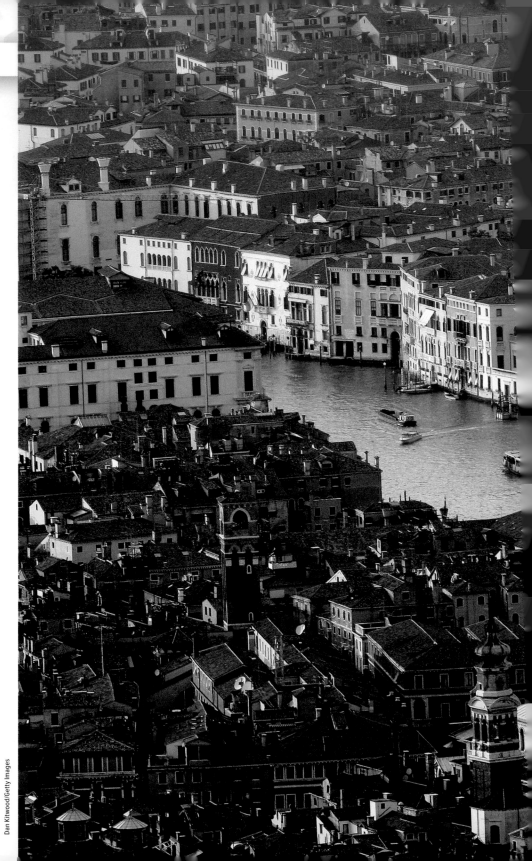

Dan Kitwood/Getty Images

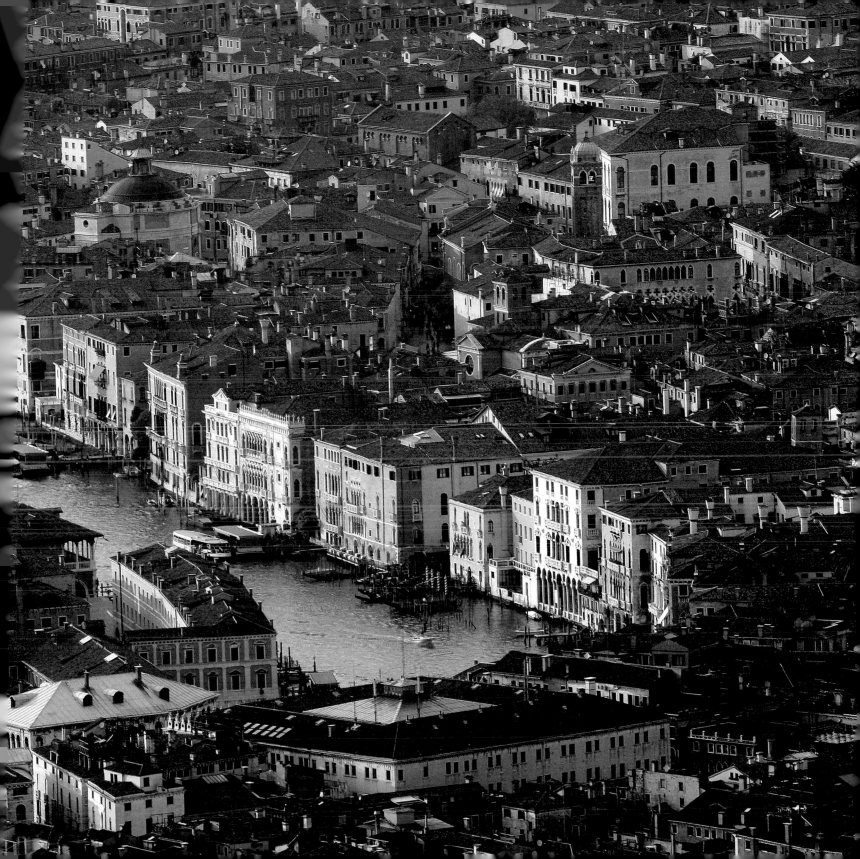

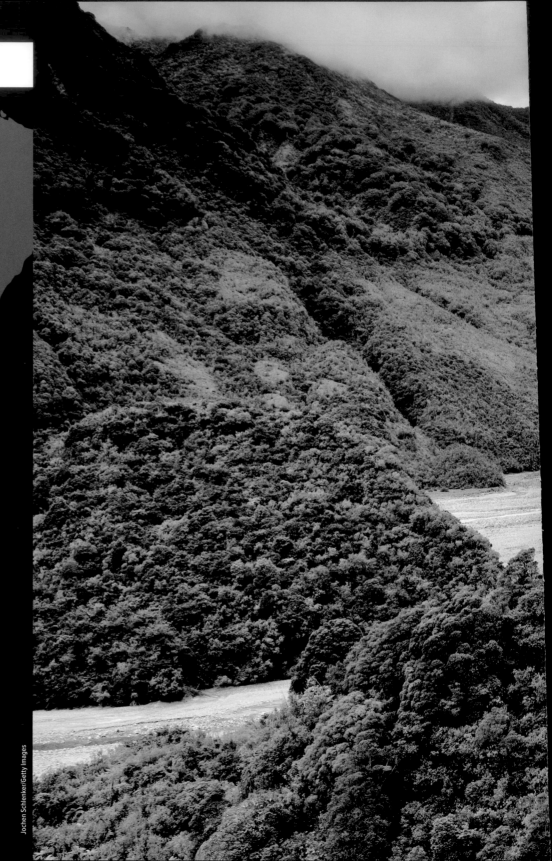

Where Ice and Rainforest Meet

The Franz Josef Glacier is widely considered to be the gem of the glaciers on the west coast of New Zealand. It descends from about 11,500 feet (3,500 meters) to just 787 feet (240 meters) above sea level in the middle of a temperate rainforest, making it the alpine glacier that terminates at the lowest altitude in the world. The ice melts into the Waiho River.

The glacier was named after Emperor Franz Josef I of Austria in 1865, but its more poetic Maori name is *Ka Roimata o Hinehukatere*, meaning "The Tears of Hinehukatere," deriving from a local legend about a girl whose lover dies in an avalanche. Her tears flow down the mountainside, freezing and forming the glacier.

Like some other glaciers, Franz Josef has its own cycle of retreating and advancing, which is independent of climate change. Having retreated a couple of miles between the 1940s and 1980s, it started to advance again in 1984. In the long term it is shrinking, however, as are all of the glaciers in the New Zealand Alps.

Globally, the combined mass of mountain glaciers and snow cover has been declining consistently in both the northern and southern hemispheres. Between 1991 and 2004, the speed at which the glaciers of the world have been shrinking has accelerated, contributing .03 inch (0.8 millimeter) per annum to the rise in sea level.

The glaciers in the New Zealand Alps have been shrinking since 2000. On average, those in the Southern Alps have shortened by 38% and lost 25% of their area.

According to glaciologists from New Zealand's Canterbury and Victoria universities, the Franz Josef Glacier could disappear within the next 100 years. By the end of the century, Hinehukatere may well have cried her last tear.

Jochen Schlenker/Getty Images

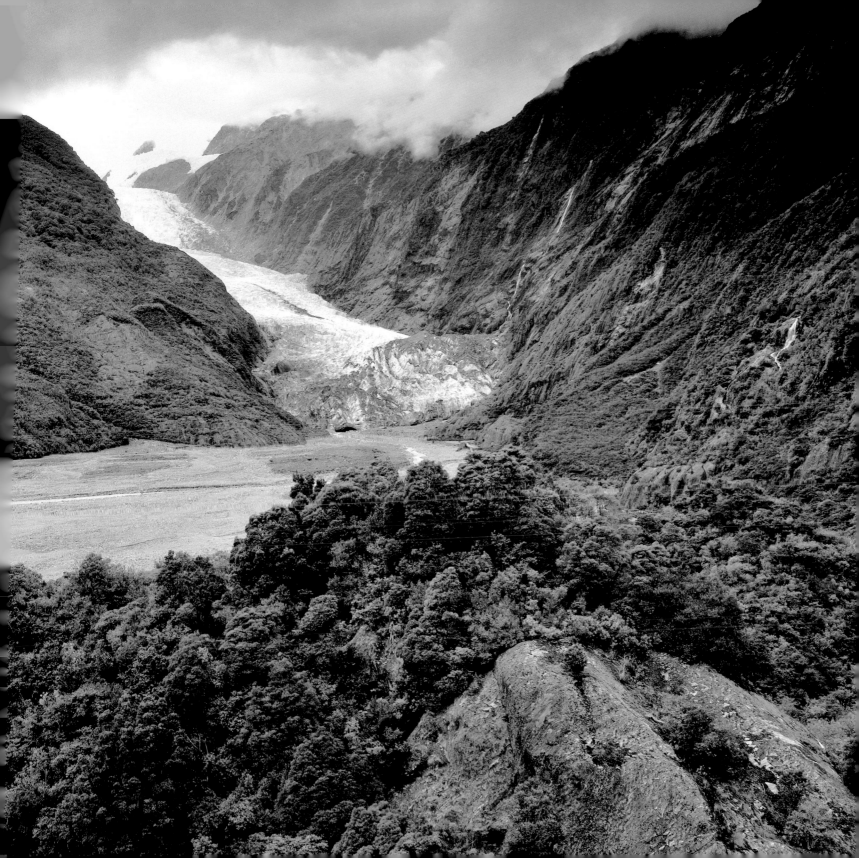

Water for
20 Million
People

Lake Chad is located in the savannah of the Sahel region, just south of the Sahara desert. Surrounded by four countries—Chad, Cameroon, Nigeria, and Niger—it is the most important source of water for drinking, crops, and livestock, as well as extensive subsistence fishing, for nearly 20 million people.

Lake Chad is believed to have been an inland sea some 13,000 years ago, at one point covering an imposing area of 155,00 square miles (400,000 square kilometers). As it is shallow, the size of the lake has always fluctuated greatly, but it has shrunk at an unprecedented rate over the last four decades. In the 1960s, the lake covered more than 10,000 square miles (26,000 square kilometers); by 2000, this had fallen to less than 580 square miles (1,500 square kilometers).

For the first time, human activity is now causing the water level to change dramatically. Irrigation and damming of the rivers that feed Lake Chad are draining the lake and overgrazing on the savannah is damaging vegetation. It is likely that these factors will make the climate even drier.

Water shortages have led to disagreements about jurisdiction between the neighboring states, as well as to violent clashes between farmers, who are constantly diverting the water, and fishermen, who are worried about the lake shrinking.

Once one of the largest lakes in the world, Lake Chad now looks set to disappear. It is predicted that climate change, in the form of higher temperatures and increasing evaporation, will accelerate the shrinkage and the transformation of grasslands and wetlands into dusty deserts. The poverty and conflict that are expected to ensue would further exacerbate the situation in an already severely distressed region.

Jeff Hutchens/Getty Images

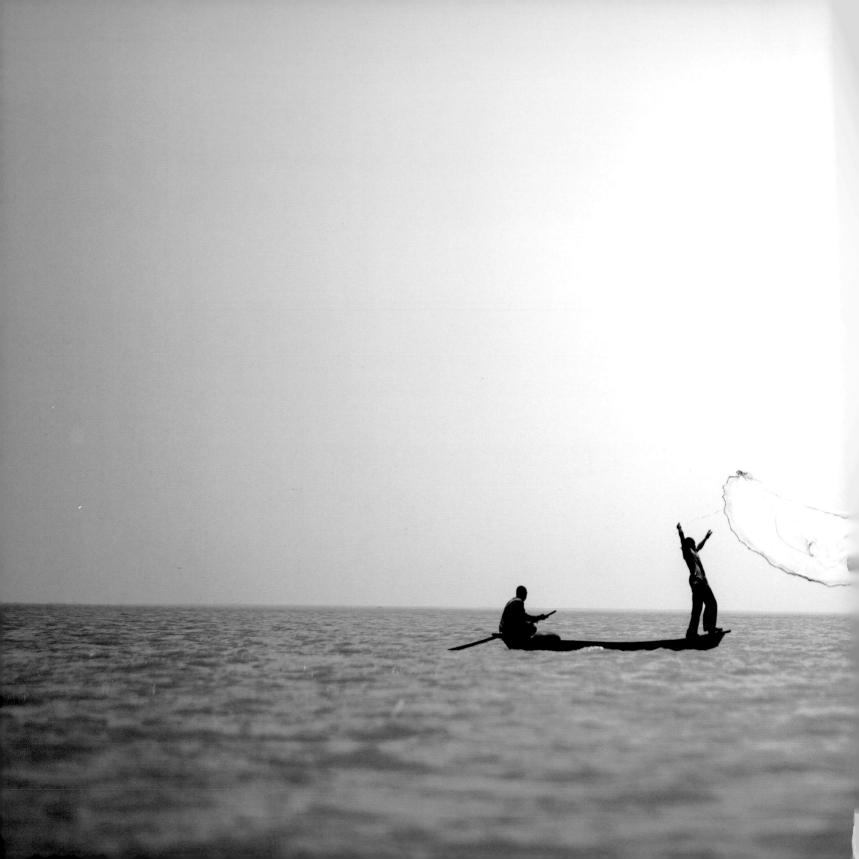

From Gulags to Modern Cities

Until the construction of the Trans-Siberian Railway between 1891 and 1916, the vast region of Siberia remained virtually unexplored. Covering almost 10% of the Earth's land surface, or 5.1 million square miles (13.1 million square kilometers), Siberia extends eastwards from the Ural Mountains all the way to the strait between the Pacific and Arctic oceans.

A brutal chapter of Russia's history unfolded in the harsh arctic and subarctic climate of Siberia. For long periods of time, except for a few explorers and traders, the population of Siberia consisted mainly of prisoners exiled from western Russia. A system of labor camps, known as Gulag, was established during the Stalin era. The deportation of the prisoners reached staggering proportions and, between 1929 and 1953, at least 14 million people were sent to the camps. The Gulag served as a source of labor for the mines of the remote Siberian plateau, which is rich in natural resources such as oil, gas, coal, lead, gold, and diamonds. Some of the camps of the Gulag have turned into major industrial cities, e.g. Norilsk, Vorkuta, and Magadan in the Kolyma Region to the east. However, Siberia is still sparsely populated, with a density of only nine inhabitants per square mile.

Many of the 36 million people in the region may soon face new problems. The Siberian oil and gas complexes, pipelines, roads, and railways are all built on top of the permafrost that covers large parts of the region. In Yakutsk, the world's largest permafrost city, everything—apartments, hospitals, factories—is built on top of wooden piles hammered into the permafrost. Forty years from now, it is projected that global warming will have caused the permafrost in the northern hemisphere to decline by 20–35%. If the permafrost thaws under the sites of oil and gas facilities, it could lead to leaks and cause extensive damage to the infrastructure. In some places, buildings are already less stable due to the thawing permafrost.

Arctic-Images/Getty Images

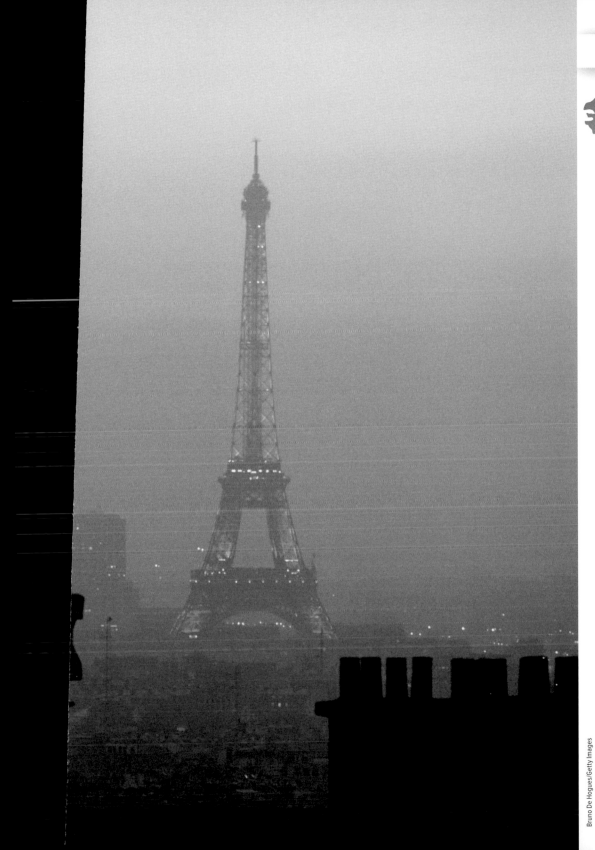

The Birth of a Monumental City

Most of modern Paris was formed in the mid-19th century, when Napoleon III initiated the modernization and rebuilding of the city, turning the old narrow streets and half-wooden houses into wide boulevards lined with neoclassical stone buildings.

Today, the city's avenues and iconic monuments attract 45 million tourists every year, drawn by its balmy winter days and warm summer nights. The North Atlantic Current means that Paris rarely sees extremely high or low temperatures. Almost 12 million people live in the metropolitan area, making the city one of the most heavily populated places in Europe.

In 2003, a heat wave struck Europe. It hit France particularly hard, especially the north, where people are unaccustomed to high temperatures. Summer temperatures reach an average high of 77°F (25°C) in Paris but that year the temperature rose to over 104°F (40°C). In August, 14,802 excess deaths were recorded in the whole of France, with the Île-de-France region, which includes Paris, accounting for a third of them. Many French families, physicians, and family doctors go on holiday in August and many of the people who died were elderly people who had been left alone in their apartments. There were so many deaths that unclaimed bodies had to be kept in a refrigerated warehouse outside Paris.

Across the whole of Europe, about 35,000 people died because of the heat wave in 2003. Temperature records were broken in Britain, Germany, and Spain, while in Portugal forest fires destroyed 5% of the countryside and 10% of the forests.

Toward the end of the 21st century, it is predicted that summer temperatures could be similar to those of the 2003 heat wave. By then, heat waves will be even more extreme, which poses a risk that populations and authorities will need to address.

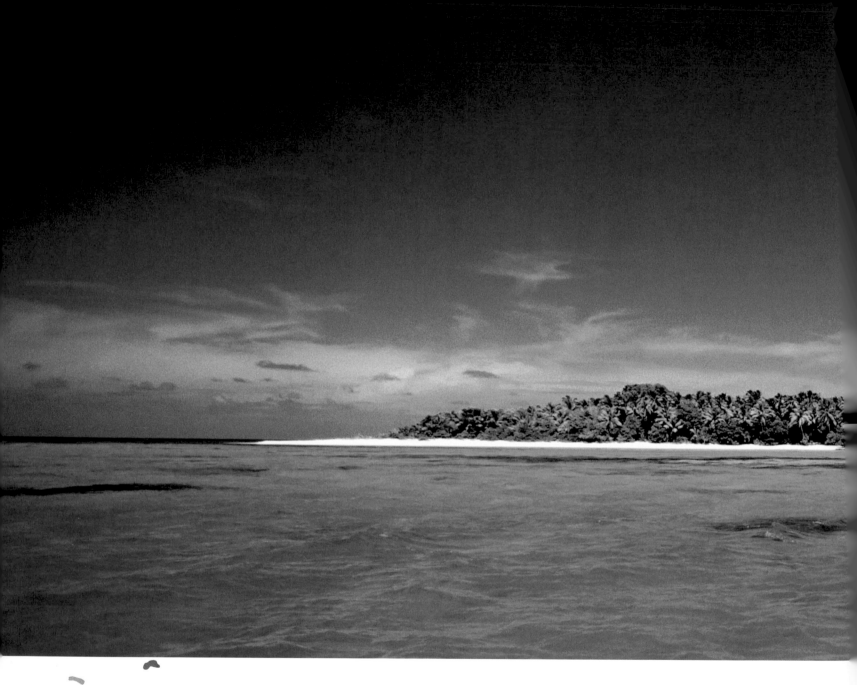

29. Tuvalu | *Pacific Ocean*

The Fourth-Smallest Country in the World

Between Australia and Hawaii, in one of the most remote areas of the Pacific Ocean, lies the nation of Tuvalu. At only 10 square miles (26 square kilometers), Tuvalu is the fourth-smallest country in the world, made up of tropical reef islands and narrow coral atolls encompassing blue lagoons.

Only 12,000 people inhabit the nine islands of Tuvalu. Theirs is a distinctive Polynesian culture with a traditional way of life, each family playing its own role in the community, such as fishing or house building.

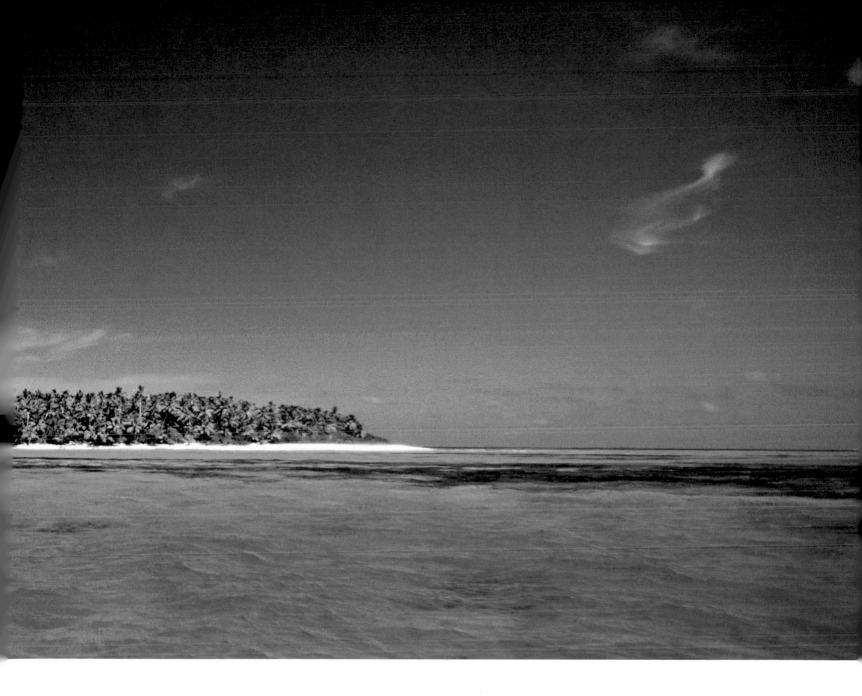

The name *Tuvalu* means "eight standing together," and originates from a time when only eight of the nine islands were inhabited. In the future, not much might be left standing at all.

At 16 feet (5 meters) above sea level, Tuvalu has one of the lowest maximum elevations in the world, making it extremely vulnerable to storms and changes in sea level.

With sea levels projected to rise by up to 24 inches (60 centimeters) by the end of the 21st century, parts of Tuvalu will be flooded, and the intrusion of saltwater will damage important crops such as coconut and the staple taro.

Rising sea temperatures and acidification will have a devastating impact on the coral and may eventually kill it, destroying essential coastal protection and the very

foundation for life on the islands. Tuvalu is also affected by what is known as the King Tide—a high tide that raises the sea level higher than normal. Combined with the expected rise in global sea levels, this could ultimately submerge the nation entirely, forcing the Tuvaluan people to move to neighboring countries.

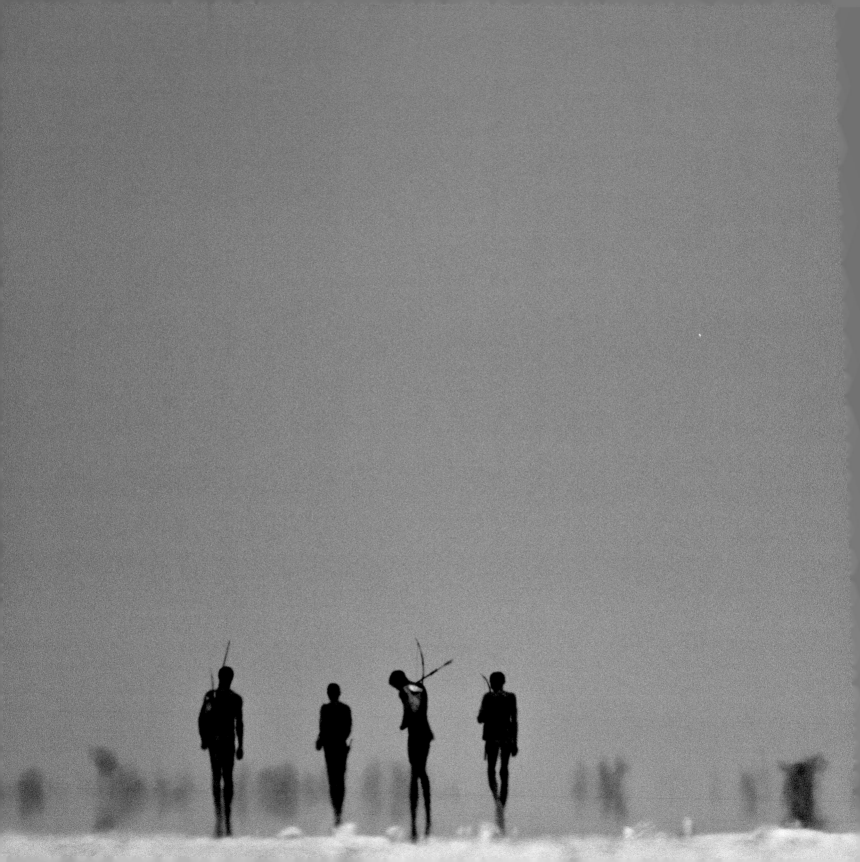

The Ability to Find Water Where No One Else Can

In the harsh climate of the Kalahari Desert in southern Africa, the San people are always on the move, searching for wild fruits, berries, and nuts, and tracking water and game. Believed to be descendants of the first inhabitants of southern Africa, the San are famous for their exceptional hunting skills. By imitating the movements of animals, they are able to get close enough to herds to kill their prey with poisonous arrows.

The San's knowledge of how to find water and food in places where no one else can has been passed from generation to generation, and European colonists, armies, and farmers have all taken advantage of their tracking talents to pursue poachers and guerrillas. Recently, the San's knowledge of desert plants has led to the discovery of an appetite suppressing drug that treats obesity.

The San tribes have gone through more changes in the last 50 years than in the preceding 40,000. Once numbering millions, less than 2,000 now lead a traditional hunting and gathering lifestyle.

Conflicts between the San and both neighboring tribes and European colonists have forced them to the more remote reaches of the Kalahari. Ancient scrubland is being turned into privately owned cattle ranches, and the San's search for fertile land will become even harder as decertification encroaches on the bush vegetation, caused by rising temperatures and rainfall that is decreasing by up to 40% during the austral winter. Global warming could eventually prevent the last of the San from hunting and gathering food on the desert plains.

Chris Johns/Getty Images

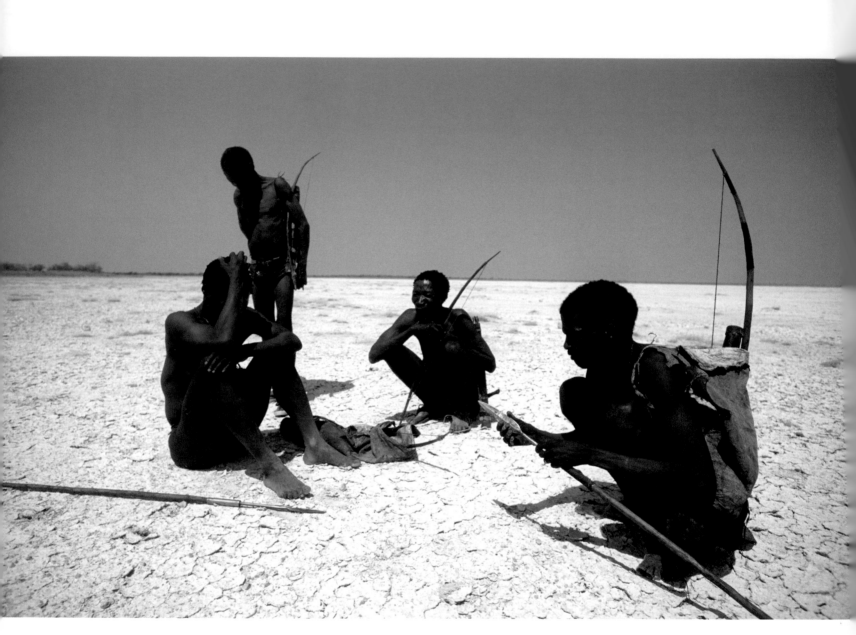

THERE IS NO KNOWN ANTIDOTE to the most lethal poison used by the San, which consists of a mixture of grubs, beetles, and tree gum. Armed with poisonous arrows, the San men set off in small parties to hunt, tracking game by reading the traces left behind by animals.

At night, women, men, and children gather round the fire to perform dance rituals, accompanied by clapping and rising chanting. This sometimes develops into a trance dance, through which the San believe they are able to cure sickness and communicate with dead or absent relatives.

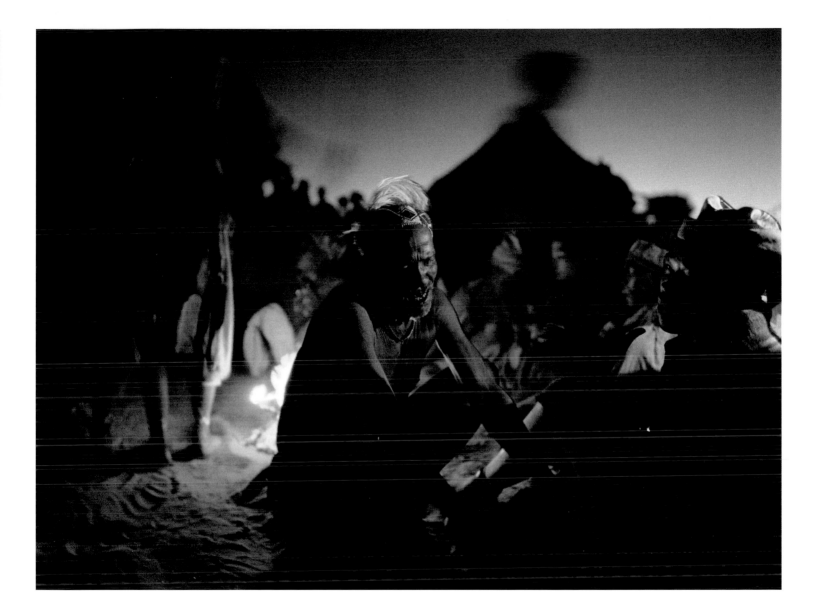

So Vast,
It Is Visible
from the
Moon

So vast it is visible from the moon, the Great Barrier Reef covers 132,000 square miles (344,000 square kilometers), stretching a massive 1,615 miles (2,600 kilometers) off the northeast coast of Australia.

The largest coral ecosystem in the world, it is far bigger than Britain, the Netherlands and Switzerland combined.

The Great Barrier Reef consists of some 400 different species of hard and soft coral in every imaginable color. It is home to 1,500 varieties of fish and thousands of different shellfish, whose existence depends on the coral.

Higher water temperatures are very likely to have devastating consequences for the reef, as will increasing acidification of the oceans. If the water temperature rises 2.7–3.6°F (1.5–2.0°C), many more parts of the coral will bleach and eventually die. An increase of 5.4°F (3.0°C) would wipe the reefs out completely.

Global warming is expected to raise the temperature of the water in the area by at least 3.6°F (2.0°C) by 2100. In other words, it is highly probable that the Great Barrier Reef will disappear from the surface of the Earth.

Annie Griffiths Belt/Getty Images

The Forest of the Cedars of God

At one time the plains and mountains of Lebanon were densely covered with majestic cedar trees. Today, the heavily reduced remains of the immense forests are found on the high slopes of Mount al-Makmal in northern Lebanon. They are known as the Cedars of God.

Beneath the Cedars of God lies the deep, yawning valley of Ouadi Qadisha, or the "Holy Valley," which is scattered with chapels, temples, and monasteries. Like the Phoenicians and Israelites, the Christians used the cedar trees to construct religious buildings, and the Holy Valley is home to some of the earliest Christian monastic settlements. In the 7th century, Christian monks settled in caves in the steep cliffs of the valley to lead lives of solitude.

Since ancient times, the cedar tree has been a highly prized building material due to its exceptionally hard consistency and beautiful scent. Both the Babylonians and the Assyrians exploited its timber, and the Egyptians used its wood for shipbuilding and its resin for mummification. Today, its cultural importance is acknowledged in the Lebanese flag, which has a green cedar tree in the center.

It is said that the cedar of Lebanon is one of the oldest trees in the world. Among the Lebanese Cedars of God, 12 trees are more than a thousand years old, and the rest are aged at least one hundred.

In the years to come, the last ancient cedars face a severe threat from climate change. During the next 70 years the temperature in Lebanon is expected to rise, while precipitation will drop, making the climate significantly more arid than today and affecting the conservation of the cedar trees. In the future, the ancient cedars might only exist as part of a mythological past, leaving the Lebanese landscape barren.

George F. Mobley/Getty Images

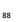

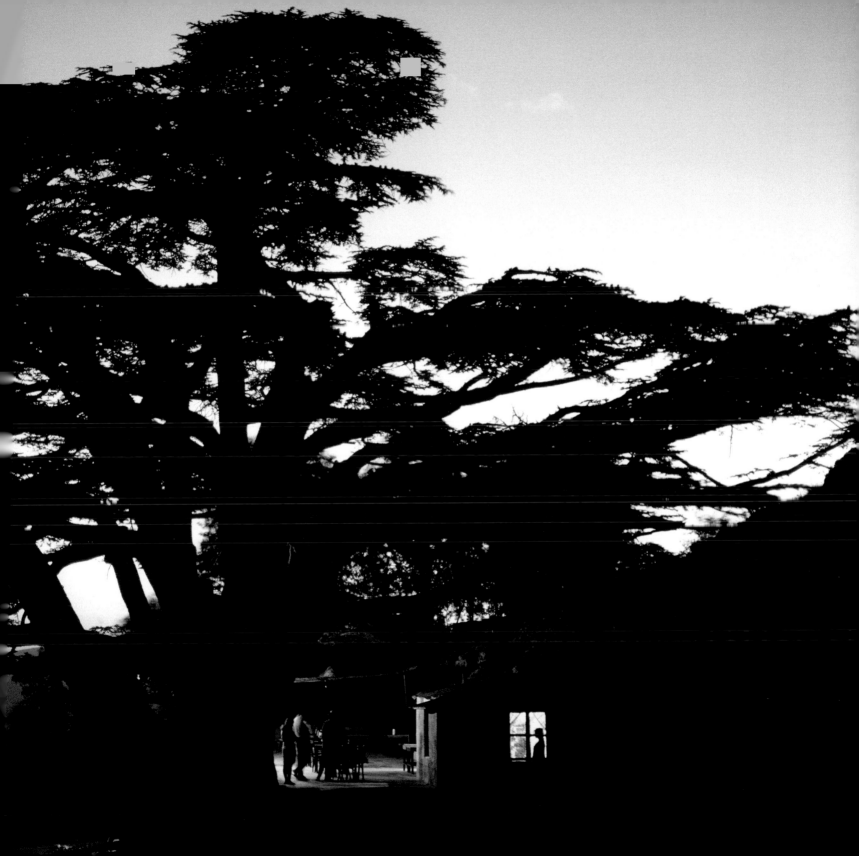

Home to a Nomadic Tribe of Boat Dwellers

Historically, the Bajau people have lived a nomadic seafaring life in the tropical monsoon climate of the Sulu-Sulawesi Sea. They stem from the southwest coast of the Philippines but are now spread across the triangle of the Philippines, Indonesia, and Malaysia.

The Bajau fish, eat, and sleep in handmade lipa-lipa boats, which have roofed living areas made of mats and poles, where meals are prepared on portable clay hearths. They fish with spears and handheld lines, using lanterns to light up the sea on moonless nights. The movements of the Bajau are largely determined by the sea cucumber, considered a great delicacy in many Asian countries. Bajau divers are capable of reaching depths of up to 100 feet (30 meters) in search of sea cucumber.

Although they are Sunni Muslims, many of the Bajau still perform older ceremonies, such as casting spirit boats into the open sea to ward off offending apparitions.

While many of the Bajau have settled on land and now live as farmers and cattle breeders, about 10% are still boat dwellers. For that 10%, the traditional life is growing increasingly complicated. Overfishing and illegal methods such as blasting and poison-fishing are damaging the coral reefs and destroying the natural habitats of fish and sea cucumber alike. Projected rises in sea-surface temperatures and increasing acidification due to climate change are likely to kill off even more of the coral. Eventually, this could herald the end of the traditional Bajau way of life.

Jurgen Freund/Getty Images

"Have Gone to Patagonia"

When Bruce Chatwin quit his job with the Sunday Times *in London to pursue a writing career that covered a wide range of travel writing, essays, and fiction, he famously sent his employers a telegram saying "Have gone to Patagonia."*

If the Southern Right Whale could speak, it might say exactly the same thing. Every year, during the South American winter, thousands of these huge mammals—up to 60 feet (18 meters) long and weighing up to 130 tons—migrate from their feeding grounds in the waters of the Southern Ocean close to Antarctica, to breed in the Valdés Peninsula of Argentine Patagonia.

Both sites are ideal for their purpose. In the Southern Ocean, the whales feed on the abundant krill—small, shrimplike crustaceans—that live in the cold waters. At the Valdés Peninsula, they mate, calve, and raise their offspring in the sheltered lagoons of the Nuevo and San José gulfs.

The whales will often cavort with their calves as little as 200 yards (200 meters) from land, attracting thousands of spectators from all over the world. To the delight of their audiences, they teach their calves a piece of behavior that is unique to the Southern Right Whale known as "sailing"— using their elevated flukes to catch the wind and glide more easily across the ocean.

Krill, the Southern Right Whale's main source of food, live on algae. Higher sea temperatures and melting sea ice around the Antarctic will decimate the algae and krill alike, posing a severe threat to the survival of the whales.

In years when the Antarctic summer has been warm, a decline has been noted in the number of calves born. Miscarriages induced by lack of food are believed to be the cause.

Research shows that young whales learn from their mothers exactly where in the immense ocean to look for food, and that this knowledge has been passed down for generations. If the food vanishes from their current feeding grounds, it will be very difficult for them to move elsewhere.

Paul Souders/Getty Images

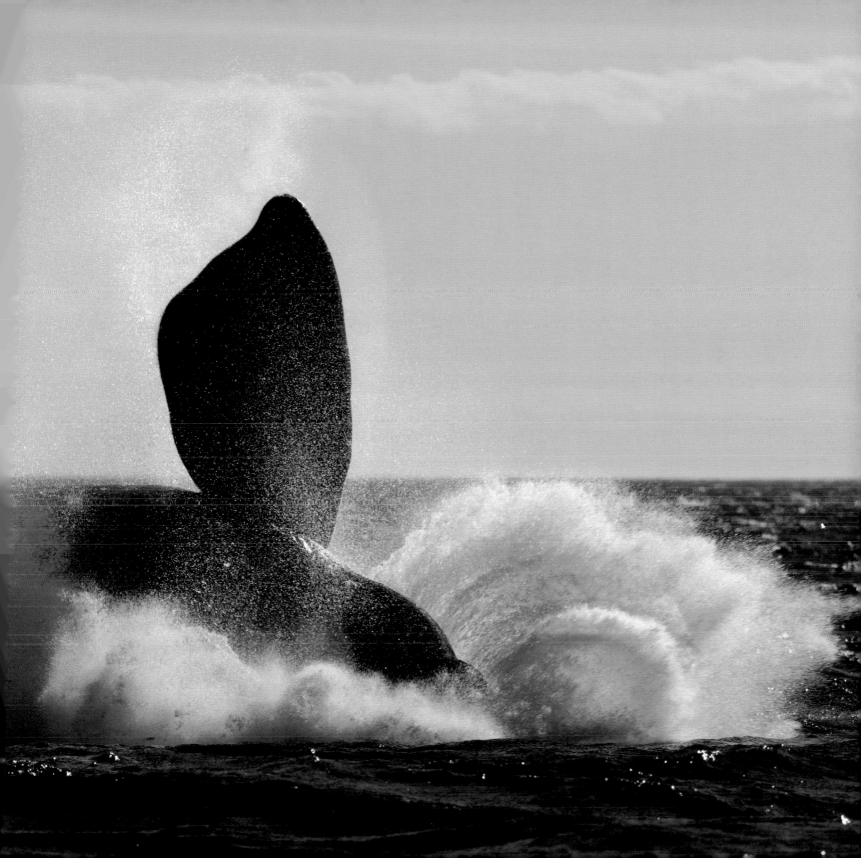

Green Metropolis on the Edge of the Desert

The city of Perth in southwestern Australia is one of the most isolated metropolises in the world, with the nearest large city more than 1,200 miles (2,000 kilometers) away.

Although Perth sits at the edge of a vast desert and has one of the driest climates in the world, it is renowned for its luxuriant European-style parks and gardens, lush green lawns, and open spaces.

Such opulent greenery is possible thanks to a geological peculiarity of the area. Perth is situated above a vast aquifer of 40,000-year-old water, which is its main source of drinking water. The only Australian city dependent on groundwater, Perth uses more water per capita than any other city in the country.

Over time, the aquifer has been supplemented with surface water stored in reservoirs. Perth's population of 1.7 million is more than double what it was 30 years ago and per-capita water consumption has gone up by more than 20%, putting severe pressure on its water reserves. In the same period, the city has seen a dramatic decline in rainfall due to global warming, and this has reduced the surface flow into water reservoirs by 65%, putting further pressure on the nonrenewable aquifer source.

Perth's famous parks and green areas have not suffered during this process, and about 50% of all freshwater consumed in Perth is now used in its parks and gardens.

During the next 40 years, the temperature in the area is projected to rise by up to 4.9°F (2.7°C) due to global warming, speeding up evaporation from soil and plants. In the same period, rainfall is expected to decrease by up to 40%, while the population will continue to grow by 3% a year.

A wind-powered desalination plant for turning seawater into freshwater opened in 2007 and now provides 17% of Perth's water needs. It is nowhere near enough, of course, and unless drastic changes are made the city could face severe shortages of freshwater.

Scott E Barbour/Getty Images

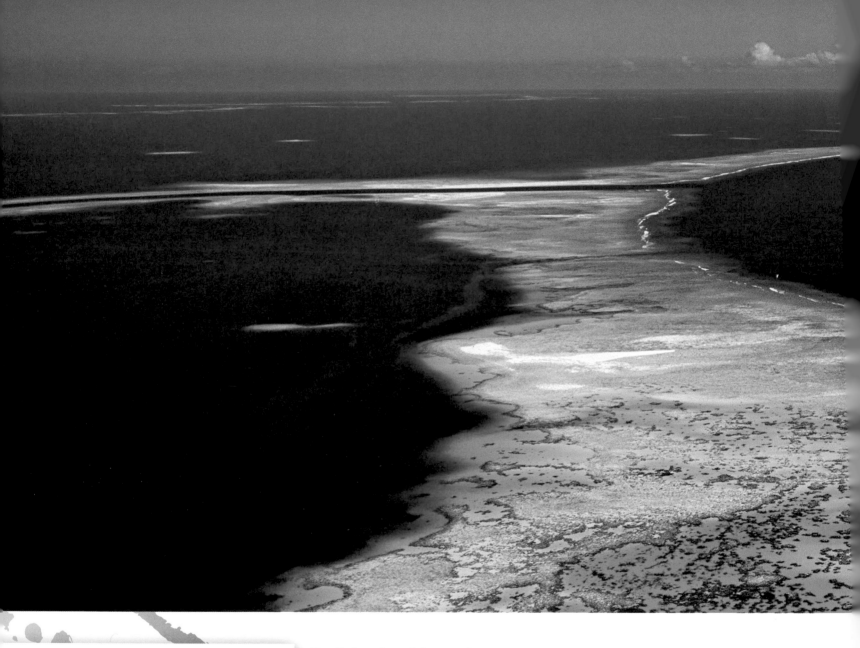

36. Ontong Java Atoll | *Solomon Islands*

A Lagoon of Fishermen at the Edge of the World

People have been fishing and gathering coconuts on the isolated tropical Ontong Java Atoll in the far north of the Solomon Islands for at least 2,000 years.

One of the largest atolls in the world, the total land area is a mere 4.6 square miles (12 square kilometers), most of it less than 7 feet (2 meters) above sea level. The 122 small coral islands encircle a lagoon measuring more than 965 square miles (2,500 square kilometers). Only two of

the largest islands are permanently inhabited, and with a total population of 2,000, this is one of the smallest, most isolated societies in the world.

The islanders live off coconuts and fish. On the larger islands, they cultivate the tropical plant taro, which also

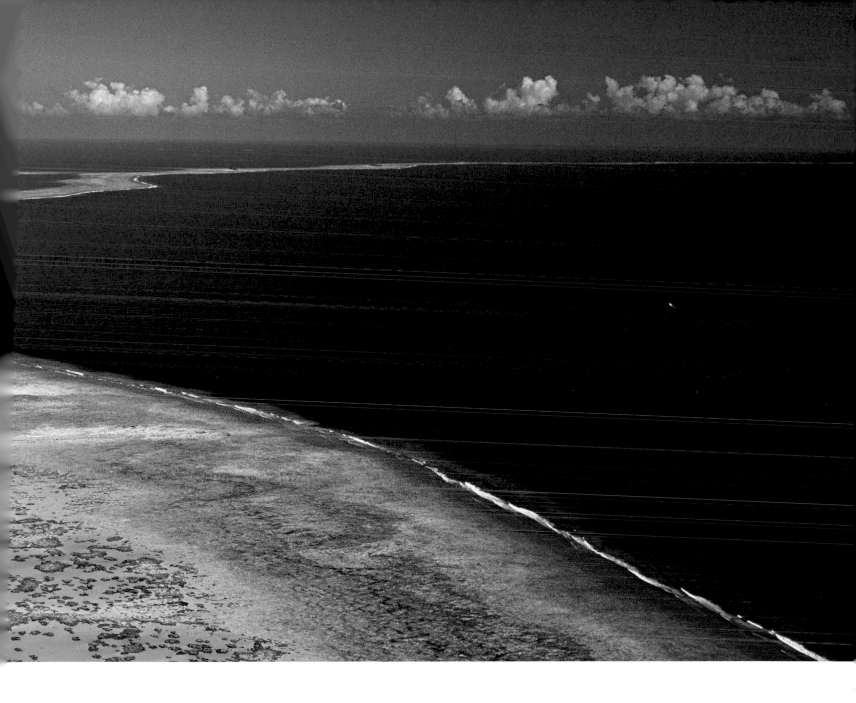

forms an important part of their diet. The taro is grown in freshwater swamps artificially deepened to form mulching pits.

The coral reefs and lagoons are home to a rich variety of seafood, and the inhabitants catch sea cucumber to sell on the Hong Kong market. They also exchange copra—the dried meat of the coconut—for goods and cash.

Climate change may change the atoll completely in less than a century. The coral, the debris of which serves as the foundation of the atoll, functions as coastal protection. Any rise in temperature or increased acidification of the seawater could eventually kill it. A rise in sea level will also cause saline intrusion into the agricultural land and freshwater, and flood the low-lying parts of the islands. The

effects on Ontong Java Atoll, on its people, the seabirds that breed on the islands, and the many species of fish that live among the coral would be devastating.

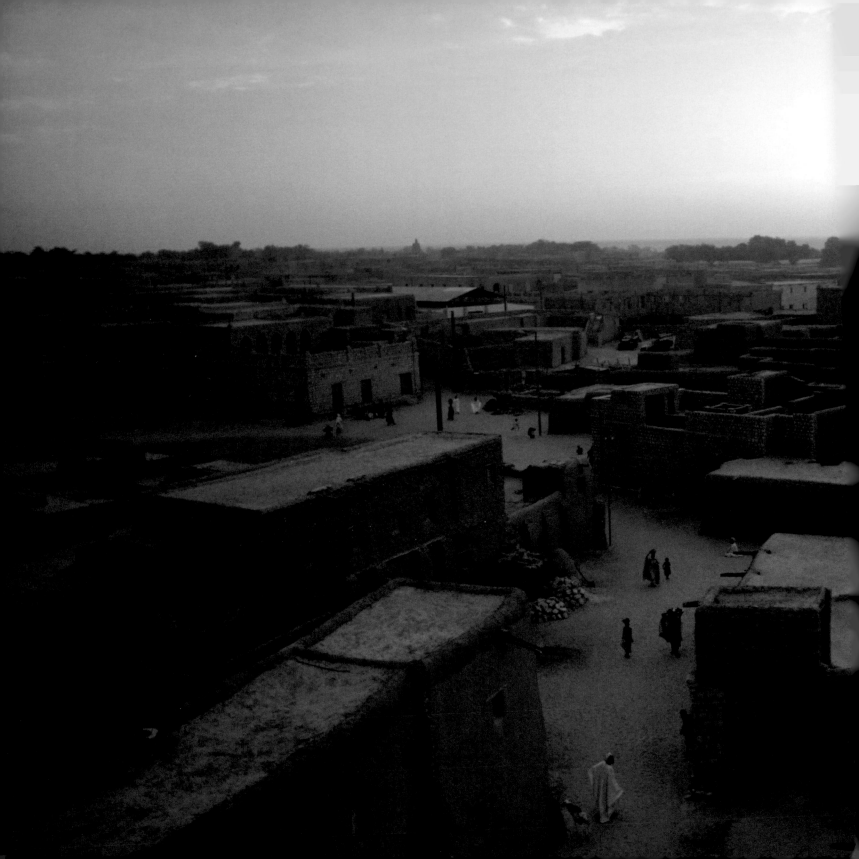

A Place as Real as Its Mud Is Hard

To many Westerners, Timbuktu is shrouded in mystery, existing more in the mind than on the map. Phrases like "from here to Timbuktu" paint it as a remote, exotic place at the edge of the world.

In fact, the city of Timbuktu is very real. Bordering the Sahara Desert in the West African nation of Mali, it was once an economic and cultural hub, enjoying a privileged position in the middle of the trans-Saharan trade routes. The great Djingareyber, Sankoré, and Sidi Yahia mosques, built during Timbuktu's golden age from the 14th to the 16th centuries, still stand today and all three are on UNES-CO's World Heritage List.

Together, the three mosques once composed the famous University of Timbuktu, which made the city a center of wisdom, attracting learned men from throughout the Muslim world. In the mosques' open courtyards and in private residences, students were taught the Qur'an, logic, mathematics, astronomy, and history.

In the city's prosperous past, books were valuable commodities and private libraries flourished in the homes of local scholars. The wisdom of Timbuktu is preserved in these manuscripts, which have largely been hidden away and kept as family secrets ever since. It is estimated that there are still between 300,000 and 700,000 manuscripts in the region.

Built mainly of mud, the mosques are highly vulnerable to climate change. Sand encroachment, believed to be a result of land cultivation and grazing, represents a constant and increasing threat to the mosques. Global warming is also projected to raise temperatures still further in the region, and extreme precipitation events are expected to become more frequent and even more extreme. This combination of climate conditions will cause damage to the mosques and threatens to consign Timbuktu's magnificent past to the realms of mythology.

James P. Blair/Getty Images

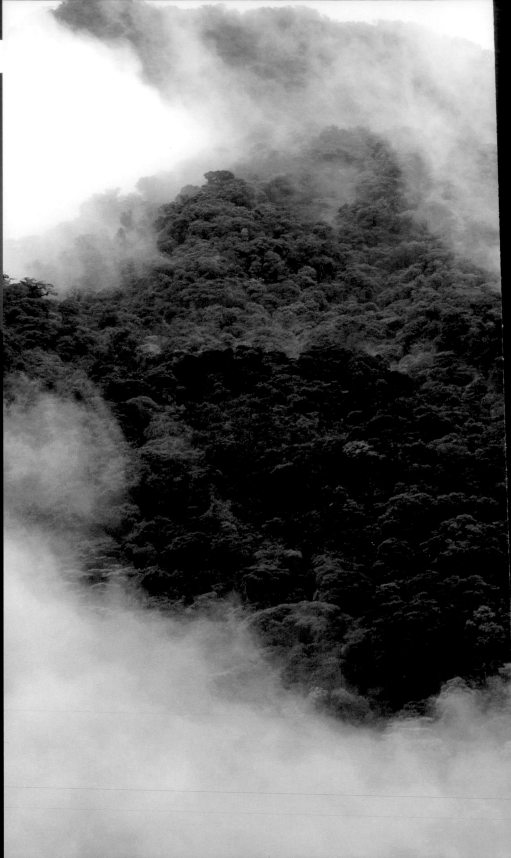

100% Humidity, 100% of the Time

The Cloud Forest of Monteverde is a tropical rainforest about 5,600 feet (1,700 meters) above sea level in central Costa Rica. With its majestic trees festooned with orchids, bromeliads, ferns, vines, and mosses, it is home to a multitude of rare animal and plant species.

Monteverde is Spanish for "green mountain" and the Cloud Forest is the natural habitat of more than 100 species of mammal and 400 species of bird, including 30 kinds of hummingbird. Among the tens of thousands of different insects are over 5,000 species of moth. Add to this 2,500 plant species, including 420 different orchids, and you have one of the most outstanding wildlife sanctuaries in the New World tropics.

Over thousands of years, the ecosystem of the Cloud Forest has adapted to its temperature and humidity, which are determined by the cloud cover on the mountains. The humidity is almost 100% for most of the year, and any change in temperature and cloud cover would have a serious effect on the ecosystem.

If temperatures increase, the clouds will rise to a higher altitude, and an increase of 1.8°F–3.6°F (1–2°C) over the next 45 years would have a substantial impact on the diversity and composition of species in tropical cloud forests. Even in areas that experience a relatively low rise in temperature, some species will be threatened with extinction as they are unable to migrate farther up the mountain.

By 2080, rainfall in Costa Rica is expected to decrease by 5–10% and temperatures to rise by around 4.5°F (2.5°C).

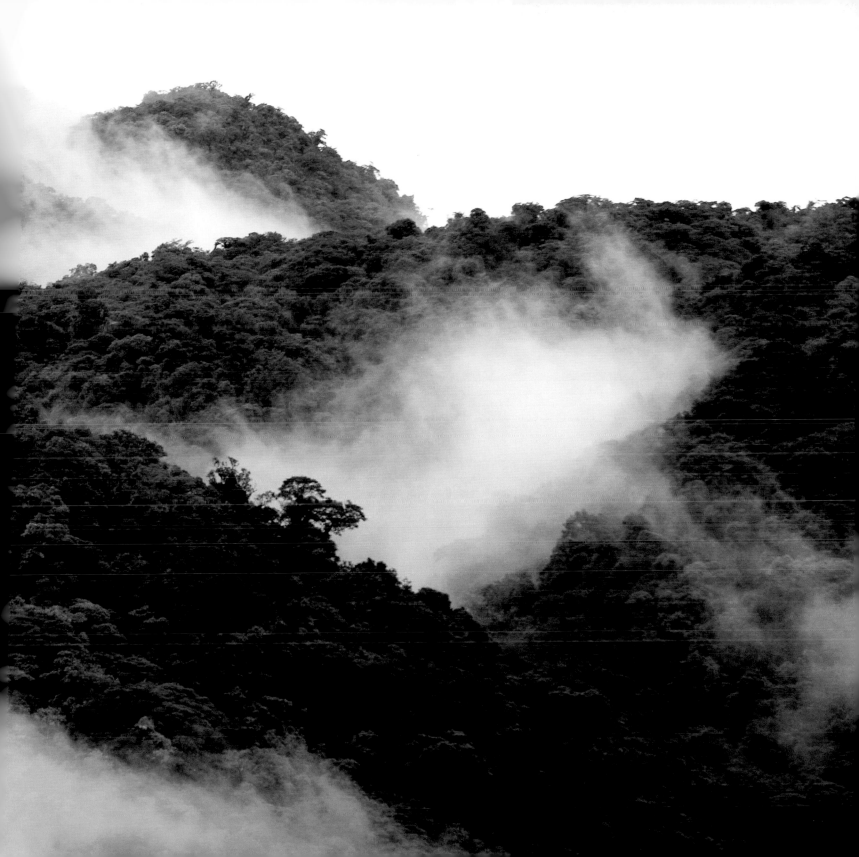

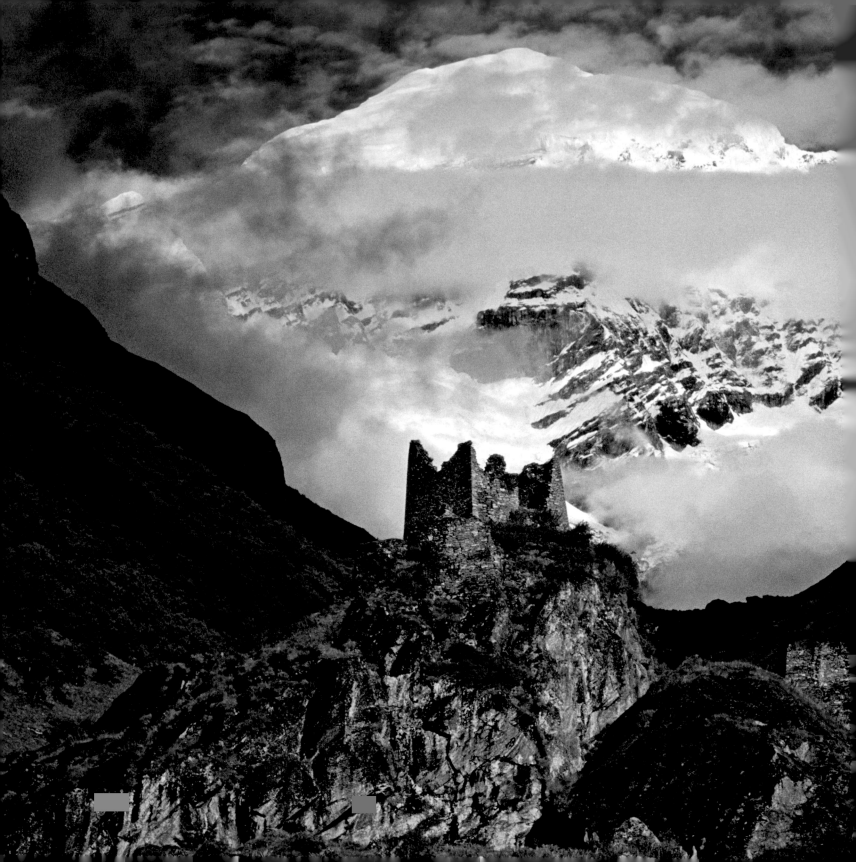

Land of the Thunder Dragon

For the last 1,200 years, Buddhism has been the dominant religion in the small kingdom of Bhutan, squeezed between Tibet and India on the southern slopes of the Himalayas. Bhutan covers some 14,670 square miles (38,000 square kilometers) (about the size of Switzerland) of rugged mountainside, deep valleys, and snow-covered peaks.

The locals call it *Druk Yu*, meaning "Land of the Thunder Dragon." It is thought that its official name, *Bhutan*, derives from a Sanskrit term meaning "at the end of Tibet."

In the 17th century, fortress monasteries—*dzongs* in Bhutanese—were built across the country to offer protection from Tibetan invaders. Many of these still survive as working monasteries but a few have been destroyed by fire, such as Soy Dzong, the ruins of which lie at the foot of the holy mountain of Chomo Lhari.

Until Bhutan became a member of the UN in the early 1970s, the country lived in self-imposed isolation. Its 600,000 inhabitants had no contact with the outside world and no foreigners were allowed access.

For centuries, the population has depended on melt-water from the glaciers of the high mountains to irrigate their farmland. In recent years, Bhutan has also used the water to produce hydroenergy.

Climate change is causing a significant increase in the melt-off from the glaciers. The rapidly increasing flow of water into the glacial lakes high in the mountains is posing a serious threat to the Bhutanese who live in the valleys. There is a danger of the banks of the lakes bursting, causing landslides and floods, and damaging farmland, housing, infrastructure, and the ancient *dzongs*.

At some point, the glaciers on the holy mountain of Chomo Lhari and other Himalayan peaks may disappear altogether.

James L. Stanfield/Getty Images

103

Where Sea Gypsies Dive Among the Coral

The blue waters and white coral reefs off the western coasts of Myanmar and Thailand are home to the Salon, also known as Moken or "sea gypsies," some of the last surviving nomadic sea hunters and gatherers in the world.

The Moken dive for fish, turtles, shellfish, and sea cucumber in and around the coral reefs, spending most of their lives on boats. They sail from island to island, catching food, sleeping, eating, preparing their catch, and giving birth on board their floating homes. Deep water is their natural element, where the children play and dive from an early age.

The area where the Moken live is home to rare hawksbill turtles, butterfly fish, and puffers.

The very existence of the Moken is now endangered by changes in the pattern of movement of the ocean and rising sea temperatures, which threaten the entire reef.

Within the next 30 years, 30% of Asian coral reefs are expected to die as a result of rising sea temperatures. At the same time, ongoing settlement and deforestation on the islands in the archipelago is causing the erosion and destruction of the coral reefs. If the reefs disappear, it will threaten the livelihood and culture of the 4,000 Moken people and force them to change their way of life.

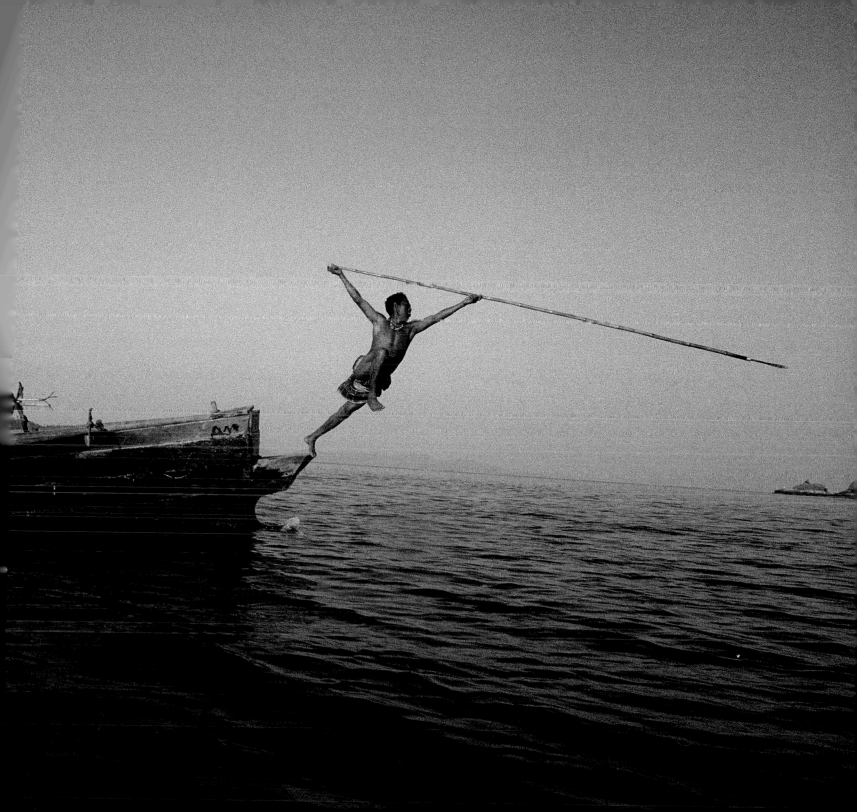

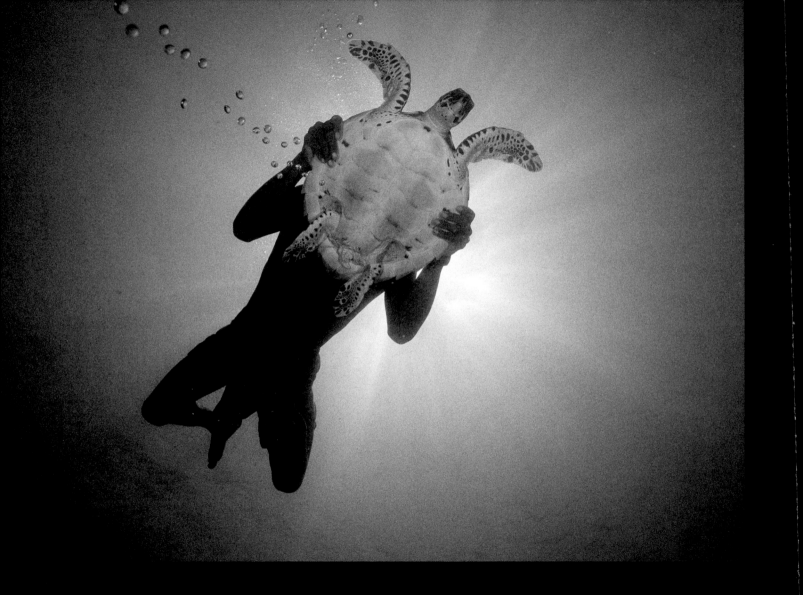

THE MOKEN CAN DIVE in deep water for long periods of time without artificial breathing support. Their underwater vision is clearer than any other people in the world.

Only in the monsoon season do the Moken seek shelter on the islands in the eastern part of the Adaman Sea. As they go ashore, they perform a ceremony in which they eat sea turtles and invoke the spirits. Like the Moken, the turtles spend most of their lives in the

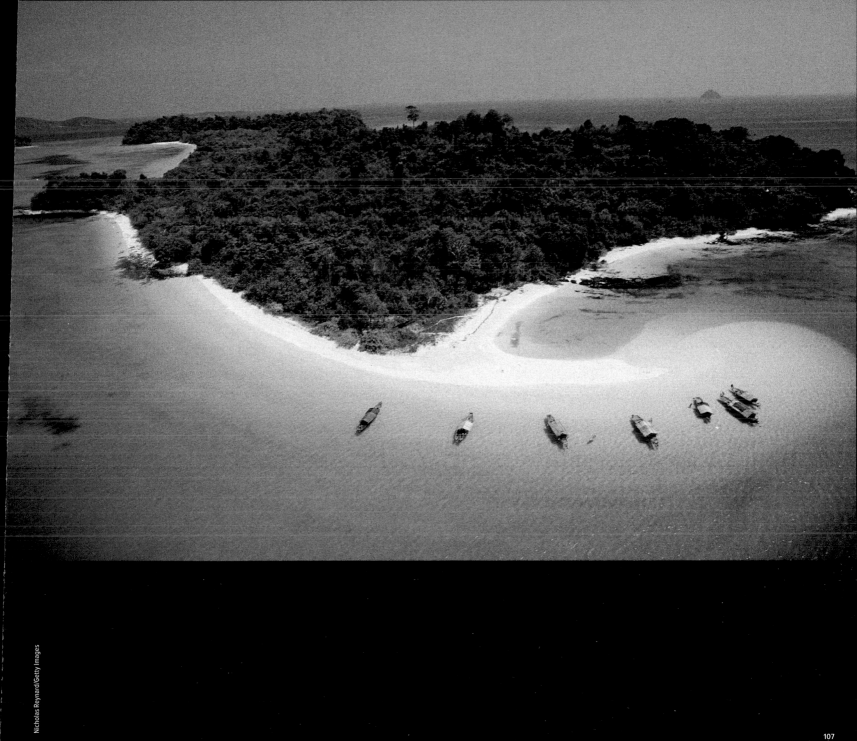

The People
of the
Forest

Orangutans, known as the last great apes of Asia, are an endangered species. The total population in the wild now numbers a mere 40–50,000, half the estimated number just two decades ago. Many of them live in the rainforests of Borneo, about 7,500 in Sumatra.

With arms twice as long as their legs, orangutans are the largest tree-climbing animals on the planet. Rarely seen on the ground, they prefer to move from tree to tree, eating fruit, leaves, bark, and insects, and sleeping in nests made from branches and foliage.

Orangutan means "person of the forest," from the Malay and Indonesian words *orang*, meaning "person," and *hutan*, meaning "forest." Sharing 96.4% of our human DNA, this animal is one of man's closest relatives and is highly intelligent. Orangutans have been observed using eating tools and fashioning rain hats and leak-proof roofs above their nests.

Borneo's rainforest is being stripped of trees. Legal and illegal logging, the building of roads, and the transformation of forest into huge palm oil plantations are causing extensive destruction. This is having brutal consequences for the orangutan and other species, such as the endangered Borneo pygmy elephant and the Borneo rhino. Palm oil is a prime export for Indonesia and Malaysia, meeting a booming Western demand for vegetable oil and biofuel.

Global warming is putting further pressure on the orangutan population. Rising temperatures are reducing the abundance of fruit, and increasing the incidence of malaria and the risk of forest fires. With logging and cultivation of land as the main culprits, up to 98% of the natural rainforests of Borneo and Sumatra may be lost by 2022. If drastic action is not taken, the orangutan may be the first of the great apes to die out.

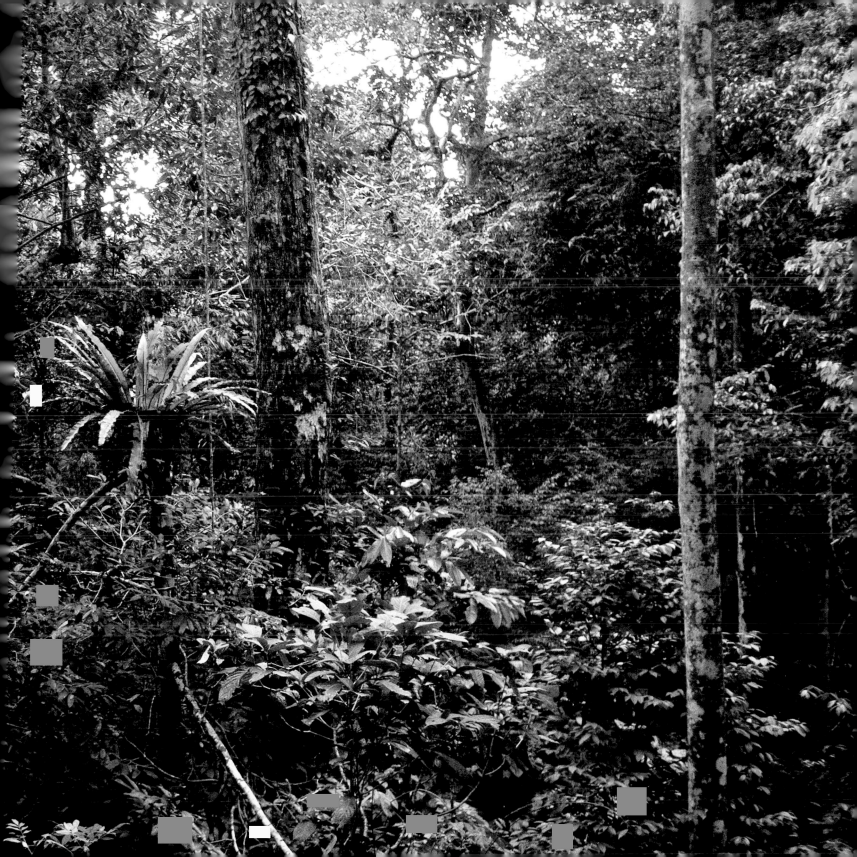

250 Coral Species that Make Life Flourish

The sea surrounding Komodo and its neighboring islands provides some of the world's best diving spots, thanks to its spectacular unspoiled coral reefs and schools of fish of all shapes and sizes, bursting with color.

Komodo Island is part of Komodo National Park, founded in 1980 to protect the Komodo dragons that stroll around the rugged island. One of the largest lizards in the world, the Komodo dragon can reach 10 feet (3 meters) in length and weigh over 150 pounds (70 kilograms). Since its foundation, the park has been charged with protecting the entire terrestrial and marine biodiversity of the area, and in 1986 it was declared a UNESCO World Heritage Site.

The manifold underwater life of the sea around Komodo is a result of strong currents and warm tropical waters from the Flores Sea mixing with cold streams from the Indian Ocean. Cool, consistent water temperatures of 75–82°F (24–28°C) create optimum conditions for the 250 coral species that flourish in these waters and form an indispensable part of the ecosystem. The coral provides a habitat for nearly a thousand fish species, whale sharks, manta rays, eagle rays, blue-ringed octopus, pygmy seahorses, and sea turtles, making these some of the most fascinating waters on Earth.

Climate change is projected to throw this area of exceptional natural beauty off balance. On the islands, rising sea levels threaten to flood and erode mangrove forests and the beaches where sea turtles nest.

In the sea, increased acidification and rising surface temperatures may eventually kill the coral. As well as affecting the coastal protection of the islands, the loss of the coral will have a negative impact on marine life and could result in an immense loss of beauty and natural diversity.

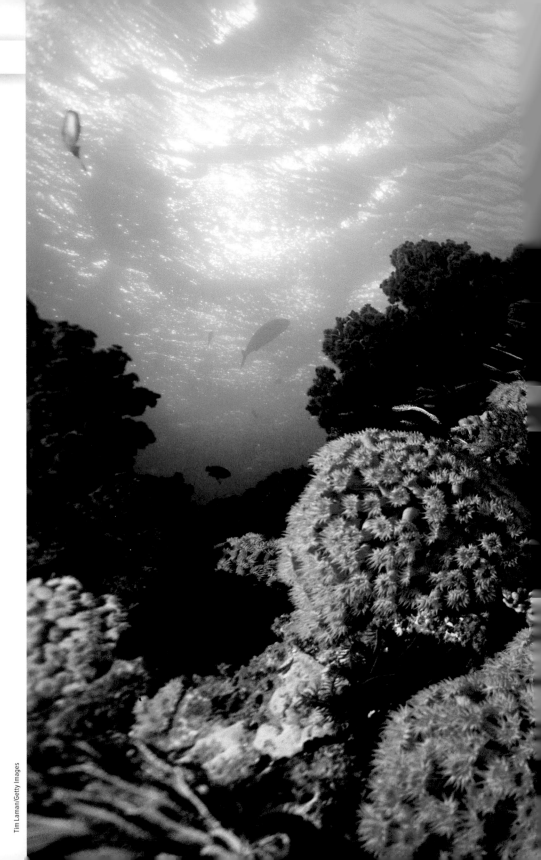

Tim Laman/Getty Images

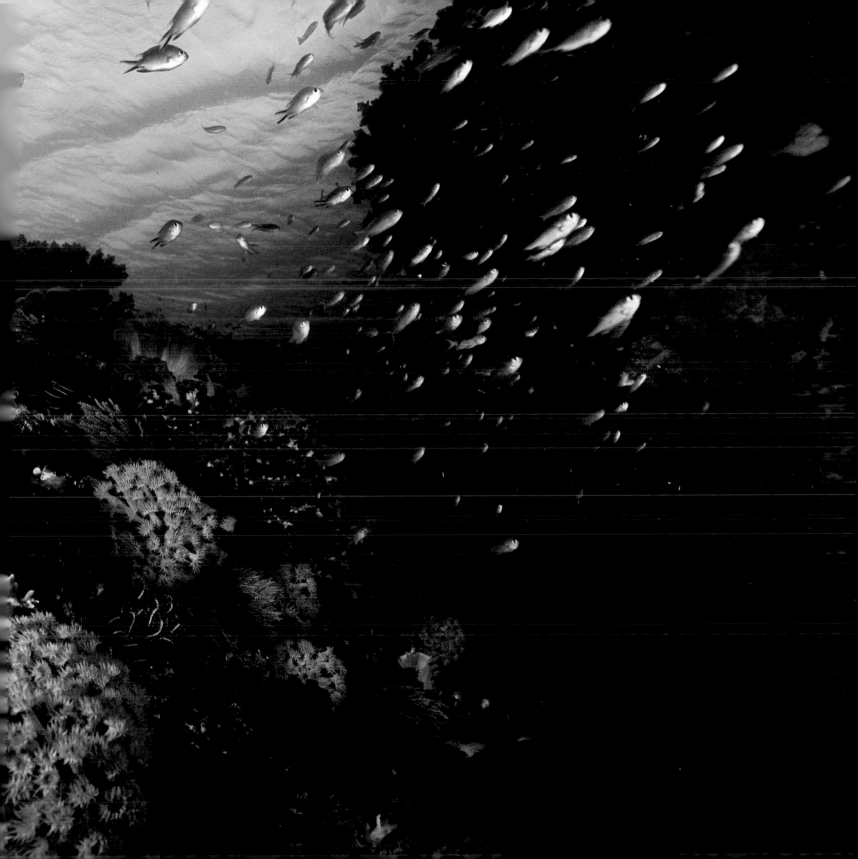

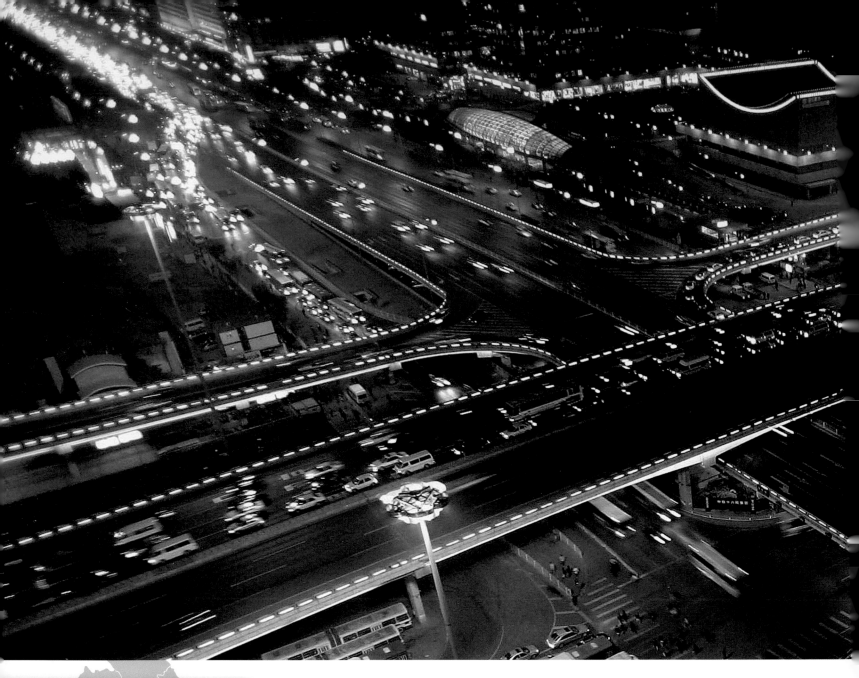

43. Beijing |
People's Republic of China

Capital of Dynasties

Beijing is China's capital and its second-biggest city after Shanghai. Many of the 17 million people of this booming city have now abandoned their bicycles in favor of cars. Huge flyovers and multilane highways have turned Beijing into a major transportation hub, and China's main international airport is also located here.

Beijing is not only a pulsating, modern city, but also one of the Four Great Ancient Capitals of China, which endows it with immense historical and cultural significance. The feudal dynasties of Jin, Yuan, Ming, and Qing all had their capitals in Beijing. The region is full of cultural relics including the Great Wall, the Forbidden City, the Temple of Heaven, and the Summer Palace.

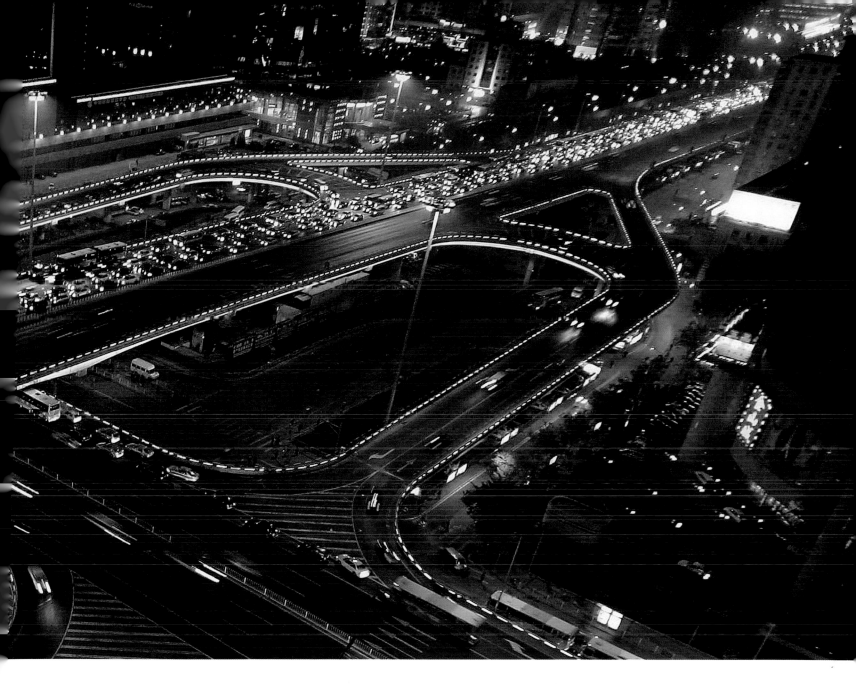

On October 1, 1949, Chairman Mao Zedong announced in Tian'anmen Square that Beijing would be the capital of the new People's Republic of China. Since then, the city has expanded exponentially. The Second Ring Road, which was constructed in 1981 on the former site of the inner city wall, has subsequently been surrounded by one ring road after another. The most recent is the Sixth Ring Road, 9–12 miles (15–20 kilometers) from central Beijing.

The city may be expanding but the desert is also encroaching on it. Beijing is plagued by sandstorms howling in from Inner Mongolia, reducing visibility to below 50 yards (meters) and forcing people to wear masks and stay indoors to protect their lungs. In 2005, one storm dumped almost 330,000 tons of sand and dirt on the city.

Along with incessant coal burning and heavier traffic, these regular sandstorms are causing severe air pollution.

Over the last 50 years, temperatures have increased, particularly in northern China, and are projected to rise at an accelerated rate for the rest of the century. Combined with less predictable rain patterns, this is likely to reduce water supplies in the regions surrounding Beijing, further exacerbating decertification and coating the streets of the city with sand time and time again.

A Raging Eddy of Mud and Water

Every year, over 2 billion cubic feet (57 million cubic meters) of silt flow into the muddy estuary of Rio de la Plata, where freshwater from the Paraná and Uruguay rivers collides with saltwater from the South Atlantic Ocean in a raging eddy caused by wind and changing tides.

At its widest point, the mouth of this immense estuary is 136 miles (220 kilometers) wide, making it the largest estuary in the world. On the southern coast is Buenos Aires, the capital of Argentina; on the northeastern coast is Montevideo, the capital of Uruguay. The estuary makes the soil of the surrounding regions rich and fertile.

Rio de la Plata is a natural habitat for a number of threatened species, including sea turtles and the rare La Plata dolphin, the only river dolphin that lives in the ocean and in saltwater estuaries.

The estuary is also home to the croaker, a drum-fish that croaks like a frog. Every year from October to January, croakers migrate to the mouth of the estuary to spawn on the riverbed and feed on mussels. For generations, the croaker has been the main catch of the local Uruguayan fishermen as well as the main food of the threatened dolphins.

The croakers are now under pressure from industrial fishing and pollution, and are also highly vulnerable to climate change. Any change in climate that causes stronger winds and higher sea levels will lead to the flooding of the coastal areas of Rio de la Plata, potentially tipping the delicate balance of the ecosystem, destroying the croaker's feeding ground, and threatening its very existence.

Domino/Getty Images

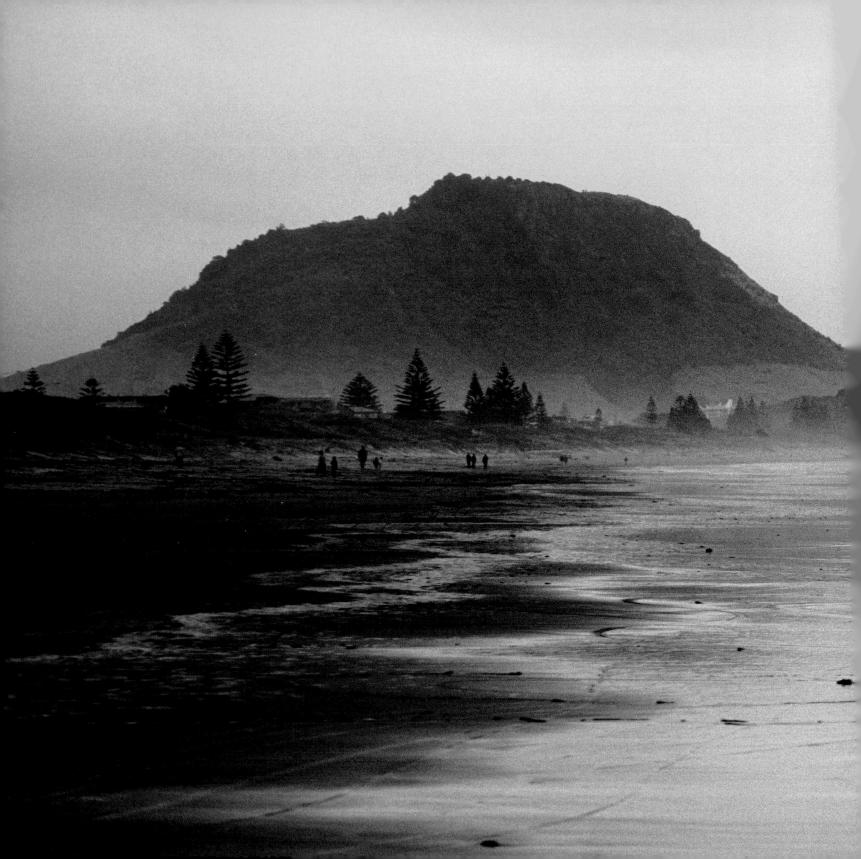

An Abundance of Food and People

The British explorer Captain James Cook reached New Zealand in 1769. Mapping the entire coastline along the way, he noted the rich abundance of fruits and crops enjoyed by the Maori villagers who live along the eastern coast of the North Island, and dubbed the region the Bay of Plenty.

The first Maori people had arrived in New Zealand almost 500 years before Cook, landing at Mauao (Mount Maunganui) in the center of the bay. They too had been drawn by the abundance of food in the region.

The Bay of Plenty is a coastal marine region covering 3,667 square miles (9,500 square kilometers) from the Coromandel Peninsula in the west to Cape Runaway in the east. Today, its endless white beaches, impressive natural harbors, warm summers and mild winters attract divers, kayakers, kite surfers and other tourists all year round.

At the entrance to the Port of Tauranga towers the sacred mountain of Mauao. One of the fastest-growing cities in New Zealand, Tauranga has tripled in size in a little over 25 years, and now has an population of approximately 116,000. The beautiful coastline surrounding Tauranga and its suburbs makes it a highly desirable area and helped trigger a housing boom throughout the Bay of Plenty in recent years. This growth is expected to continue and it is predicted that the population of the bay will double, or even triple, by 2050.

Rising sea levels and increasing storm surges are projected to cause erosion and coastal inundation in the Bay of Plenty. The rapidly growing population and ongoing development of the coastline further increase vulnerability to erosion, putting houses and infrastructure at risk.

Another impact of global climate change is that by 2080, severe drought is projected every five to ten years, which would increase the danger of fire by 10–50%. Droughts and fires will lead to loss of forests and farmland and force farmers to change their crops, posing a severe challenge to the very fertility and prosperity that gave the Bay of Plenty its name.

Anders Blomqvist/Getty Images

A Sea that Is More Like a Labyrinth

Navigating the labyrinth of the Archipelago Sea off the coast of Finland in the Baltic Sea is a hazardous business due to its varying depths and abundant rocks. The archipelago consists of roughly 40,000 islands if you count every rock that breaks the surface, but only 257 of them measure more than a third of a mile (one square kilometer) and even fewer are inhabited.

Emerging after the last ice age about 10,000 years ago, the islands are still in a post-glacial rebound process, rising 0.15–0.39 inch (4–10 millimeters) a year. The old islands are growing and newer small ones constantly emerge from the shallow water, where the mean depth is only 75 feet (23 meters).

The sea freezes over during cold winters, making it possible to drive on the ice, and official ice roads are laid out to connect the islands.

For centuries, fish has been a vital source of food for the islanders; even when the crops failed, seafood was always available. Despite the growth of tourism, fishing is still the primary source of income in the region, which is particularly famous for its Baltic herring and rainbow trout.

The Archipelago Sea is exposed to what is known as eutrophication. This is where nutrient pollution from sewage effluent or the runoff from fertilizers stimulates algal bloom in shallow, brackish waters like the Archipelago Sea. Besides making the water cloudy, the algal bloom causes a lack of oxygen and reduces the amount of food, affecting the health of fish species like salmon, trout, and Baltic herring.

Global climate change and the associated rising temperatures, decreasing ice cover, and increasing winter rainfall are expected to exacerbate eutrophication, with potentially damaging consequences for biodiversity, tourism, and fishing in the Archipelago Sea.

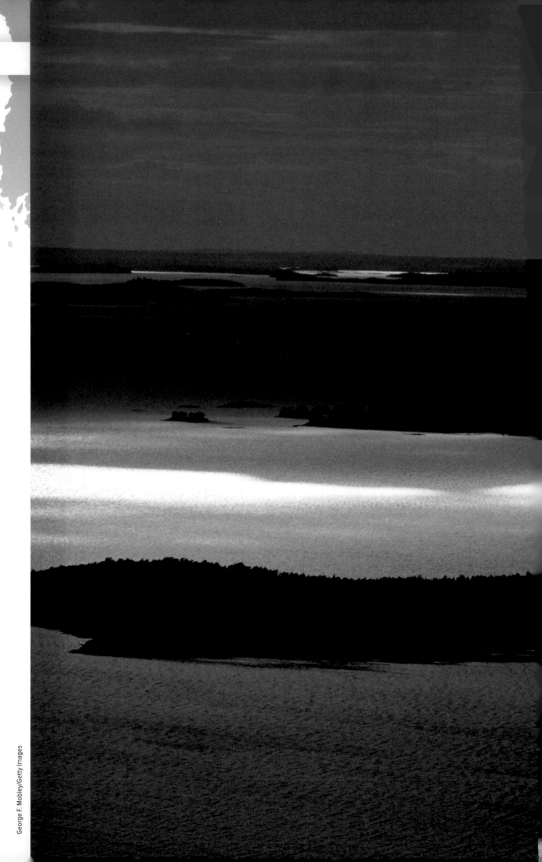

George F. Mobley/Getty Images

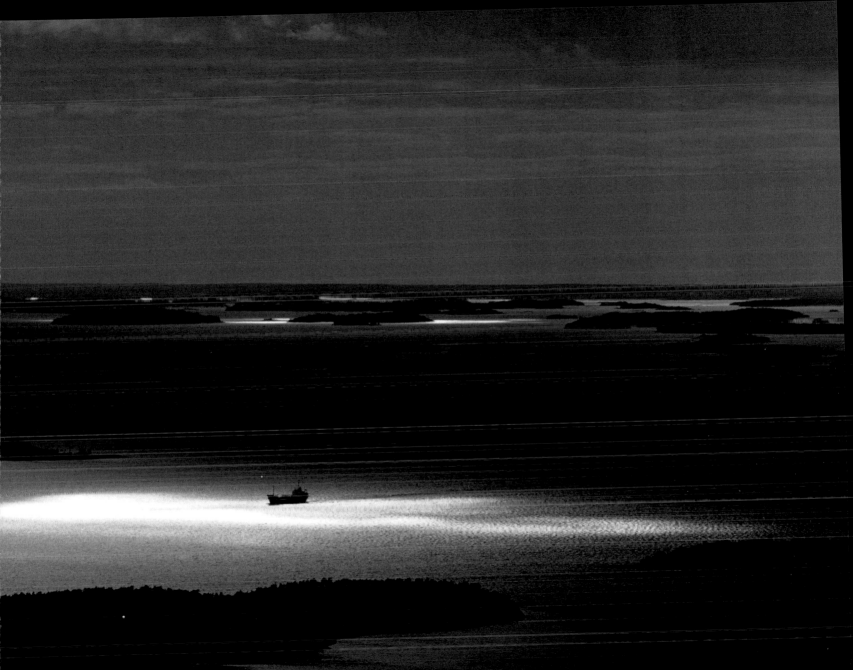

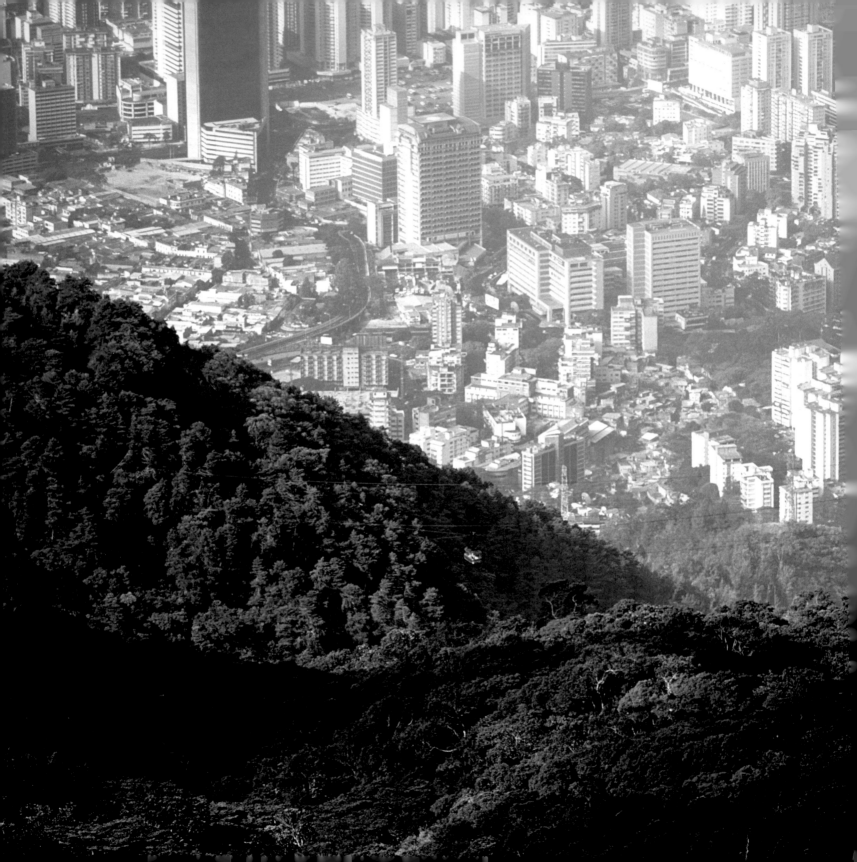

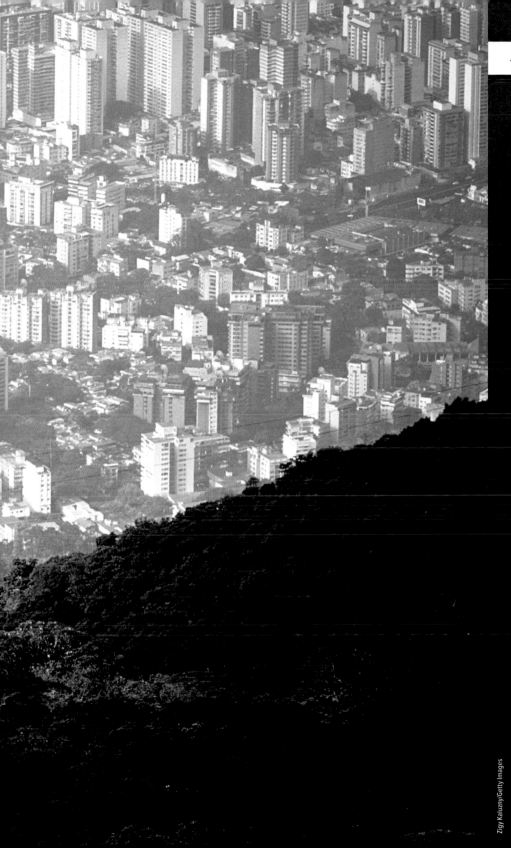

The Dangerous Birthplace of *El Libertador*

Spanish conquistadors harried the indigenous people from this beautiful valley in the north of South America in 1567 and founded Caracas among the green coastal mountains, or Cordillera de la Costa. Some two hundred years later, the city was the birthplace of El Libertador, the common name for Simón Bolívar, who headed the liberation of present-day Colombia, Venezuela, Bolivia, Peru, Ecuador, and Panama from the Spaniards.

The war of independence finally ended in victory in 1821, a decade after Bolívar and his followers had prematurely proclaimed independence in Caracas. A year after the initial rebellion, an earthquake had destroyed the city and transformed the valley into a cemetery. The tremor caused landslides to send thousands of tons of soil and debris cascading down the steep mountainsides into the valley. It is a phenomenon that may well recur, caused by torrential rainstorms as well as earthquakes.

Around 4.3 million people live in Caracas, some two million of them in poorly built shanty towns or barrios on the slopes that surround the city, where landslides caused by heavy rain are a chronic problem. In 1999, 30,000 people were killed in one of the Americas' worst natural disasters, when several days of rainstorms triggered flash floods, landslides, and flows of debris in the coastal zone on the north slopes of Cordillera de la Costa just north of Caracas.

Extreme weather events like hurricanes and heavy rainstorms are projected to hit the region of Caracas and Cordillera de la Costa more frequently in the future, and with much greater force. It is not only those living in the shanty towns who face a hazardous future. Floods and landslides pose a serious threat to the center of Caracas as well, potentially dealing a massive blow to the infrastructure of the Venezuelan capital and its suburbs.

At the Top of the Food Chain

With a thick covering of blubber, two layers of fur, small ears, and a short tail, the polar bear is perfectly adapted for survival in the icy north. For the polar bear the problem is not the cold but overheating, which is why it prefers to move at a leisurely pace.

The polar bear roams the Arctic Ocean and surrounding seas, including Canada's Hudson Bay to the south. As the animal at the top of the food chain in the Arctic, the polar bear spends most of the year on the frozen sea, hunting for seals.

The bear uses its acute sense of smell to locate seals' breathing holes in the ice. Patiently, it awaits the moment when its prey surfaces to breathe, which might be hours or even days later.

In Western Hudson Bay, the ice begins to melt and break up in late spring. Unable to hunt seals until the sea freezes again, the polar bear enters a state of hibernation and lives off its fat reserves.

With an estimated global population of 22–25,000, the polar bear is classified as an endangered species. Today, global warming is the greatest threat to it. Rising temperatures are causing the ice to melt earlier each year, preventing bears from building up sufficient fat reserves and forcing them to fast for longer periods.

In Western Hudson Bay, the ice now breaks up three weeks earlier than it did in the early 1970s. Starvation has already reduced the survival rate of cubs and young bears, and made bears of all ages less healthy. Within the next 35 to 50 years, a decline in the overall polar bear population of more than 30% is expected, and within 100 years they may become extirpated from most of their geographic range.

Norbert Rosing/Getty Images

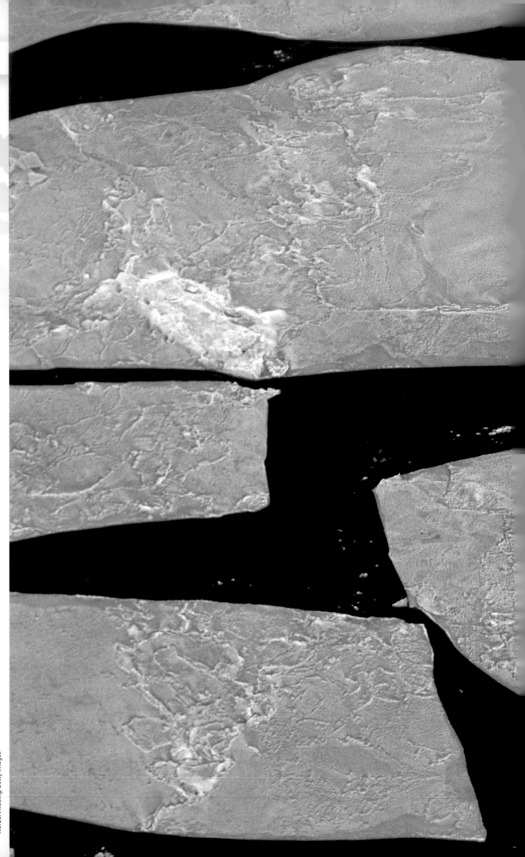

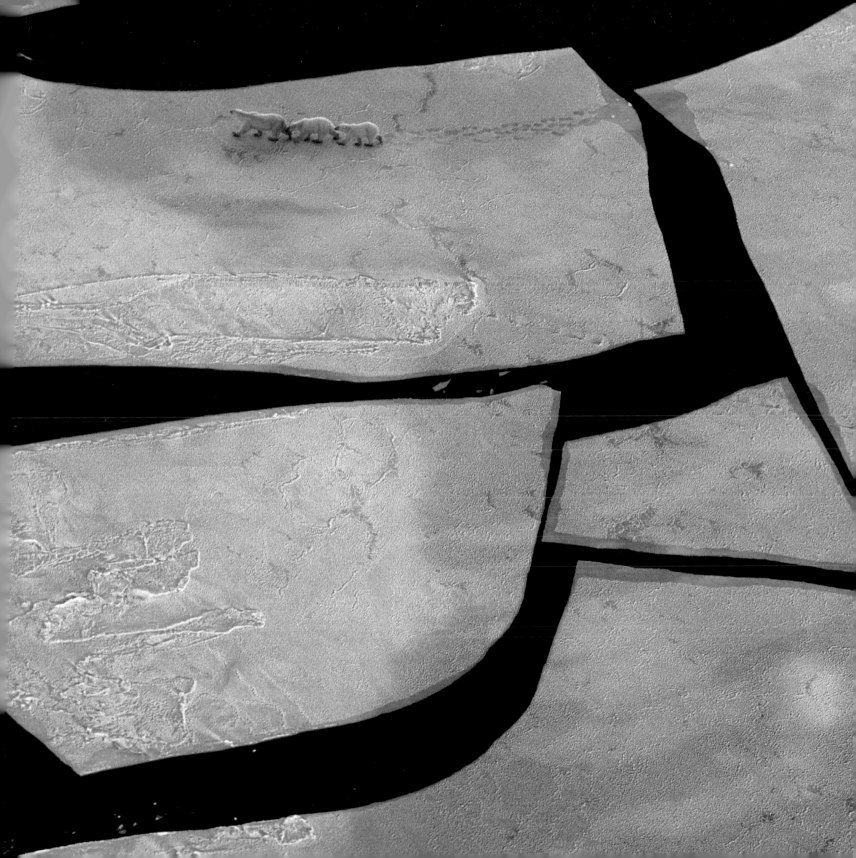

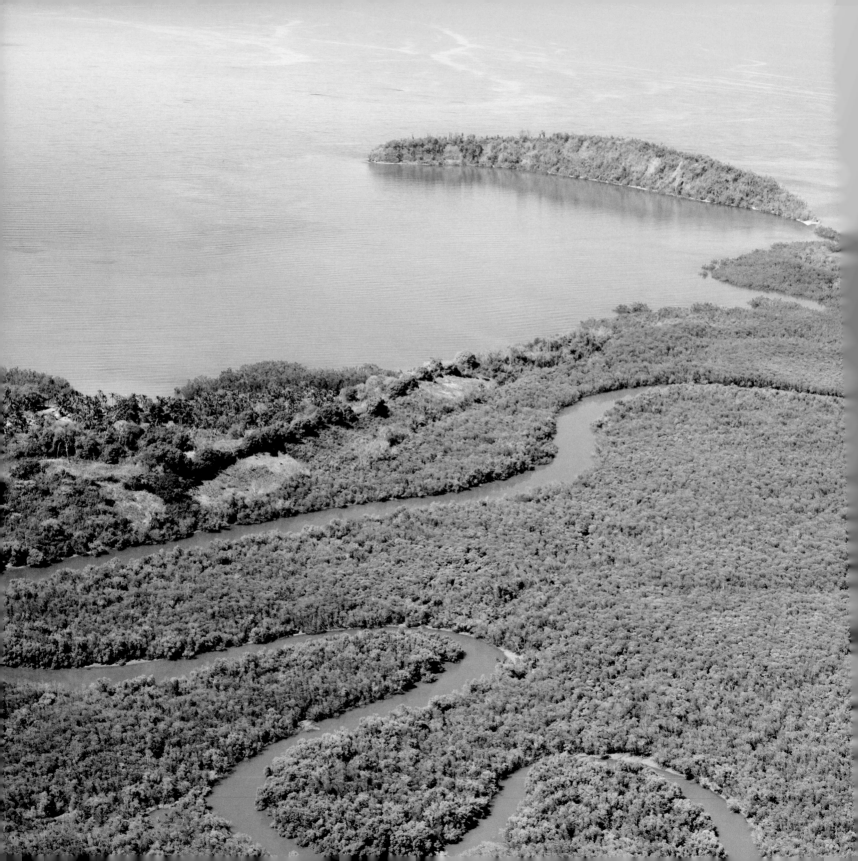

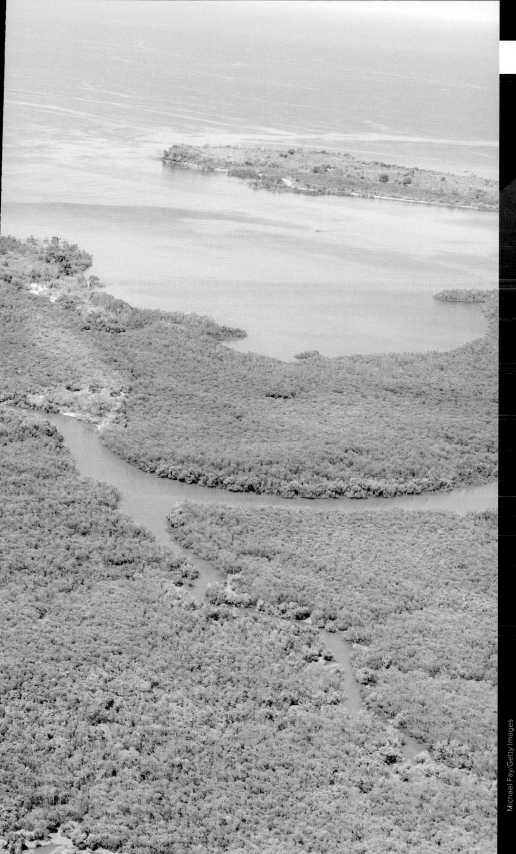

Michael Fay/Getty Images

A Delicate Balance in the Mangrove

The Republic of Madagascar is slightly bigger than France—its former colonial master—and is the fourth-largest island in the world. Madagascar is in the Indian Ocean, some 500 miles (800 kilometers) off the east coast of Africa. Separated from the mainland 80 million years ago, the island is home to a unique mix of plants and animals, many of them found nowhere else on Earth.

The central mountains protect the 1,275 square miles (3,300 square kilometers) of mangrove wetland along the western coastline from the eastern trade wind and the monsoon winds. Coral reefs protect it from the ocean swells of the Mozambique Channel.

Endless communities of molluscs, crustaceans, turtles, and tropical fish thrive among the entwined roots of the mangrove, providing food for rare indigenous birds like the Madagascar Teal, the Madagascar Plover, the Madagascar Kingfisher, and the Madagascar Fish Eagle. The mangrove is also an important habitat for migratory birds such as plovers, the African Spoonbill, and the Great White Egret.

With a tidal range of up to 13 feet (4 meters) and an influx of fresh water from the numerous rivers that flow down the mountains, the mangrove's ecosystem—not to mention the commercial shrimp farms established there—are at the mercy of a very delicate saline balance. Any rise in sea levels or seawater temperature, both of which are happening as a result of global warming, could tip that balance. Higher temperatures combined with increased acidity might eventually destroy the coral reefs that protect the mangrove, further exacerbating saline intrusion.

The outcome could be a drastic reduction in the size of the mangrove, which would pose a severe threat to the shrimp farms and to the habitat that supports such a wide diversity of animal life.

Welcome to the End of the World

The Yamal Peninsula is in the far north of Siberia, where the subsoil is permanently frozen and temperatures on the tundra can drop to -58°F (-50°C) in the winter. Yamal means "End of the World."

Large-scale reindeer husbandry continues in its traditional form in Yamal. The 300,000 wild reindeer on the peninsula have adapted to the Siberian seasons. In summer, when the topsoil defrosts, they graze in the north. In the fierce cold of winter, they migrate south of the Arctic Circle to the central Siberian Plain.

The herds are followed by the Nenets, a nomadic people indigenous to northwest Siberia whose life and culture revolve around the migration of the reindeer. They are the only herders in the world who live in total harmony with the reindeer, following migrating herds for thousands of miles all year round.

During the migrations, enormous caravans stretch for up to 5 miles (8 kilometers), with some of the reindeer pulling sledges loaded with people and camping equipment. The average winter temperature is well below –13°F (–25°C), and the Nenets wear coats made from several layers of reindeer skin.

Global warming is projected to raise the average temperature by up to 13°F (7°C) over the next 70 to 90 years, which will have a detrimental effect on the permafrost. The added warmth will allow trees to spread to the tundra where the reindeer graze, thawing the permafrost and making the ground too soggy for the herds to cross. If this happens, the thousand-year-old nomadic culture of the Nenets will be at grave risk.

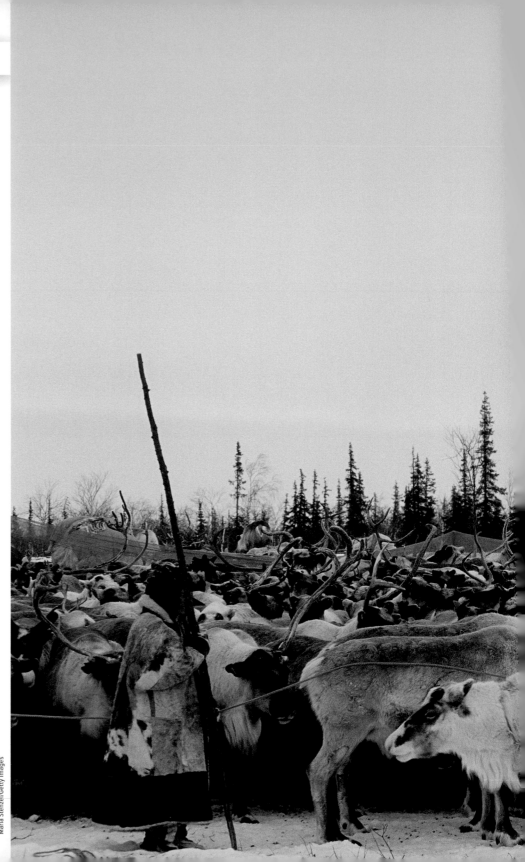

Maria Stenzel/Getty Images

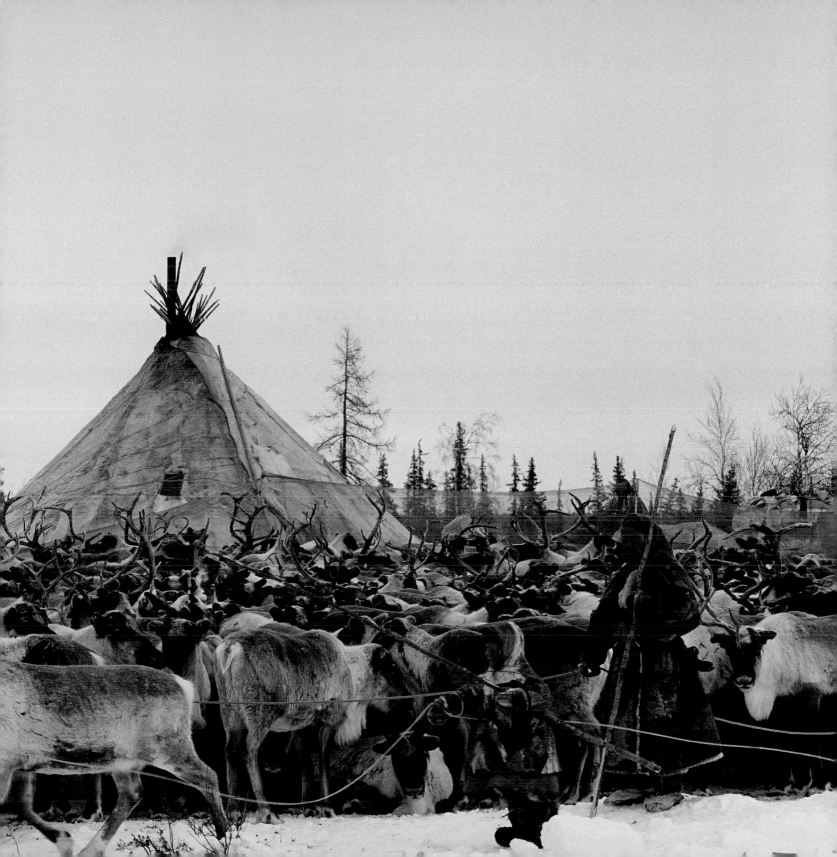

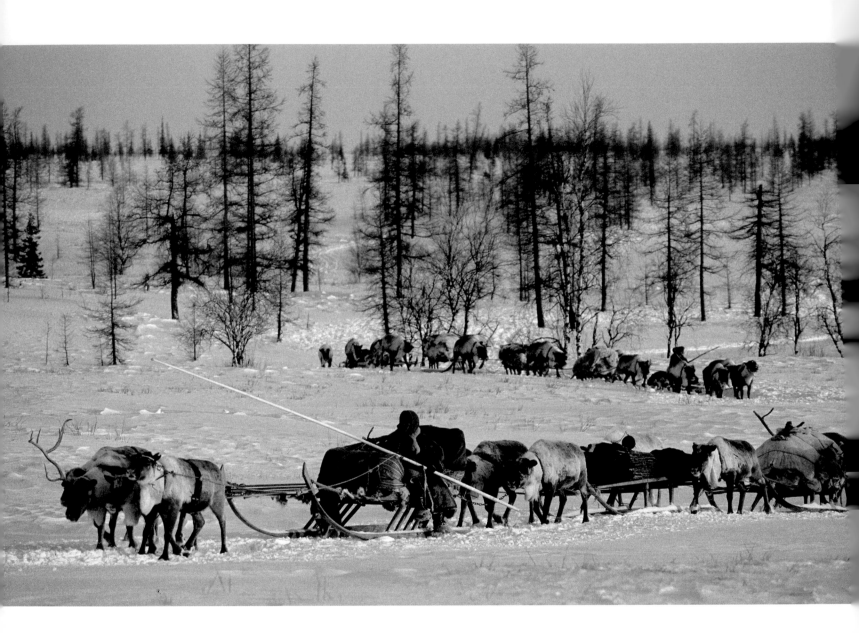

THROUGHOUT THE 20TH CENTURY, the Nenets population has grown steadily. The children attend boarding schools before choosing between life on the tundra or in the towns. Many choose the tundra, where they can earn more by selling reindeer meat, and because of the freedom offered by a nomadic existence.

The Nenets believe that during a mythical past the reindeer agreed to offer themselves as food and transport and in return the Nenets agreed to accompany them on their long journey and protect them from predators.

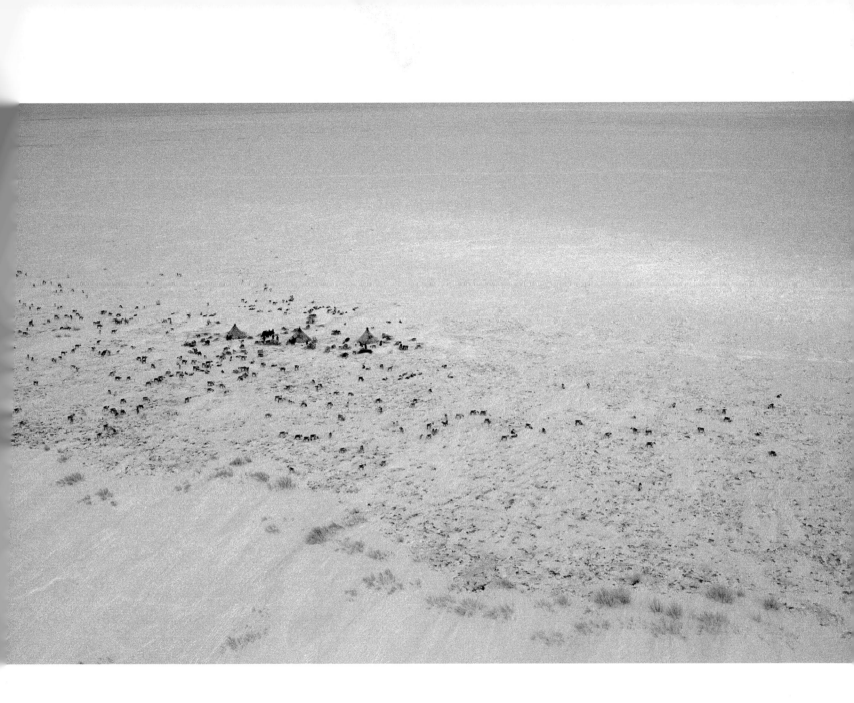

The
Royal County
of Earth Apples
and
Green Pastures

Since early times, County Meath—often informally referred to as "the Royal County" but actually meaning "the county in the middle"—has played a central role in Irish history, with some of its burial sites dating as far back as 3500 BC. From the 8th century AD, the High King of Ireland often hailed from the Kingdom of Mide, as it was called at the time. The largest Anglo-Norman castle in Ireland, Trim, was built here in 1176.

Blessed with fertile land and a strong farming tradition, Meath is Ireland's leading producer of potatoes, or "earth apples," as they are sometimes called. The potato has strong historical associations with Ireland. When it was first brought to Europe from South America in the 1600s, it quickly became a staple food of the Irish. On average, a male farm worker would consume 13–15 pounds (6–7 kilograms) of potatoes a day.

In 1845 and the years that followed, Ireland was hit by a potato blight that resulted in widespread famine. In one year, two-thirds of the potato crop was lost and 1.5 million people died of starvation or famine-related diseases between 1846 and 1851. In the same period, more than a million people emigrated to the USA and many others left for Britain, Canada, and Australia. Today, the 4.4 million inhabitants of the Republic of Ireland consume an average of 193 pounds (87.5 kilograms) of potatoes per person per year.

Over the next 45–65 years, average summer temperatures in Ireland are projected to rise by 4.5–6.3°F (2.5–3.5°C), and rainfall during summer and autumn to fall by 25% as a consequence of global climate change. In some eastern parts, including County Meath, rainfall could decrease by over 40%. Such a change in climate would result in droughts that could put an end to the potato as a commercially viable crop for most of Ireland, especially the east.

IIC/Axiom/Getty Images

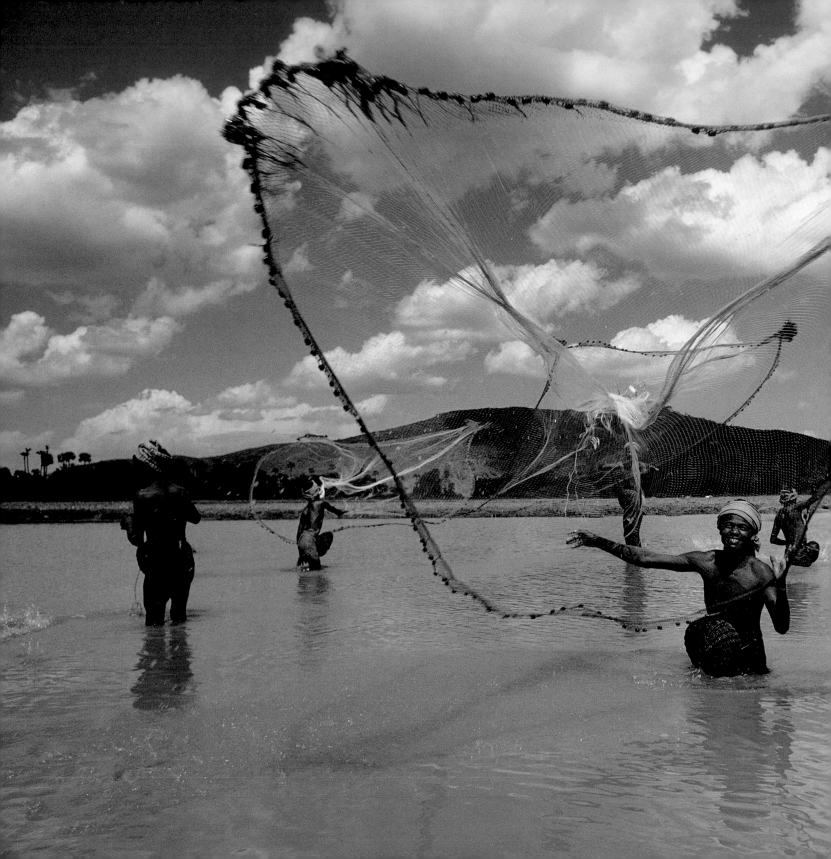

The Bengali Breadbasket

"I cannot keep your waves," says the bank to the river. "Let me keep your footprints in my heart."

These words by the Bengali poet and Nobel Prize winner Rabindranath Tangore—known as The Bard of Bengal— are as prescient today as they were when he wrote them almost a century ago.

The two great rivers of Ganges and Brahmaputra meet in the Bay of Bengal. Rich nutrients from the rivers feed the soil of the paddy fields in the low-lying Ganges Delta, and are crucial for local farmers. Some 300 million people depend on the crops produced here, 130 million of them living in the delta itself.

The delta spreads over a massive 40,540 square miles (105,000 square kilometers), covering the whole of the southern part of Bangladesh and continuing into the Indian state of West Bengal. It is extremely vulnerable to climate change, as this is likely to increase rainfall and cause more frequent and strong flooding and hurricanes.

With temperatures predicted to increase, sea levels are expected to rise significantly throughout this century. This will lead to parts of the Ganges Delta being permanently flooded within the next 50 years. By 2050, about a million people may have been forced to leave farmland in the delta.

James P Blair/Getty Images

At the Head of the Sky, the Home of the Sherpa

The Himalayan glaciers are the largest mass of inland ice in the world, their size surpassed only by the volume of ice at the two poles. They feed rivers that supply a third of the world's population with freshwater.

In the eastern part of the Himalayan range is Mount Everest, the highest mountain in the world at 29,029 feet (8,848 meters). The Nepali call it *Sagarmatha*, meaning "Head of the Sky," and the exceptionally beautiful Sagarmatha National Park is named after it.

This high-altitude landscape of snow, ice, rock, and deep valleys filled with subalpine vegetation is home to rare species of wildlife such as the snow leopard, musk deer, and red panda. It is also populated by nearly 6,000 Sherpa people, with their unique culture and traditions.

In the last decade, two-thirds of the Himalayan glaciers have retreated significantly. The resulting melt is leading to the formation and rapid expansion of glacial lakes whose banks could burst and cause floods and landslides, with disastrous consequences for the people and biodiversity of the region.

The melting of the glaciers is subject to the self-perpetuating "albedo effect." When a snow-covered area warms and the snow melts, the white surface of the ice shrinks and more sunlight is absorbed into the ground rather than being reflected back into the atmosphere. This causes the temperature to increase further.

If the current trend in global warming continues, the last Himalayan glacier will probably have disappeared by 2035. This would cause a substantial variation in seasonal water flow in the rivers and disrupt general water supplies. Mountain slopes and valleys would lie barren and agriculture, wildlife, and human habitation would be severely affected.

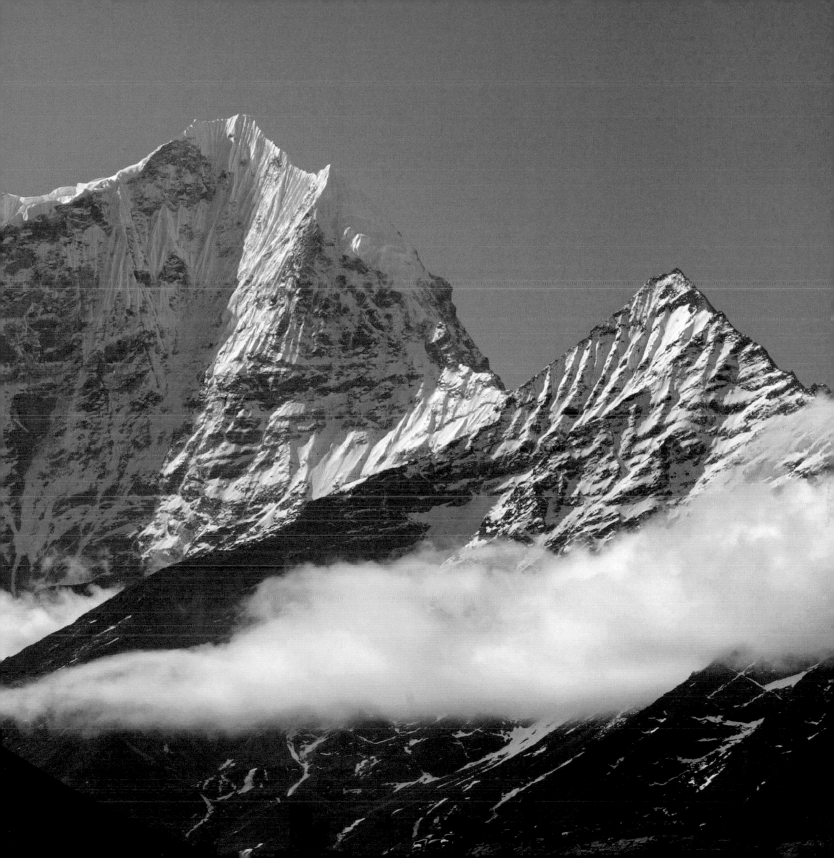

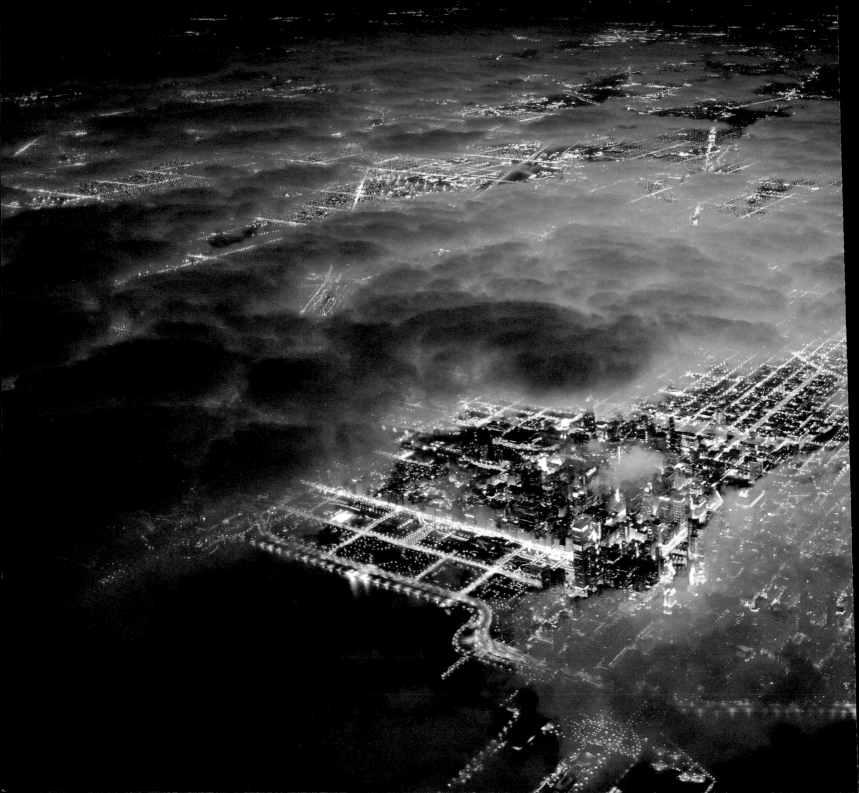

Jim Richardson/Getty Images

"Chicago! It's the Pulse of America."

Chicago has been the Midwest's center of transportation, industry, finance, and entertainment ever since it was founded in the 1830s. As French actress Sarah Bernhardt said: "Chicago! It's the pulse of America."

Today, it is the third most populous city in the USA. More than 9.5 million people live in the Chicago metropolitan area, popularly known as Chicagoland. It is intersected by the Chicago River, which runs through the downtown area, its banks lined with modern architecture and futuristic tower blocks.

Known as a Mecca of music, film, theater, and culture, Chicago is a melting pot of the descendants of immigrants of every imaginable origin. Its most famous son is US president Barack Obama, but others include the notorious gangster Al Capone. Chicago attracts 45 million tourists a year.

Chicago is also an extremely important transport hub, with a network of 60 miles (97 kilometers) of underground freight railways encompassing most of the downtown area, and freeways connecting it with other cities in the Midwest.

In the last 30 years, the city has seen an average temperature rise of 2.7°F (1.5°C). In 1995, a severe heat wave killed 700 Chicagoans. In 1986, 1996, and 2008, it experienced severe flooding, with torrential rain shutting down highways and railroads, causing damage to streets and bridges, and flooding properties in much of Chicagoland.

Throughout the rest of the 21st century, Chicago could experience a gradual, dramatic increase in heat waves and flooding due to global warming. Prolonged summer droughts and heavy rainfall would have a grave effect on its infrastructure and transport system.

An increase in hot summer days with temperatures rising above 109°F (43°C), combined with unpredictable heavy rain and flooding, could cause more heat-related health problems and damage Chicago's tourism industry. By the end of the century, the climate in Chicago could be similar to that of southern states like Texas and Alabama today.

A Floral Kingdom of "Fine Bush"

Surrounding the city of Cape Town at the most southwestern point of Africa is a region hailed as "the world's hottest hotspot" for plant diversity and endemism. Nowhere else on Earth are so many indigenous species concentrated in such a small area.

Its name is Cape Floral Region, and though this temperate bushland makes up less than 0.5% of Africa, it is home to nearly 20% of the continent's floral diversity. It is also known as the *Fynbos*, after an ecosystem unique to the region. Fynbos is Afrikaans for "fine bush," and the main vegetation is a collection of evergreens, shrubs, and small plants with tough, fine leaves and reeds. Covering an area of 34,750 square miles (90,000 square kilometers), the Fynbos is home to 9,000 different plant species, a third of them found nowhere else on Earth.

Some of the most spectacular of the plants belong to the protea family. The King Protea, South Africa's national flower, is also known as the Honeypot or King Sugar Bush because sugarbirds and sunbirds feed on its flowers. The proteas of Cape Floral Region evolved six to eight million years ago, when the climate was cooler than it is today. They are particularly sensitive to warming and climate change.

By 2050, the region may face a temperature rise of about 3.2°F (1.8°C) and a dramatic increase in wildfires, which would eliminate up to 30% of the plant species in the Fynbos, many of them indigenous, and destroy the delicately balanced ecology of the region.

Steve Corner/Getty Images

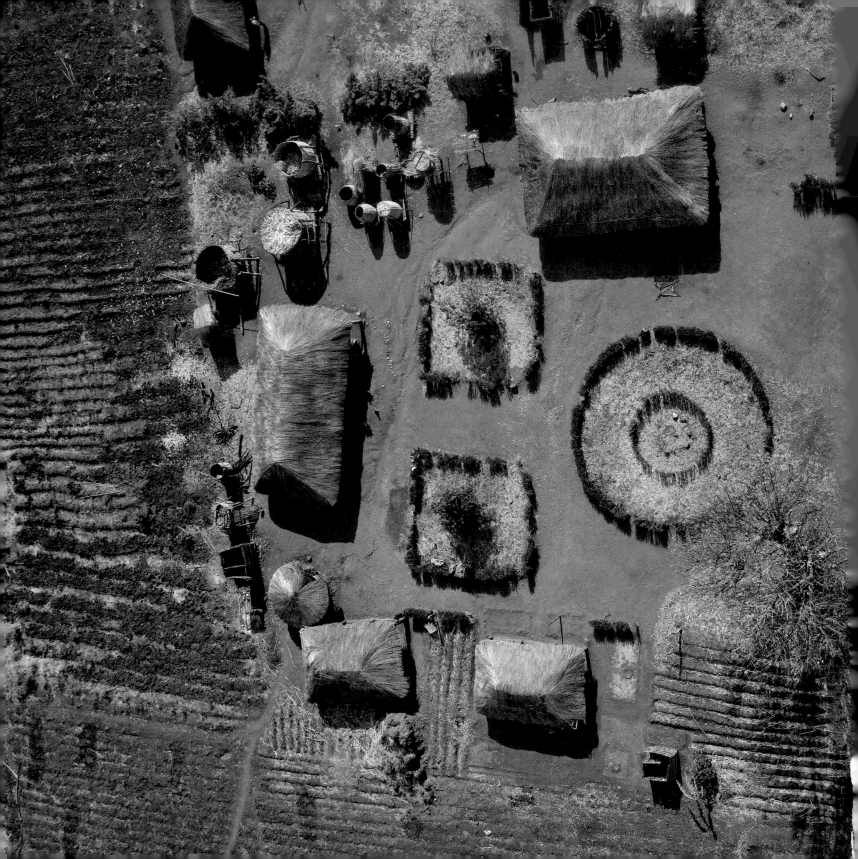

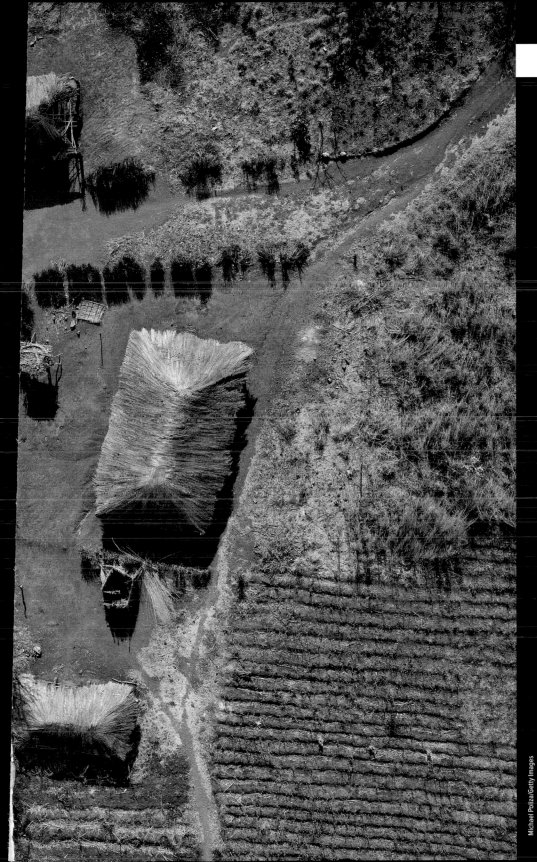

Picturesque Villages in a Harsh Countryside

In 1859, when the British explorer and missionary Dr. David Livingstone became the first European to set foot in Malawi, the African Bantu tribes had already lived in the area for more than a thousand years.

Among the first things to attract Dr. Livingstone's attention were the bomas. The fortified African villages had palisades around the dwellings to protect them against wild animals, hostile tribes, and local slave traders. Since then, the Bantu term boma has been used to describe any kind of fence, from a colonial fortress to a makeshift shelter.

In the small villages of modern-day Malawi, the picturesque bomas are grouped to safeguard the crops, harvest, and livestock. Two things they cannot protect against, however, are the spread of HIV/AIDS and drought.

The 14 million inhabitants of Malawi are among the poorest people in the world, with 85% of them living in rural areas as smallholder subsistence farmers, dependent on crops like maize, sorghum and cassava as their staple foods. Up to two-thirds of the population live below the national poverty line, unable to produce enough crops to cover household needs because of drought and floods, and depending heavily on foreign aid.

More than a million people here are also living with HIV/AIDS, and the epidemic is rapidly escalating, leaving many households short of adult manpower.

By 2050, global warming is projected to increase temperatures by 3.6–5.4°F (2–3°C), change the rainfall patterns, and reduce seasonal water availability. This could cause serious droughts that would affect more than 10 million people in rural parts of Malawi. Together with the HIV/AIDS epidemic, this would cause a downward spiral for the already vulnerable people of Malawi.

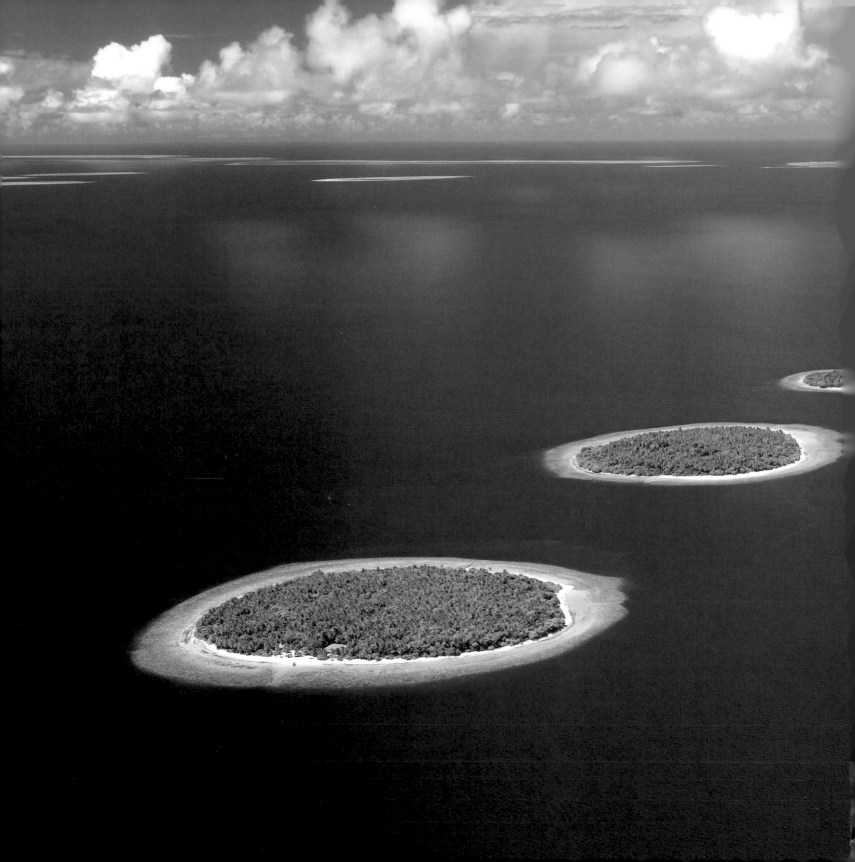

A Tropical Paradise Just Above Water

Famous for its 1,200 tropical islands, snow-white beaches, swaying palm trees, and richly colored coral reefs, the Maldives has become a tourist paradise.

This island nation, officially called the Republic of Maldives, consists of 22 atolls with many small islands scattered in circles. It stretches almost 620 miles (1,000 kilometers) from north to south in the Indian Ocean, southwest of the Indian subcontinent.

Only 198 of the islands are permanently inhabited, although many others have been developed into tourist resorts. For the 360,000 inhabitants, tourism has become the biggest industry, accounting for almost 30% of national income and more than 60% of foreign currency.

With 80% of the country less than 3 feet (1 meter) above sea level, climate change poses a serious threat to the Maldives, especially since almost all of the human settlements, vital infrastructure, and industries are located in close proximity to the coast.

In the last 15 years, the sea level in the ocean surrounding the Maldives has risen by 1.8 inches (4.5 centimeters). Estimates suggest a further rise of 8–23 inches (20–60 centimeters) by the end of the century. The area could also see an increase in the intensity of tropical storms. This would threaten both the tourist industry and the Republic of Maldives as a nation.

The Maldives was the first country in the world to sign the Kyoto Protocol.

Sakis Papadopoulos/Getty Images

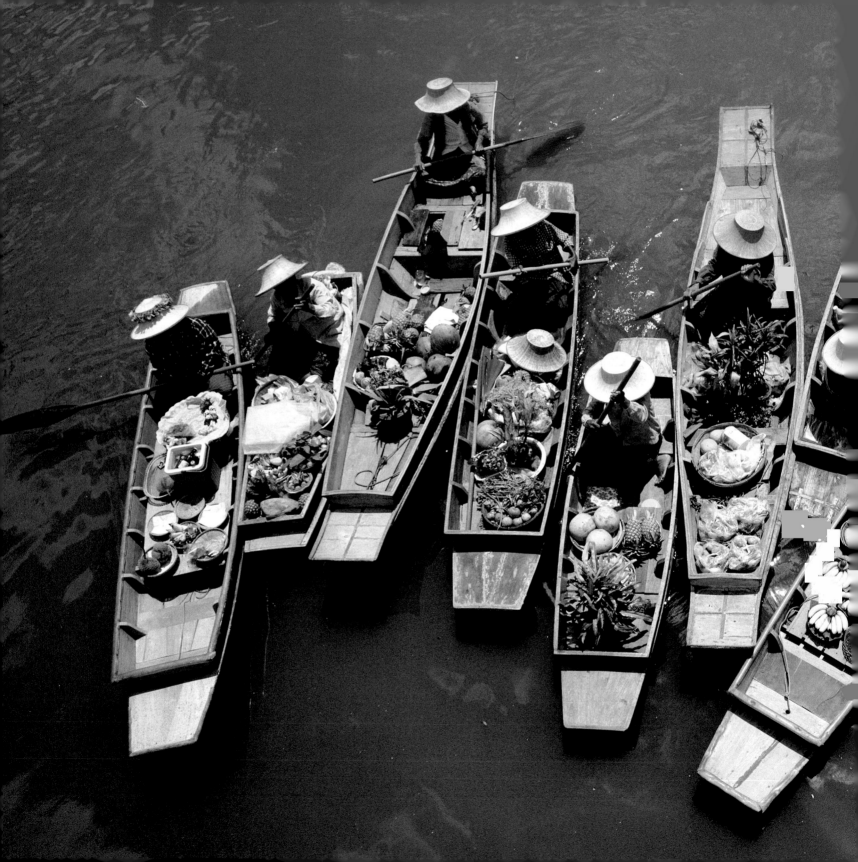

The Sinking City of Angels

Home to hundreds of Buddhist temples and tiny canals, a multitude of street vendors, thousands of skyscrapers, an elevated urban sky train, and a brand-new airport, Bangkok is a tropical metropolis where the traditional East meets the modernity of the West.

Dissected by the Chao Phraya river and built on the soft, loamy soil of its banks and delta, Bangkok, now home to a population of almost 15 million, used to be a minor port and trading center. In 1782, it became the capital of the independent kingdom of Siam, the official name for Thailand until 1939. The Thai name for Bangkok is *Krung Thep*, meaning "City of Angels."

Since US soldiers serving in the Vietnam War began spending their leave in Bangkok in the 1960s, Thailand has developed rapidly as a tourist destination. The capital now serves as a gateway to Southeast Asia from the rest of the world, with up to 15 million tourists passing through every year.

Located in one of Asia's "mega deltas" and only 6 feet (2 meters) above sea level, Bangkok is massively exposed to flooding, especially during the monsoon season. This is compounded by the fact that the city is sinking due to the soft underground, heavy urbanization, and excessive pumping of groundwater. Some estimates suggest that the whole city is subsiding by as much as 2 inches (5 centimeters) a year.

All of these conditions make the Thai capital particularly vulnerable to climate change and rising sea levels. Any increase in extreme storm surges would erode the coastal area and cause severe flooding. Saltwater intrusion could also seriously affect supplies of drinking water.

Unless urgent steps are taken, large parts of Bangkok could be under water before the end of the century.

Paul Chesley/Getty Images

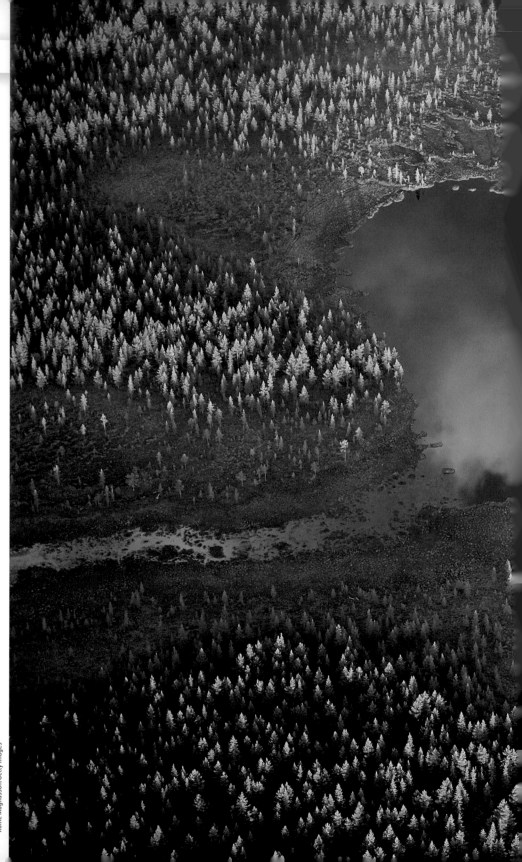

The Oldest Tree in the World

Scientists made a fascinating discovery in the mountain tundra of Dalarna in south-central Sweden recently—the oldest living tree in the world. The roots of this ancient spruce tree are 9,550 years old, dating all the way back to the end of the last ice age, when Sweden was covered in ice.

Forest covers almost 60% of modern Sweden's total land-mass, corresponding to 1% of the world's total forest cover. Majestic spruces dominate, making up 42% of the total. Apart from being used as Christmas trees, the spruce also serves as the basis for one of Sweden's most important industries, the paper and timber industry.

A distinctive feature of Swedish forestry is that nearly 355,000 private individuals, many of them smallholders and family businesses who pass their plot from one genera-tion to the next, own half of all the nation's trees.

The spruce is tolerant of severe cold and, to a certain extent, drought, and grows best in regions with cold win-ters. Its hardiness and longevity are partly due to its ability to clone itself—as soon as one trunk dies, another emerges from the same rootstock.

The 9,550-year-old find is now shedding new light on the origins of the Swedish spruce. Climate change means the spruce forests face an uncertain future, however. It is projected that higher temperatures and declining summer precipitation will cut the number of spruce in southern Sweden.

The spruce bark beetle constitutes a further threat to the species. Frequent storms and warm summers have caused an explosion in the number of beetles. Global warm-ing is likely to increase their number yet again, which would pose a serious threat to the ancient Swedish spruce.

Roine Magnusson/Getty Images

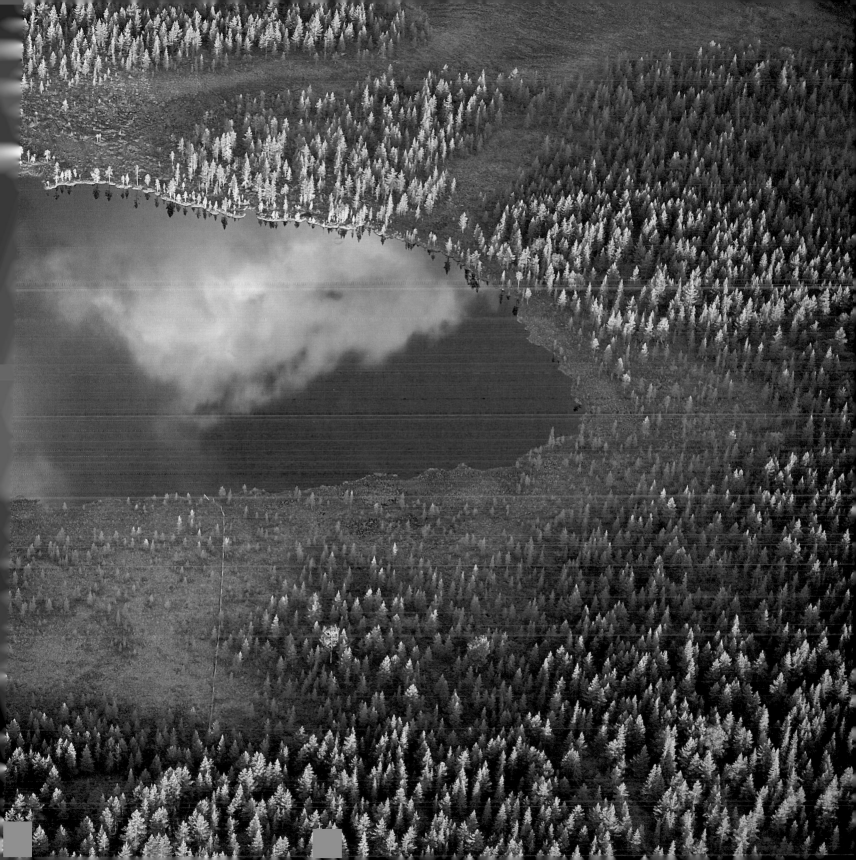

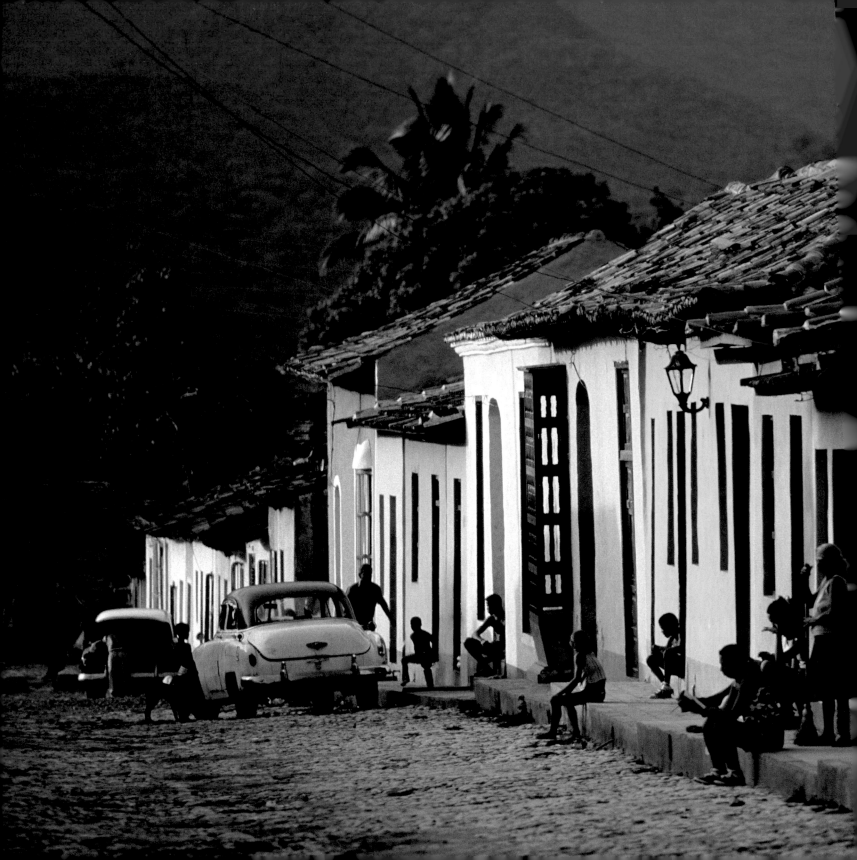

To Visit Here Is to Step Back in History

The historic town of Trinidad in the province of Sancti Spíritus is one of Cuba's greatest attractions. Its cobblestone streets are surrounded by pastel-colored houses with terracotta tiled roofs, the wrought-iron grilles on the windows redolent of the atmosphere of a bygone colonial age.

Founded 500 years ago on December 23, 1514, by the Spanish conquistador Diego Velazquez de Cuellar, Trinidad is renowned for its preserved Spanish colonial architecture and has been declared a UNESCO World Heritage Site.

The Plaza Mayor, and the majestic 18th- and 19th-century houses that surround it, form Trinidad's historic center. The once-rich town belonged to wealthy landowners who prospered from the sugar and slave trades. Today, most of their houses are museums and tourist attractions.

Located in the Caribbean Sea at the mouth of the Gulf of Mexico, Trinidad, together with the rest of Cuba, lies in the path of hurricanes. In September 2008, Hurricane Ike struck Cuba just ten days after another major hurricane had roared through the country, damaging almost 1,000 homes in Trinidad and causing massive landslides and river flooding that cut off roads to and from the city. The two hurricanes caused $7 billion in damage throughout Cuba.

Trinidad has managed to protect and repair many of its historic sites but global warming is expected to lead to more frequent extreme weather events in the Caribbean Basin. The rebuilding and reinforcing of buildings may not be able to keep up with the storms, which are growing fiercer and more regular. These potentially lethal extreme weather events threaten to destroy the colonial heritage of Trinidad as well as the homes of the ordinary citizens.

Bertrand Gardel/Getty Images

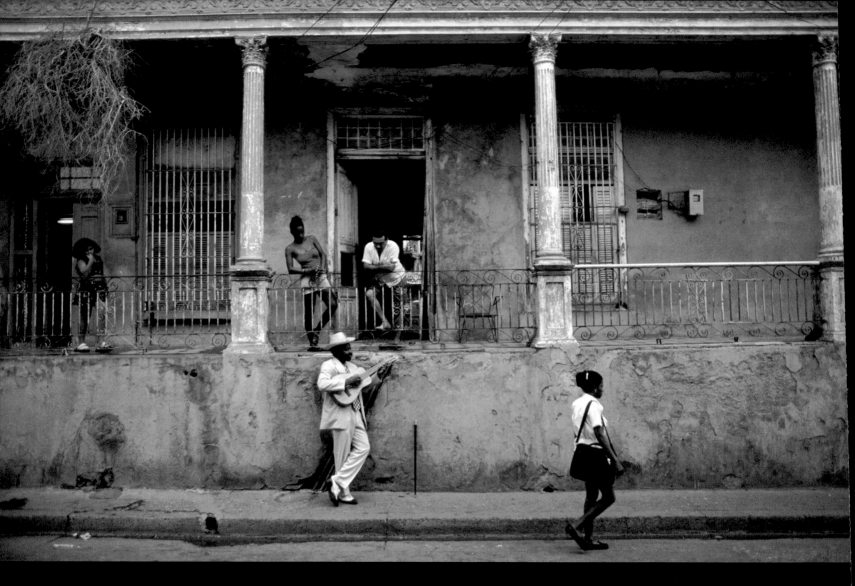

TIME SEEMS TO HAVE SKIPPED a few decades in the tranquil town of Trinidad, especially due to the laid-back, nonchalant attitude of its people. Dominoes are played on the sidewalks and at night in the city center, where cars are not allowed, people dance to Cuban music such as Son Montuno or Salsa.

Outside the city is another UNESCO World Heritage Site, the Valle de los Ingenios (or Valley of the Sugar Mills). The center of Cuba's sugar industry in the 19th century, its three valleys contain more than 70 old sugar mills at the foot of the Escambray Mountains. Today, tobacco processing has replaced the sugar trade as Trinidad's main industry.

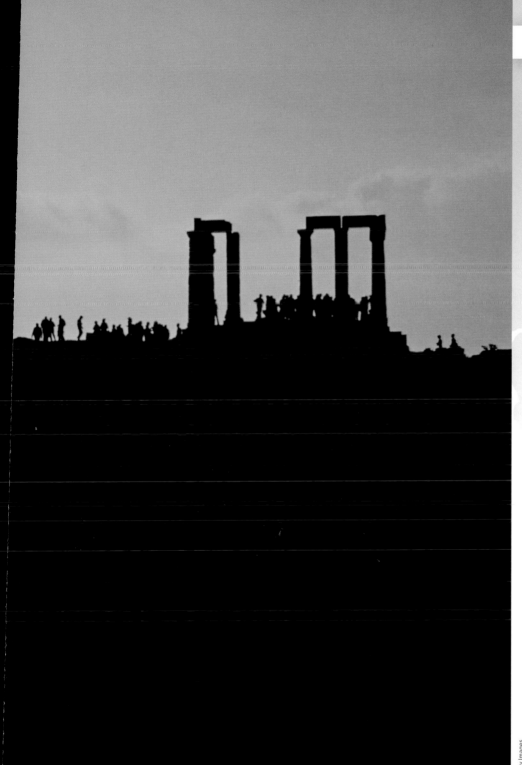

James P. Blair/Getty Images

A Shelter for One of the World's Rarest Animals

The word "archipelago" was originally coined to describe the many rugged islands dotted throughout the Aegean Sea between Greece and Turkey, many of them the tips of the mountain chains that extend from the mainland far out into its deep blue waters.

Beneath the surface of the Aegean lives one of the rarest animals on Earth, the Mediterranean Monk Seal. With a population of around 400, it teeters on the verge of extinction. Its close relative the Caribbean Monk Seal has already been wiped out and the Hawaiian Monk Seal is also under threat.

Until a century ago, the Mediterranean Monk Seal gave birth, rested, and congregated on open beaches. They have now abandoned the beaches in favor of sea caves along the most remote, rugged coasts, which are almost inaccessible to humans. This change of habitat is thought to have been the result of population growth and the expansion of tourism and industry in the 20th century, which clashed with the shy nature of the Monk Seal.

One of the few places they are still able to flourish in relative peace is the Greek Alonissos Marine Park in the northern part of the Aegean Sea, where a vast area has been allocated to the preservation of the seal and its habitat. It may not be enough to save the remaining Monk Seals, however. Any rise in sea level caused by global warming is likely to submerge their caves and rob them of their final refuge from mankind.

A Settlement at the Edge of the Sea

Herschel Island is just off the mainland near the Alaskan border in the far northwest of Canada. Traces of very early human settlement are still to be found in this Arctic wilderness. The indigenous people of the area, the Inuvialuit, have used the small island for thousands of years, and many of their old dwellings are still visible.

The remains of the first whaling station in the area, dating from the 1800s, are found at Pauline Cove, on the east of the island—alongside its graveyard.

From November to July, when Herschel Island is locked in ice, the distinction between island and mainland is blurred and the old whaling station and its graveyard are covered in ice and snow.

Average temperatures are about –16°F (–27°C) in winter and 43–45°F (6–7°C) in summer, but they can fall as low as –58°F (–50°C) in winter and rise as high as 86°F (30°C) in summer. The island is covered in permafrost, but the top layers become warm enough in summer for rare arctic plants and flowers to grow. Herschel Island is a protected site because of its biological significance and cultural heritage.

The sea ice and permafrost have been protecting the island's coastal areas for centuries. As temperatures rise, the sea ice will decrease, the permafrost will start to melt, and the coastal area will become more vulnerable to storms and erosion. The coastline at Pauline Cove is already eroding and is now desperately close to the whaling settlement, which is in danger of being swept into the sea.

The same could happen to the ancient Inuvialuit dwellings and the old graveyard, both of which will be susceptible to changing weather conditions as the permafrost melts and the soil becomes waterlogged.

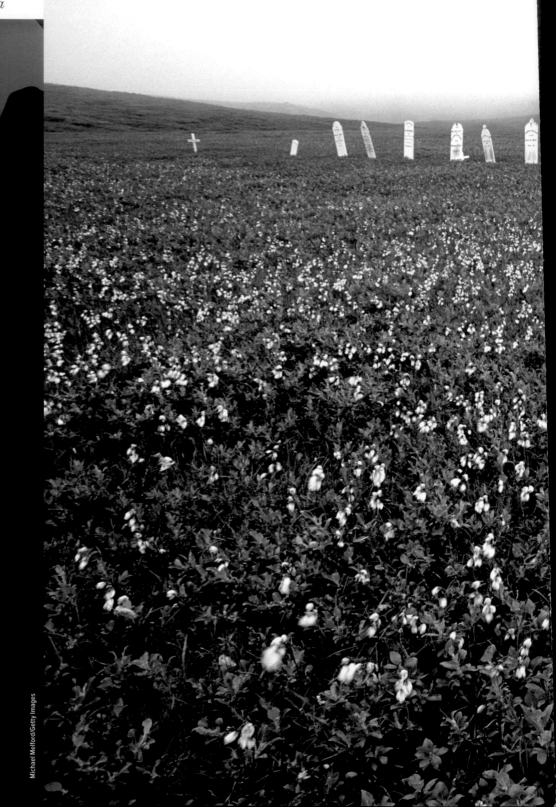

Michael Melford/Getty Images

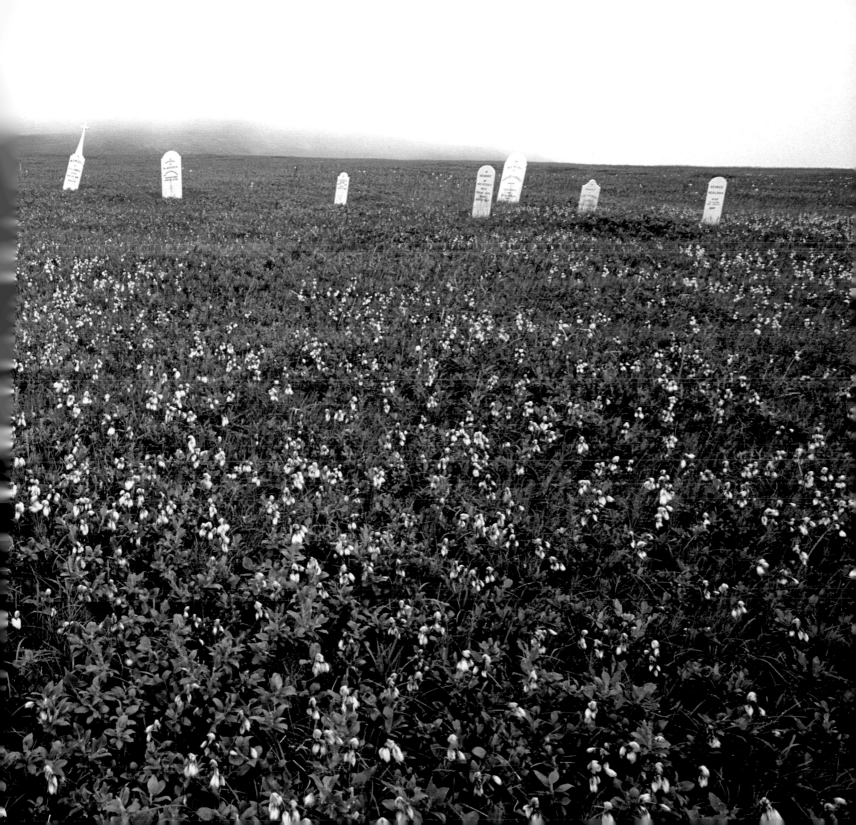

The Lungs of the Earth

Known as "the lungs of the Earth," the Amazon is the largest rainforest on the planet. It covers 2.1 million square miles (5.5 million square kilometers) spread over nine South American nations, 60% of it in Brazil, and accounts for more than half of the world's remaining rainforest.

Home to 20% of all plant and animal species in the world, the biodiversity of the Amazon rainforest is unparalleled anywhere on Earth, and includes some 2.5 million species of insect, and tens of thousands of species of tree and plant. Its biosphere also has an incalculable impact on the climate and living conditions of the whole planet.

Over the past 30 years, almost 232,000 square miles (600,000 square kilometers) of the rainforest have been felled in Brazil alone. If this trend continues, more than 30% of the forest will be gone by 2050, contributing to global warming through emissions of CO_2 on a very large scale.

Even without deforestation, the rainforests are under serious threat. Many tropical plant species are highly sensitive to even the slightest climate variation. A temperature rise of 5°F (3°C) could reduce the forest in parts of the Amazon by more than 40%, adding further to global warming, wiping out thousands of endemic species, and transforming the landscape into savannah.

Daniel Beltra/Getty Images

Shaped by a Restless Underground

Positioned near the junction of three tectonic plates, Honduras has been shaped by millions of years of underground movement that has created the most mountainous country in Central America, albeit with alluvial plains covering the Caribbean lowlands in the north.

Most of Honduras' 7.6 million inhabitants live in villages and towns tucked into its numerous valleys or clinging to the slopes of its mountains. Smallholders grow coffee on the steep mountainsides, and the lower coastal plains are covered with banana plantations and palm trees that produce palm oil and biodiesel. Coffee and bananas are vitally important exports for Honduras, one of the poorest countries in the Americas.

Despite its unstable geology, it is not earthquakes but hurricanes that have proven to be the biggest threat to Honduras. In 1998, Hurricane Mitch ravaged Central America, hitting Honduras the hardest. It sent waves almost 23 feet (7 meters) high crashing into the coast, and the extreme rainfall made the Choluteca River flood to six times its normal width.

Flooding and mudslides wiped out entire villages, roads, and nearly all the country's bridges, obliterated about 80% of the coffee and banana crops, washed away the topsoil, and covered plantations with sand. The hurricane also killed almost 6,000 people.

Mitch was the fourth-strongest hurricane ever observed in the Atlantic basin, but since then no fewer than three others have already surpassed it. Rising sea temperatures are projected to increase the frequency of extreme weather events, particularly across Central America. Time and again, hurricanes like Mitch will set back the development of poor countries such as Honduras.

Holly Wilmeth/Getty Images

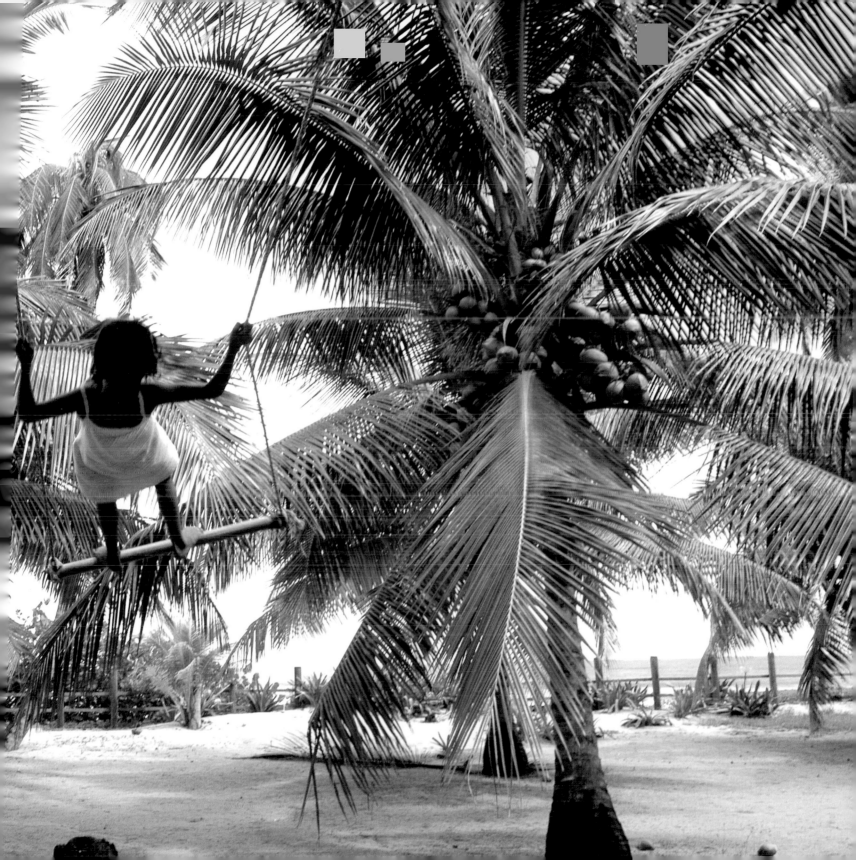

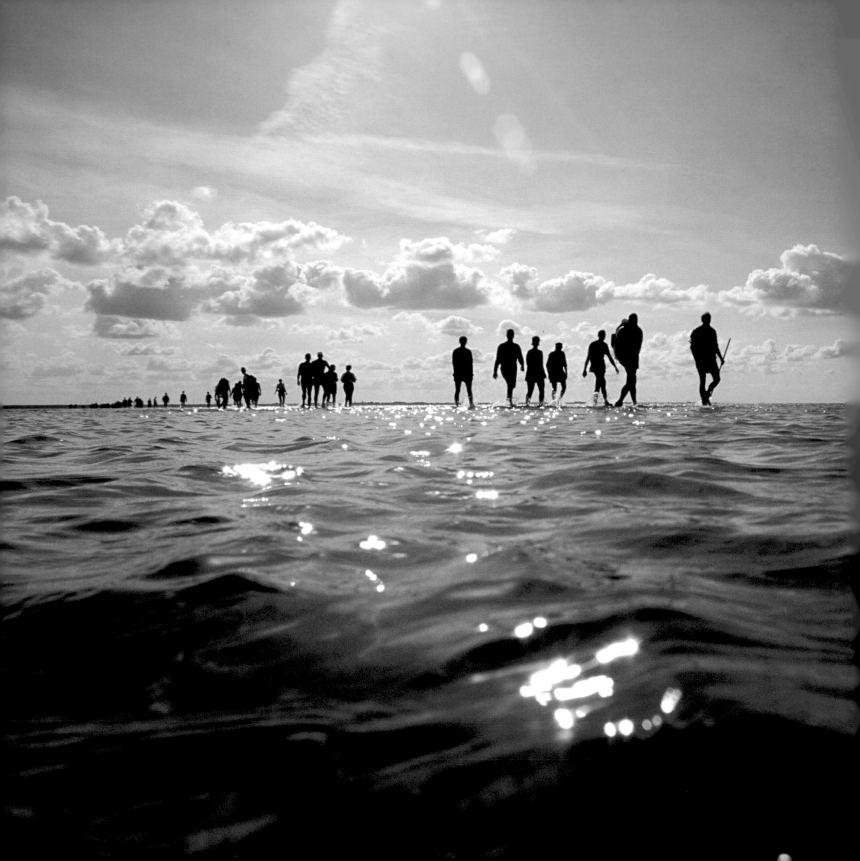

Where You Walk on Water

The Wadden Sea is a low-lying coast formed some 10,000 years ago at the end of the last ice age, when the ice that had covered most of Denmark melted and the water flowed westwards. As it reached the coast, silt deposits created new, low-lying land that has been changing shape with the ebb and flow of the sea ever since.

Tourists from Denmark and abroad flock to the Wadden Sea in droves to "walk on water" and see the varied landscape of cliffs, marshes, sandy beaches, and tidal mudflats, where the difference between low and high tide can be up to 6 feet (2 meters).

The flora and fauna of the region have adapted to the rise and fall of the sea, as well as its shifting salinity, which has created an ecosystem so incredibly rich and diverse that the Wadden Sea is considered one of the ten most important wetlands in the world.

With up to 100,000 shrimps, worms, snails, and clams per square yard, the Wadden Sea also serves as a well-stocked pantry for more than 10 million migratory birds. Every autumn, geese, ducks, gulls, dunlins, and other

"Hush, be quiet!
The mystic
Barrier!"

The Ross Ice Shelf in the Antarctic is Earth's largest ice shelf and forms part of its biggest ice mass. It contains a massive 70% of the freshwater on the planet. Named after James Clark Ross, the British naval officer and explorer who first set eyes on it in 1841, it is associated with dangerous adventures, heroic discoveries—and an uncertain future.

In 1911, when it was still known as the Ice Barrier, the explorers Robert F. Scott and Roald Amundsen set off on their legendary race to the South Pole from opposite edges of the shelf. In his book *South Pole*, Amundsen records his immediate feelings on arriving at its huge face for the first time: "Hush, be quiet! The mystic Barrier!"

The Ross Ice Shelf is linked to Antarctica but most of it floats on the sea. At 188,000 square miles (487,000 square kilometers) it is almost as big as France. The sea-facing side is almost 375 miles (600 kilometers) long, its vertical face rising to heights of 50º165 feet (15–50 meters). Only 10% of the shelf is above water and visible; at its thickest, it plunges several hundred yards below the water line.

In the last 50 years, the average temperature on the west coast of the Antarctic has risen by almost 5.4°F (3.0°C), ten times the average increase for the planet as a whole.

The temperature in and above the sea around the Antarctic is projected to rise again over the next hundred years. This could lead to the Ross Ice Shelf collapsing and breaking away from the continent, which would raise sea levels quite dramatically all over the world and cause further melting of the ice on the Antarctic continent.

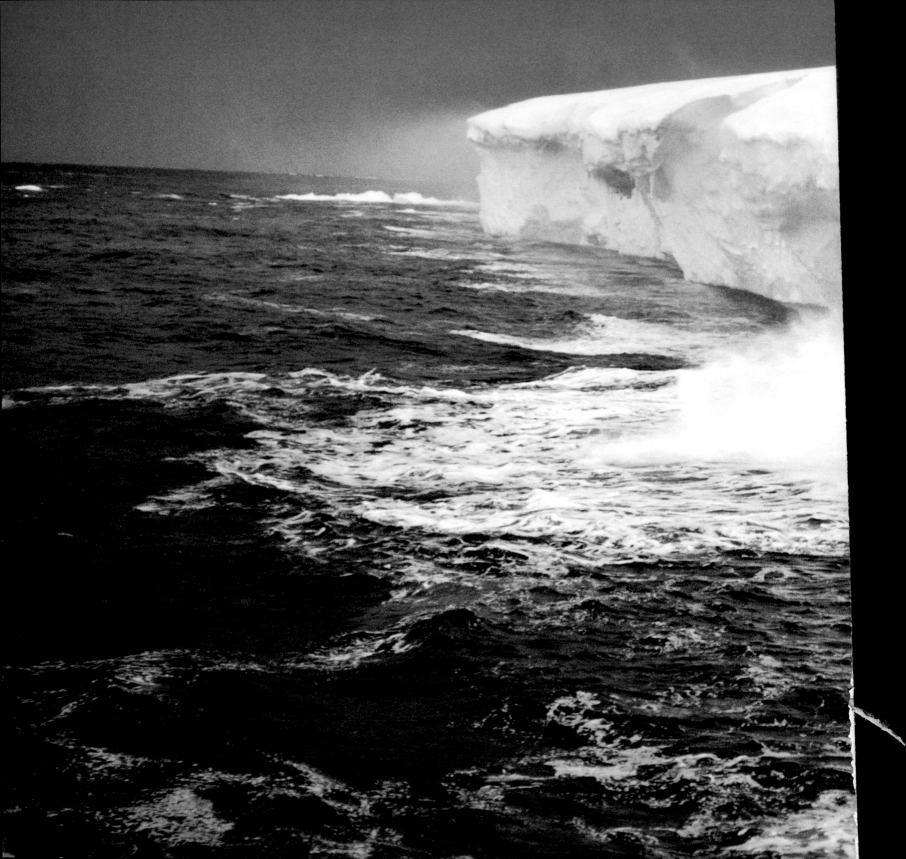

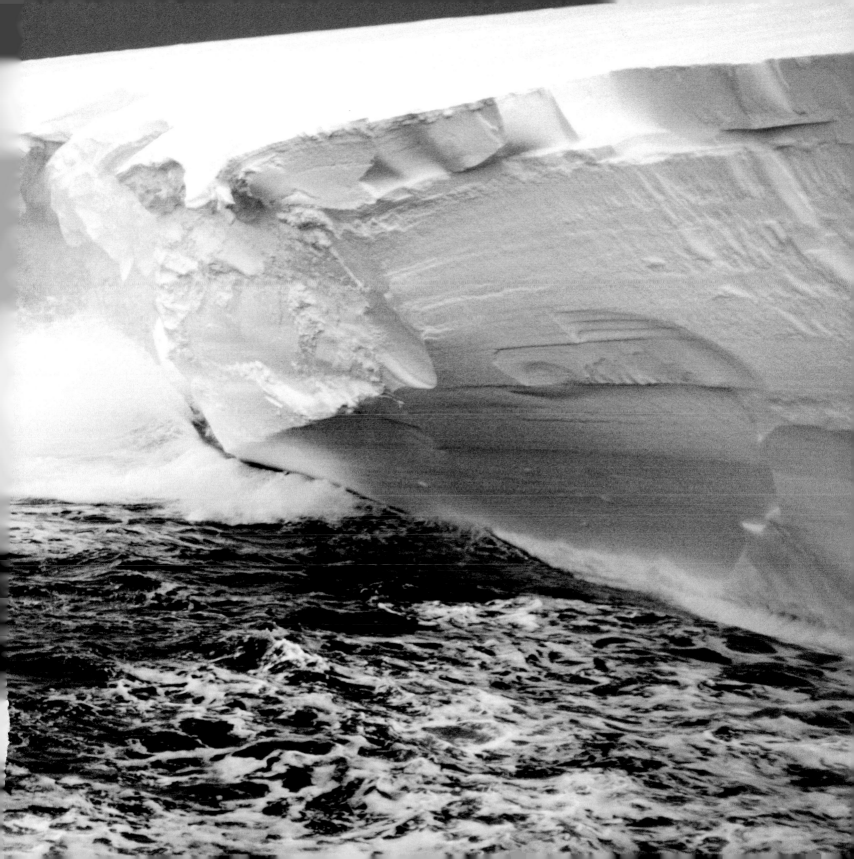

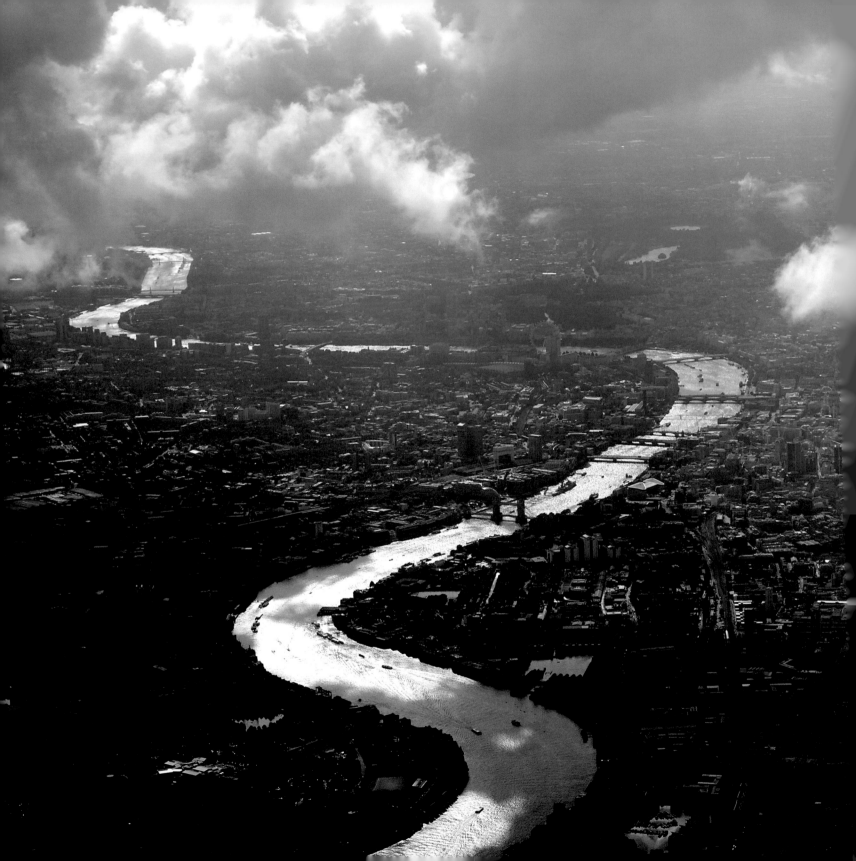

An Artery of Life and a Constant Threat

"It has always been the river of commerce... The city itself owes its character and appearance to the Thames."
(Peter Ackroyd in *London, The Biography*)

It was the Romans, under Emperor Claudius, who founded the first settlement on the northern bank of the Thames in 43 AD and called it *Londinium*. The location was chosen because of its position by the river and proximity to the sea. Ever since then, the Thames has been the main artery of life for the city that was to become the world's first metropolis and center of commerce and finance.

However, the river also presents London with its biggest threat. From the early Middle Ages until the present, the city has been expanding into the river, building out from its banks and narrowing the tidal course.

Embankments have been built along the Thames to protect London from flooding, but they have not always been sufficient. The city has only had adequate defenses against extreme weather conditions since the Thames Barrier was built in 1983. By 2025, even the Thames Barrier might not be enough to protect London from flooding.

If climate change continues, the combination of high tides, mid-latitude cyclones, and rising sea levels could overwhelm the barrier, with devastating results. Huge parts of London would be flooded, including parts of the underground rail network, train stations, hospitals, thousands of homes, and historic areas including the Houses of Parliament and the Tower of London.

A flood would have a direct effect on 340,000 properties and the 1.25 million people who live in the low-lying London area. If the Thames Barrier is breached just once, the blow to the UK economy will be an estimated £30 billion ($48 billion).

Michael Dunning/Getty Images

A Sea that Feeds Walruses, Polar Bears, and Two Superpowers

In 1725, the Danish navigator Vitus Bering led an expedition on behalf of the Russian czar, Peter the Great, who wanted to know whether Siberia and North America were connected by land. It took him three years to reach what is today known as the Bering Strait.

The Bering Sea provides almost half of the seafood caught in the USA, valued at around $1 billion p.a., and the Russian catch is worth $800 million. It is also home to sea lions, walrus, polar bears, and endangered whales such as the blue whale, sperm whale, bowhead whale, humpback whale, killer whale, and the rarest of them all, the North Pacific Right Whale. More than 30 species of seabird breed in the region, including the Spectacled Eider and the endangered Short-tailed Albatross.

The cornerstone of the sea's rich biodiversity is the diatom, a large phytoplankton that grows on the underside of the ice. The northern part of the Bering Sea is typically covered in ice for seven months of the year. When the ice melts, the diatoms float to the bottom, creating a rich food layer for sea-floor populations, which then support birds and marine mammals. The walrus plays an essential part in the ecosystem as well. By rooting for food with its whiskered muzzle, its stirs up the seabed and circulates vital nutrients.

With the warming of the oceans, there is little doubt that the biodiversity of the Bering Sea will change. There is already less ice than just a few decades ago, and it melts earlier every year, reducing the size and abundance of the diatoms. As the cold waters grow warmer, the fish and crabs move northwards, eating into food supplies that until now have been reserved for ice-dependent species. This means new mouths to feed and less food for the sea lions, walrus, and whales. By the end of the 21st century, all the ice in the Bering Sea may be gone.

Michael Melford/Getty Images

173

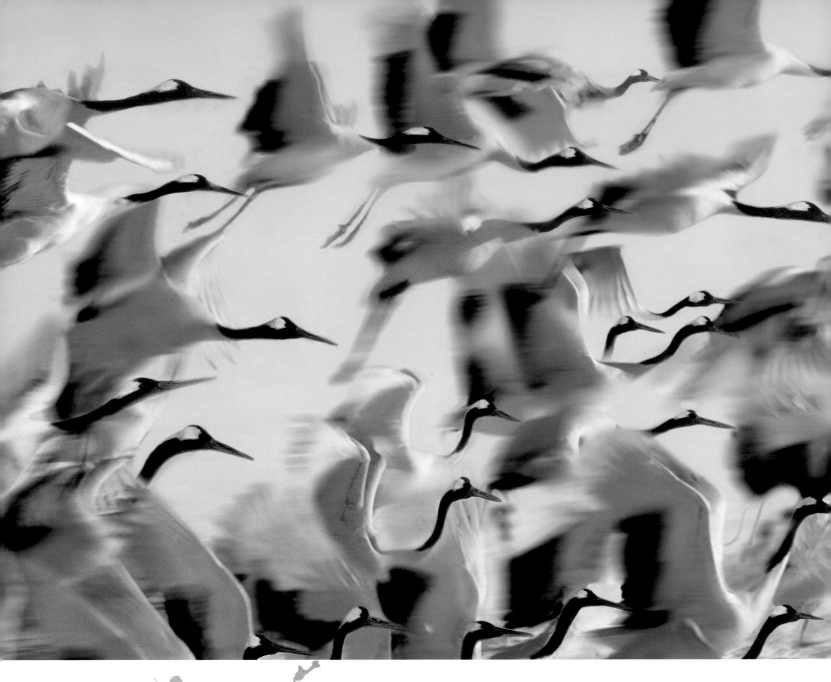

69. Kushiro Marsh | *Japan*

The Call of the Crane

The red-crowned crane, or tancho, is encountered everywhere in Japan. It can be seen in icons such as the early logo for the Japanese airline JAL, it is used in the names of cities and streets, and it appears in folktales and myths.

In Japan, the tancho is said to live a thousand years. The crane has long been considered a symbol of longevity and good luck, and its majestic appearance has made it a national treasure. It is rare to see a real crane in Japan, however. By the beginning of the 20th century, the long-necked bird with its sharply contrasting black and white plumage and characteristic red crown was thought to be extinct. That was until a dozen cranes suddenly appeared in Kushiro on the northernmost main island of Japan, Hokkaido. In 1952 local farmers started feeding the birds, and slowly their numbers rose.

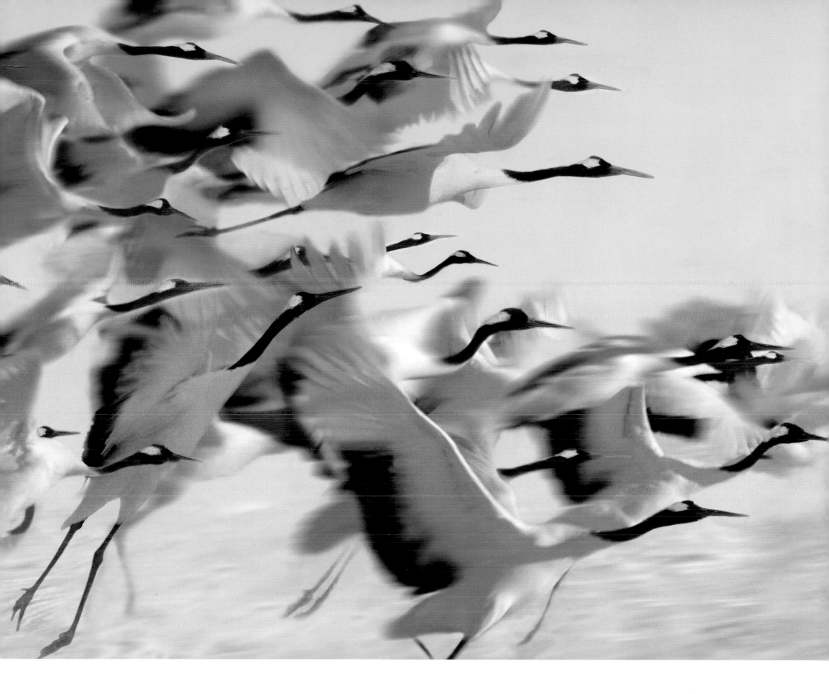

Today, the red-crowned crane is the second-rarest crane species in the world. There are around 1,200 in Hokkaido, where they breed, stalk the fields, and dance their wild courtship dances in the cool marshland habitat of Kushiro. Although their numbers have increased in the last 100 years, their habitat is shrinking, and this ultimately poses a serious threat to the crane.

The Japanese expression *tsuru no hitokoe* ("the call of the crane") can mean the voice of authority. In this case it might also be seen as a cry for help, drawing attention to the massive developments and deforestation that threaten to make further inroads into their marshlands.

With the oceans rising because of global warming, coastal wetlands such as the Kushiro Marsh may become

flooded, leading to increased salinity in the land and generating further uncertainty about the future of the tancho, which is so embedded in Japanese culture.

Deep in the Heart of Africa

The Mbuti pygmies live in the Ituri Forest in the northeast of the Democratic Republic of Congo. The Mbuti are nomads and the forest serves as the foundation for their culture and livelihood, sustaining them spiritually as well as materially.

Pygmies grow to heights of 4–5 feet (130–150 centimeters) tall and the Mbuti are one of many groups that live along the Congo Basin, which stretches from Cameroon in the west to Zambia in the southeast.

This vast region contains the world's second-largest tropical rainforest, surpassed in size only by the Amazon. The Congo Basin is one of the most species-rich areas in the world. Around 90% of the region remains untouched, but deforestation threatens to change this.

If logging continues at its present rate, half of the rainforest will vanish in the next 50 years, putting the livelihood of the Mbuti at risk and endangering rare species such as the okapi, chimpanzee, leopard, elephant, and buffalo, all of which live in the Ituri Forest.

Deforestation results in large amounts of CO_2 being released into the atmosphere. In 2004, a massive 8.4 billion tons of CO_2 were emitted worldwide as a result of deforestation. This is equivalent to a quarter of the global emissions from fossil fuels.

Michael Nichols/Getty Images

THE MBUTI LIVE IN HARMONY with the forest, which they call father/mother. Nomadic hunter-gatherers, they build temporary huts from branches and leaves. Between the ages of nine and twelve, Mbuti boys undergo a manhood ritual to learn how to survive and support their families. They are circumcised and sent out into the forest for five months, clad in skirts made from plant fiber. Apart from singing, they are not allowed to use their voices, and their mouths are symbolically covered by leaves. Their bodies are decorated with clay and whipped to strengthen them for adulthood.

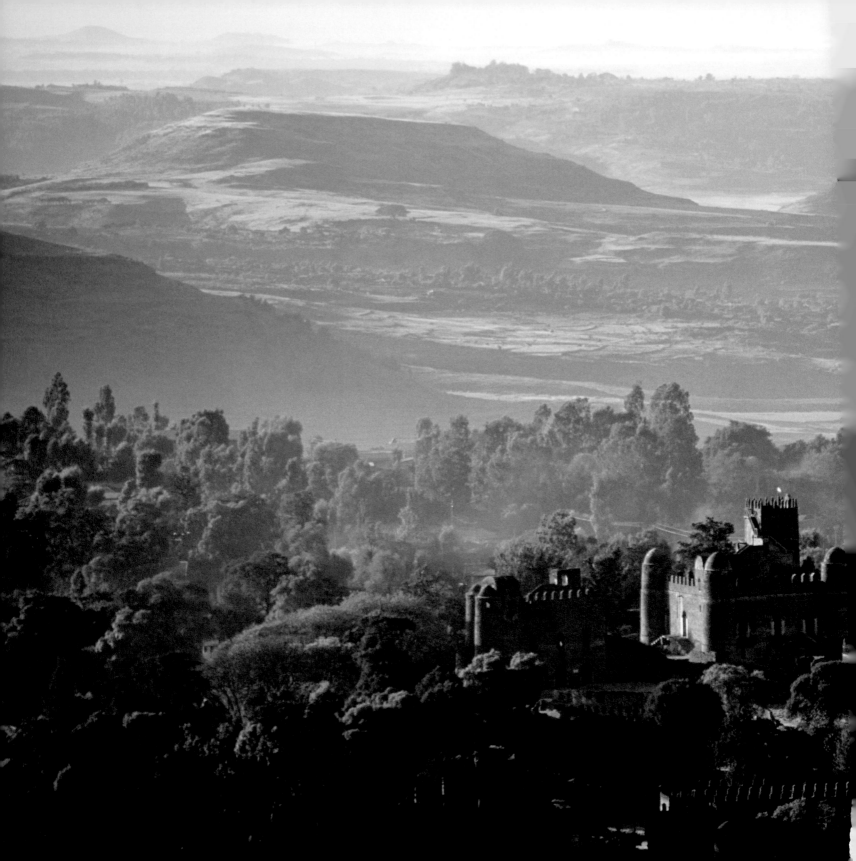

Royal Seat of the Solomonic Emperors

The imperial castle of Gondar in the northern highlands dates back to 1636, when Gondar was the capital of Ethiopia. One of the oldest countries in the world, Ethiopia has been a sovereign state for more than 3,000 years, apart from the occupation by Mussolini's Italy from 1936 to 1941.

According to myth, the royal family is able to trace its lineage all the way back to the Queen of Sheba and King Solomon. The hereditary rulers were known as the Solomonic Emperors of Ethiopia, a line unbroken until the last Emperor, Haile Selassie I, was deposed by a Soviet-backed military junta in 1974.

The earliest human remains ever found were excavated here, and scientists believe Homo sapiens migrated from Ethiopia to the rest of the world at least 150,000 years ago.

The old royal castle remains one of Ethiopia's main tourist attractions. Now a modern university town with a population of 200,000, Gondar is the biggest city in the Amhara region, where most of the 17 million inhabitants are smallholder farmers of cattle, sheep, goats, and poultry.

The highlands are between 4,920 and 8,200 feet (1,500 and 2,500 meters) above sea level, making the climate rather cool for this part of Africa. As a result, the highlanders largely escape the scourge of malaria, the most prodigious of killer diseases in Ethiopia, which takes the lives of 160,000 lowlanders every year and strikes down millions of others.

Temperatures are expected to rise and precipitation to increase in the northern highlands. If this happens, it will cause the mosquitoes that transmit malaria to seek new breeding grounds in the high-altitude area of Amhara and other highland regions, spreading the disease to millions of people. Between 2050 and 2080, the highlands of East Africa could become a high-risk area for malaria, causing huge loss of life and extensive damage to the economy.

Travel Ink/Getty Images

181

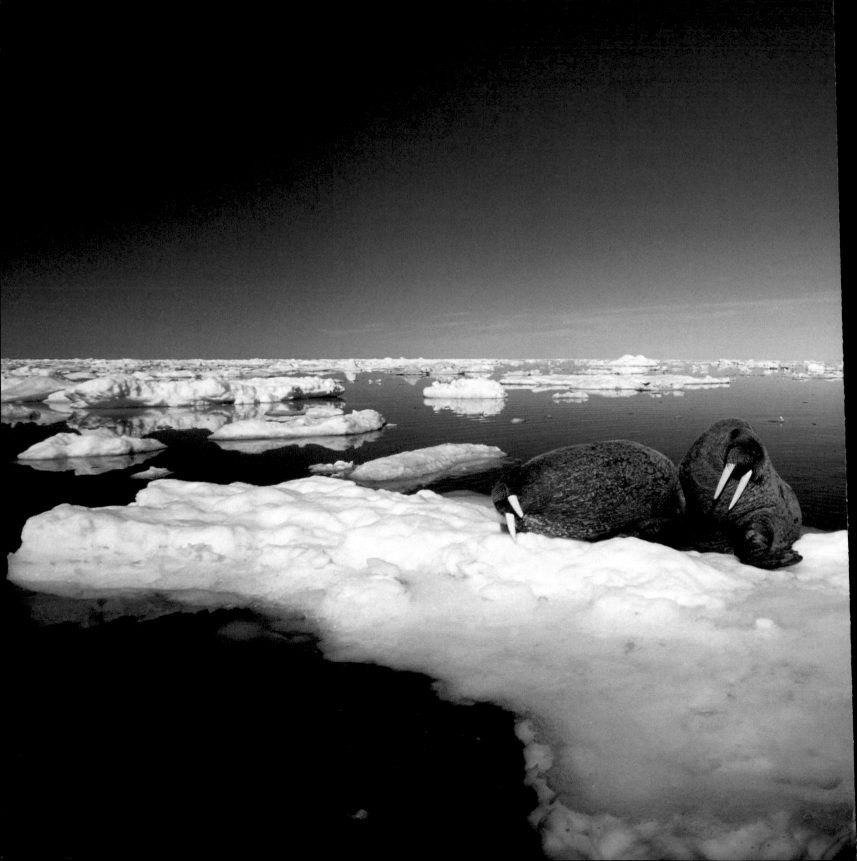

An Arctic Community for Millennia

Northern Canada is home to an indigenous population of some 26,000 Inuit. For thousands of years, they have coexisted with walruses, polar bears, and seals in the 772,000-square-mile (2-million-square-kilometer) Arctic area known as Nunavut.

For much of the year, animals and Inuit alike depend for survival on the ice that covers coastal waters. The large mammals live, hunt, and reproduce on the ice. The Inuit travel and hunt on it.

Within the next century, the average annual temperature in the Nunavut area is expected to rise by up to 9°F (5°C), which will mean there will be no Arctic sea ice for most of the year.

This would threaten the walrus, polar bear and seal with extinction. With the animals gone, the traditional Inuit way of life that has survived for thousands of years will vanish. In many parts of the Arctic, the polar bear population is already in decline.

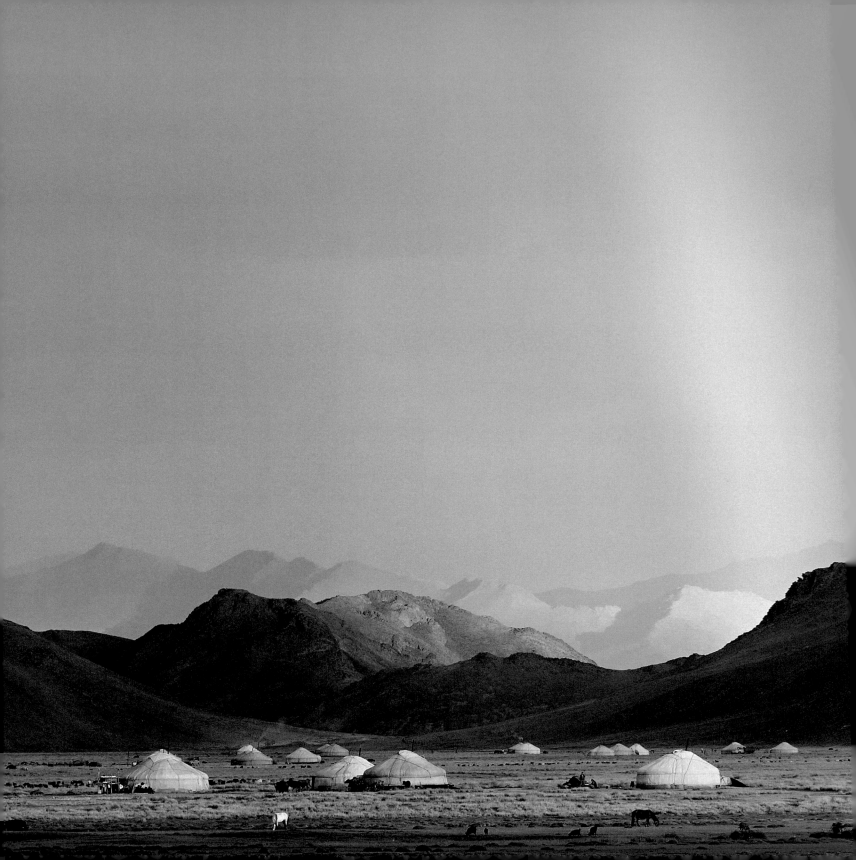

Pastoral Life on the Mongolian Plains

The nomads of Mongolia have roamed the plains of Central Asia for the last 3,000 years. They lead a pastoral way of life, moving around in search of pasture for their livestock and sites for their gers (their word for a yurt, a round, moveable dwelling).

Today, half of the nearly three million inhabitants of Mongolia still live as herdsmen and share the lifestyle of their ancestors in the harsh environment of the steppes.

For Mongolian herdsmen and women, horses are indispensable. They provide transport and the mares supply milk, which is also fermented into the national alcoholic drink, airag.

The herdsmen raise cows, yaks, sheep, and goats and, in the Gobi Desert to the south, they breed camels as well. The cattle supply them with essential meat, milk, yogurt, and cheese, the sheep with wool for clothing and felt for the gers.

Depending on the season, most Mongolian nomads move their campsite three times a year, but in the harsh south they can move up to 18 times a year.

During the next 80–90 years, rainfall patterns are expected to change and temperatures are projected to rise by 6.3–7.2°F (3.5–4.0°C). This will have a negative impact on the production of grass and herbaceous vegetation on the plains. The harsh semidesert of the Gobi will move farther north, and it will become more difficult for the Mongolians to find enough fodder for their livestock, threatening their traditional nomadic lifestyle and cutting production of meat, milk, and wool.

Bruno Morandi/Getty Images

A City that Thrived for Centuries

The heart of the colonial city Saint Louis is located on the island of Ndar, where the River Senegal meets the Atlantic Ocean. The city has expanded eastward to the mainland, where it is surrounded by marshes, and over time it has also encroached on the long narrow sand peninsula, the Langue de Barbarie, to the west.

French traders founded Saint Louis on the uninhabited island of Ndar in 1659. Named after King Louis XIV, it served as the capital of French West Africa for nearly three centuries, making it one of the busiest cities on the continent, exporting slaves, ivory, gold, hides, gum arabic, and later ground nuts to Atlantic merchants.

During this period, a Franco-African community emerged in Saint Louis. Descendants of local women and European merchants became indispensable middlemen in the trade between the middle and upper Senegal regions and the coast. This community constituted an important element in the economic life of the city and from it evolved a refined urban culture.

The vivid life of Saint Louis started to fade when Senegal gained its independence in 1960 and Dakar was made the capital. Saint Louis has struggled to get by ever since. Today, its economy is based on tourism, sugar production, agriculture, and fishing, with many of its people living in poverty.

Saint Louis is extremely exposed to flooding from the river, high tides, and periodic heavy rainfall. Rapid urbanization has forced many poor people to set up homes on long dried-out riverbeds—virtually uninhabitable due to the risk of floods and landslides. Poor infrastructure and inadequate drainage networks are also core problems. With the sea level rising and more intense rainfall events predicted, flooding is expected to occur more frequently, each new flood representing a further nail in the coffin of an ailing city.

Bobby Haas/Getty Images

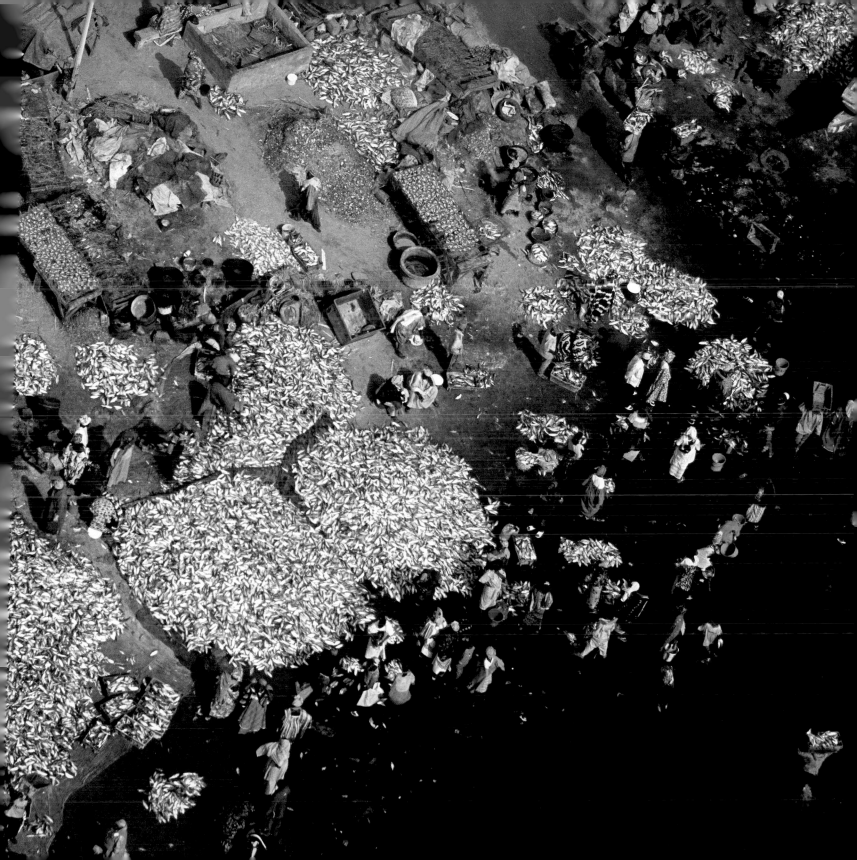

The Oldest and Deepest Lake in the World

Lake Baikal in southern Siberia is the world's deepest lake, and the largest freshwater one by volume. It contains more water than all of North America's Great Lakes combined, equivalent to 20% of the world's surface freshwater. Baikal is also the oldest lake in the world, possibly dating back more than 25 million years.

Very little was known about this immense body of water until the Trans-Siberian railway was built between 1896 and 1902, encircling the lake. Due to its age and isolation, Lake Baikal contains some of the most extraordinary flora and fauna in the world. This is of great value to evolutionary science and has given rise to the lake's nickname, "The Galapagos of Russia." Baikal is home to nearly 2,000 plant and animal species found nowhere else on the planet, including the Baikal freshwater seal, or nerpa.

Lake Baikal was formed as the Earth's crust pulled apart in a gigantic rift valley in the Siberian plateau. The rift is still active and widens by about .75 inch (2 centimeters) a year, continuously expanding the lake.

The lake will not escape the impact of global warming, either. The biodiversity of Lake Baikal is adapted to cold, long winters during which its waters freeze for five months. In the last 60 years, Baikal's waters have warmed by 1.8°F (1°C), and the winters have become shorter. If temperatures rise as they are projected to do, it will have severe consequences for the entire ecosystem, not least the Epischura, which depend on a narrow range of temperatures. Pollution and global warming now threaten to destroy much of the ancient marine life of Lake Baikal.

Sarah Lee-1/Getty Images

A Forest Imbued with Spirits

Boreal forest covers more than a third of Canada, sweeping across the country in a band nearly 620 miles (1,000 kilometers) wide from the Pacific to the Atlantic. Dating back 12 million years, the forest emerged in its most recent incarnation 20,000 years ago, after the last glacial era, when it also became home to the indigenous First Nations people of North America.

Dominated by conifers, and with a diverse mixture of wildlife, the character of the forest has been sustained for 5,000 years. It is a breeding ground for more than 200 bird species and home to mammals such as caribou, lynx, black bear, moose, coyote, timber wolf, wood bison, grizzly bear, and beaver. Broadleaved trees like birch, aspen, rowan, and poplar grow in the southern parts and along the rivers, including in Quebec's Charlevoix Region.

The First Nations people consider themselves an integral part of the forest, deeply linked to the wildlife and spirits that imbue their world.

The word "boreal" derives from Boreas, the Greek god of the cold north wind. Apart from Canada, this type of forest expands around the northern hemisphere in Europe and Asia, just south of the Arctic Circle, making up 25% of the world's canopy forests.

During the next 80 years, the rise in temperature in North America is expected to exceed that for the rest of the world. Climate models show that the Boreal Forest might shrink by 50%, giving way to expanding grassland from the south.

Whooping crane, woodland caribou, and wood bison are currently the most endangered species in the region, but drastic reduction of the forest would affect all of the species that live in this vast ecosystem. It would also have a negative impact on the home of the First Nations people and contribute to the emission of even greater volumes of carbon into the atmosphere.

Jean du Boisberranger/Getty Images

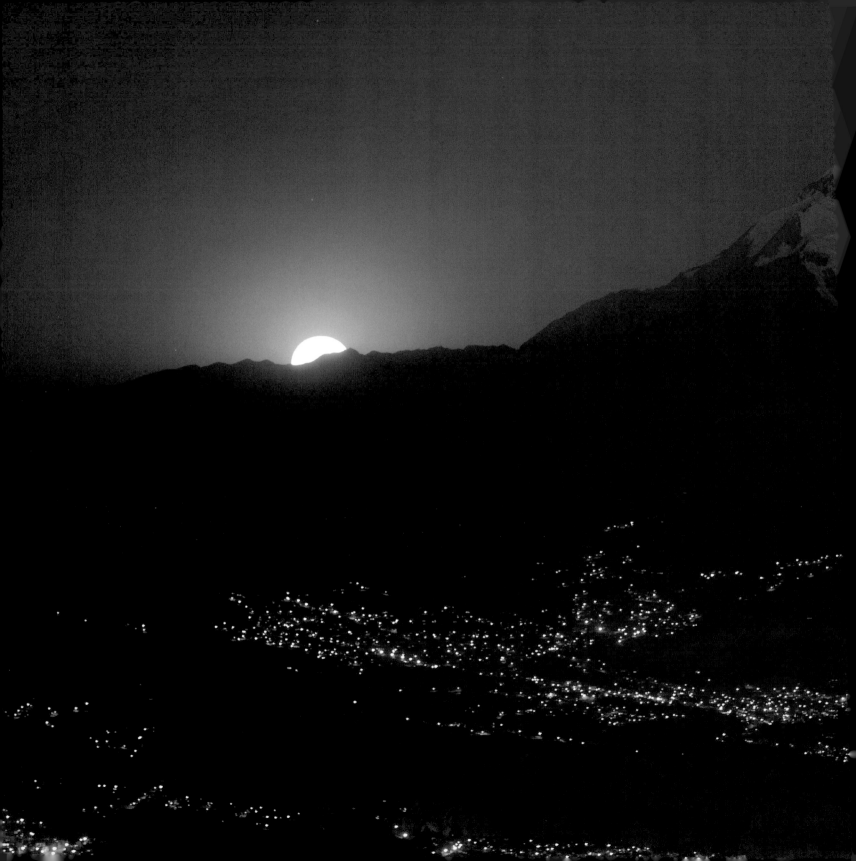

Where the Skiers Meet the Sky

Glowing under the moonlight in the thin air above the Bolivian capital of La Paz, the snow-covered peaks of the Chacaltaya Mountain rise 17,785 feet (5,421 meters) above sea level.

The Chacaltaya glacier is more than 18,000 years old, and its meltwater serves as an important resource for the 1.6 million inhabitants of La Paz and the neighboring town, El Alto.

For decades, the glacier has also been a favorite destination for the capital's middle classes. Since the 1930s, it has been the site of the country's only ski resort and the world's highest lift-served skiing area, from where the famous Lake Titicaca is visible. The snow is too icy for safe skiing during the dry winters, so high season is in the South American summer, from November to March.

Over the last 20 years, the Chacaltaya glacier has lost more than 80% of its volume due to global warming. Although still covered in snow several times a year, these periods are shorter now. As a result, the once famous ski resort has lost much of its appeal, and the old ski lift has ground to a halt.

Chacaltaya is just one of several small-scale glaciers in the tropical Andes mountain range that have shrunk significantly, posing a severe threat to water supplies. Temperatures are expected to continue to rise, so the Chacaltaya glacier may soon disappear completely, taking with it an important part of Bolivian cultural and natural heritage as well as vital reserves of freshwater.

James Balog/Getty Images

California at Its Very Best

Stretching for 90 miles (145 kilometers) along the Californian coast midway between San Francisco and Los Angeles, and extending 20 miles (32 kilometers) inland, Big Sur is one of the most breathtaking landscapes the west coast of the United States has to offer.

Its deep gorges cut through rugged mountain terrain, heavily covered by pine forests that reach almost to the sandy beaches of the Pacific Ocean. Big Sur is a natural wonder offering an astonishing biodiversity that includes many rare and endangered species.

Until Highway 1 was built along the coastline in the late 1930s, Big Sur was an isolated and inaccessible wilderness. It was not until electricity was introduced after World War II that it started to attract a new generation of writers and artists that included Henry Miller, Jack Kerouac, Hunter S. Thompson, and Orson Welles.

Ever since then, Big Sur has enjoyed a reputation as an artisan-bohemian hotspot, and it is the setting for many novels, movies, poems, and songs. Despite this popular status, it remains sparsely populated and has never lost its unspoiled isolation and frontier mystique. Less than 1,000 people live in these remote mountain forests, many of them privately owned or part of state parks.

The coastal area has a mild climate all year round, with dry, sunny summers and autumns, and cool, wet winters.

For the last 20 years, most of California has been experiencing higher temperatures and a decrease in precipitation in spring and summer. This has led to a severe escalation in the number of large, dangerous wildfires, which threaten cities such as Los Angeles. During one major wildfire in 2008, 16 houses in Big Sur were destroyed and more than 13,000 hectares of forest were swallowed by the flames.

A continuing rise in temperatures and prolonged summer heat would make wildfires more frequent and intense, seriously endangering the mountain forests of Big Sur and many other forests in California.

Hiroyuki Matsumoto/Getty Images

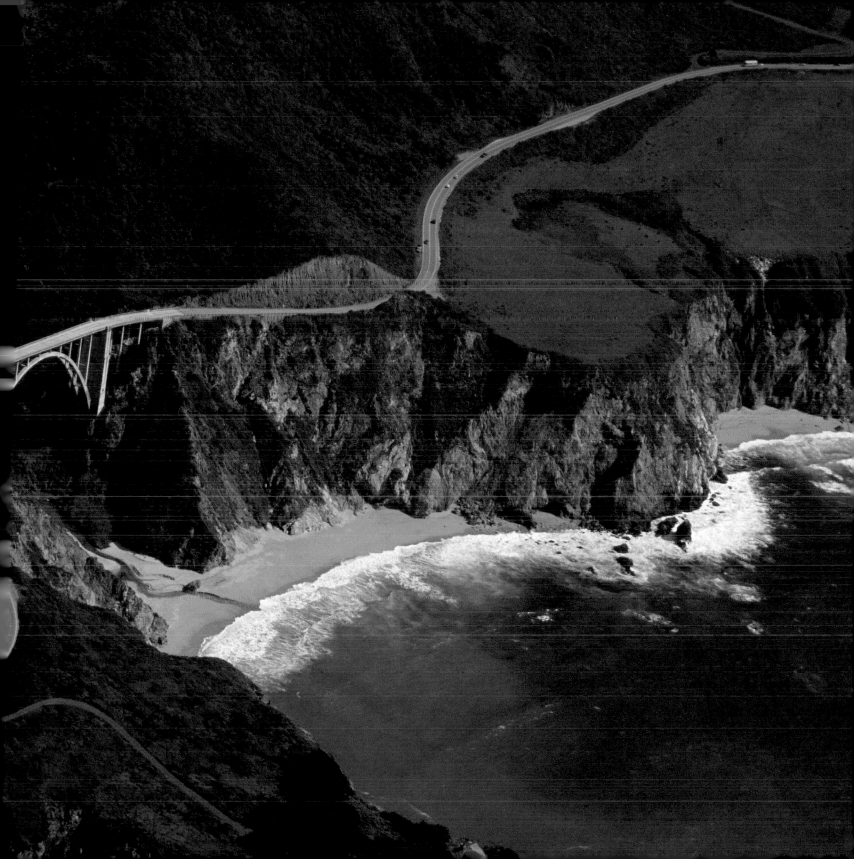

The Precious Glue of Sudan

Sudan, the biggest country in Africa, is also the world's largest single producer of gum arabic. A thick belt of hashab trees (Acacia senegal), from which the gum is extracted, stretches from one end of the country to the other, supporting small-scale farmers and the Sudanese economy as a whole.

Essential to the mummification process in ancient Egypt, and used to preserve paintings since biblical times, gum arabic is still a treasured commodity. It is a natural emulsifier with the same properties as glue, yet edible by humans and highly soluble in water. In soft drinks, it prevents the color from separating and the sugar from precipitating, and it holds the ingredients in medicines together in the same way. In newspapers, multiple layers of gum serve as a protective film that keeps the print consistent and permanent.

Benefiting from major global demand, small-scale farmers tap the amber-colored gum by cutting holes into the bark. The raw sap is then sent to Europe to be processed and sold. In the last decade, however, exports have declined dramatically, partly due to the ongoing humanitarian crisis in Darfur, which has damaged Sudan's reputation and had a negative impact on all exports.

Global climate change has also contributed to the decline in exports. During the last 50 years, lower-than-average rainfall, drought, and rising temperatures have had a negative impact on the forests, affecting gum production and the lives of millions of Sudanese people.

As well as being a vital source of income, the hashab trees improve the fertility of the soil and reduce wind erosion. With temperatures projected to rise and rainfall trends unclear, the prospects for the gum arabic forests are uncertain. Any further loss of forest and income would threaten livelihoods and escalate already existing conflicts in the region.

Randy Olson/Getty Images

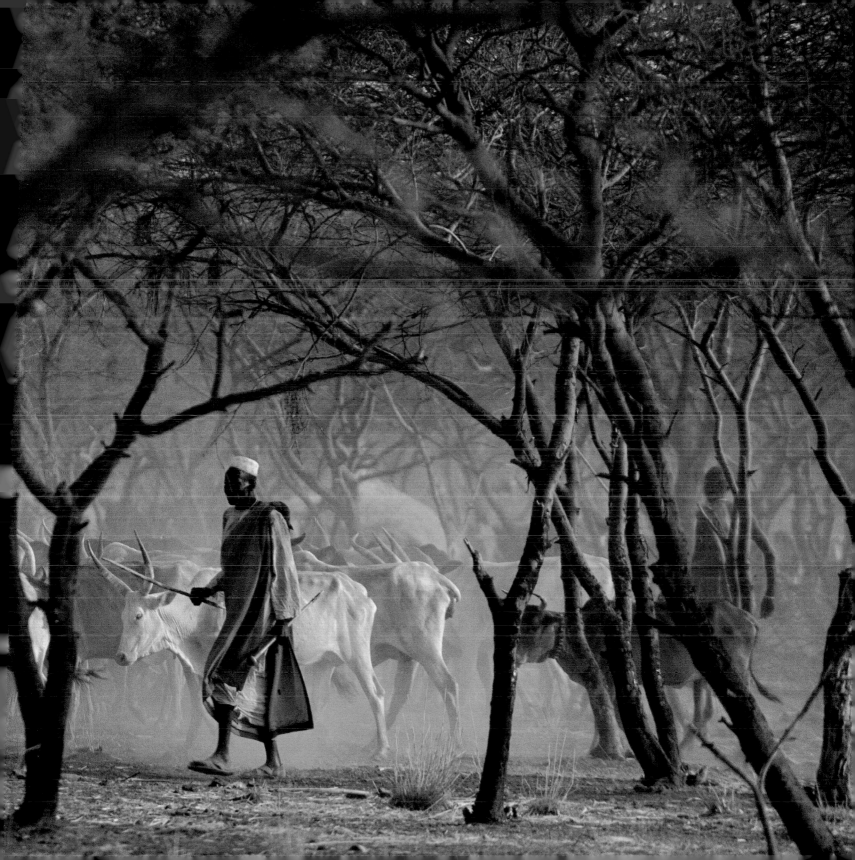

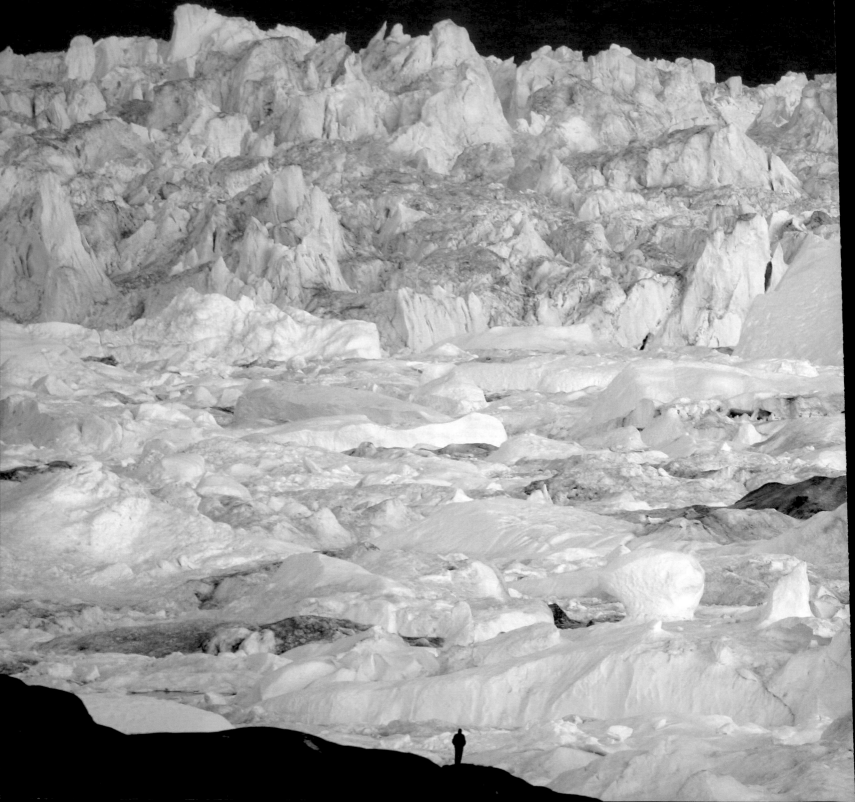

A Highway of Glistening Icebergs

It is said that you can tell what will happen on the rest of the planet by observing the Arctic.

The Ilulissat Icefjord is a massive wall of icebergs that have broken off from the Jakobshavn (or Sermeq Kujalleq) glacier. They stretch 37 miles (60 kilometers) from the town of Ilulissat to the ice cap of Greenland. It is one of the most beautiful and impressive places in the world, but the tongue of the glacier has retreated by 4 miles (7 kilometers) since 1992.

The glacier forms part of Greenland's inland ice, which covers more than 80% of the island and is 2 miles (3 kilometers) deep at its thickest point. This is one of the fastest-warming places on Earth. The latest research shows that in 2007, warm air temperatures and ocean currents led to 314,000 cubic yards (240 cubic kilometers) of ice melting into the sea—that is 97% more than the average melt-off between 1995 and 2006.

As the climate changes drastically, so, too, do people's lives. As the sea ice is no longer permanent at the Ilulissat Icefjord, local people can no longer use their sled dogs to hunt seal. Their homes are threatened by storms and their traditional travel routes are becoming hazardous. The polar bear has moved farther north, and the narwhal is less abundant.

With the sea-ice melting and snow cover diminishing, rays from the sun are absorbed into the sea and earth instead of being reflected back into the atmosphere. This exacerbates global warming, causing the ice to melt faster. It is as if the world is wrapped in a self-heating electric blanket.

The melting of the inland ice contributes to the rise of sea levels, causing saltwater intrusion and flooding of coastal areas around the world. Were the whole of the Greenland ice to melt, the oceans would rise by 23.7 feet (7.2 meters).

LIKE MOST GREENLANDERS, the 5,000 inhabitants of Ilulissat have been hunters and fishermen for generations. Parents teach their children how to use traditional hunting tools and methods. It is a major event when a child captures his first seal or reindeer, and a *kaffemik*, or traditional social gathering, is held to mark the occasion.

Most of the population of Ilulissat make their living from shrimp and halibut fishing and tourism. Greenlanders are entitled to do a limited amount of whaling, so the hunting of

porpoise and Beluga whales continues to offer a significant source of income for some. Due to the sea-ice melting, dog sleds—once an essential element in hunting and ice fishing—are now often used for taking tourists on rides across the inland ice.

Søren Rud

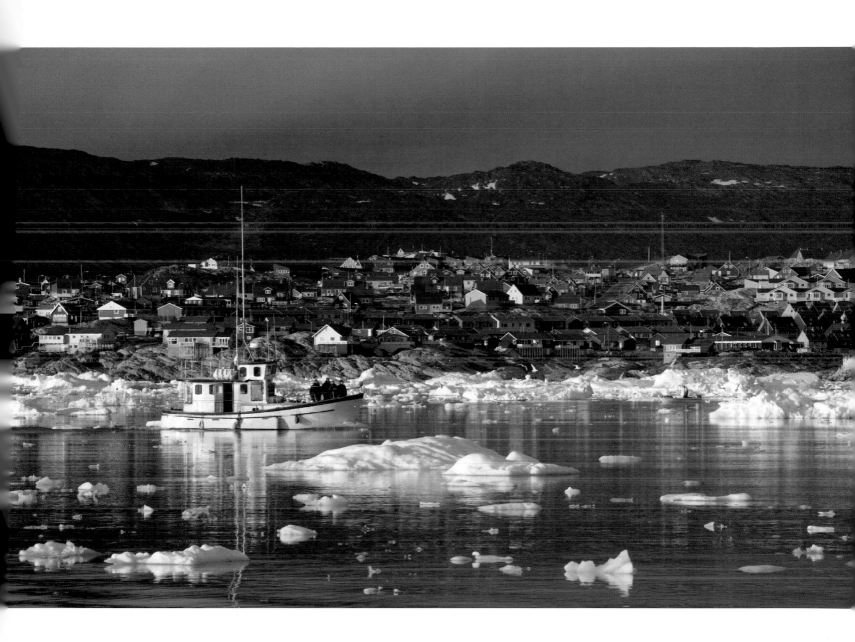

Come and See Whales in the Wild

Vava'u is a chain of islands that makes up the northern part of the Kingdom of Tonga in the South Pacific Ocean. It has one large island and about 50 smaller ones, many of them tiny, uninhabited coral islets with beautiful beaches of soft white sand.

While the rest of Tonga depends mainly on agriculture and income from Tongans living abroad, tourism is the greatest asset of the sparsely populated Vava'u islands. Vava'u has become a major player in the South Pacific tourism market, attracting large numbers of charter yachts to more than 40 remote anchorages off uninhabited islands protected by coral reefs.

This is the best place on Earth to see whales in the wild, and offers some of the world's best big game fishing. Its untouched tropical islands are ideal for diving, swimming and snorkeling.

Though Vava'u has been spared most of the storms and hurricanes that have damaged many other Pacific islands, global climate change may take its toll in the future, especially on Vava'u's small coral islands.

With sea levels and sea surface temperatures projected to rise, these islands could see an acceleration in coral bleaching, leading to a slow extinction of the coral reefs and the plentiful marine life that depends on them.

Another serious threat to the coral is the increasing acidity of the ocean, caused by growing emissions of CO_2. When seawater absorbs CO_2, its pH level decreases and its acidity increases. This is extremely dangerous for the world's coral reefs, all of which could reach a critical state by 2070, further eroding the reefs off Vava'u and threatening their ability to protect the islands' coastal areas.

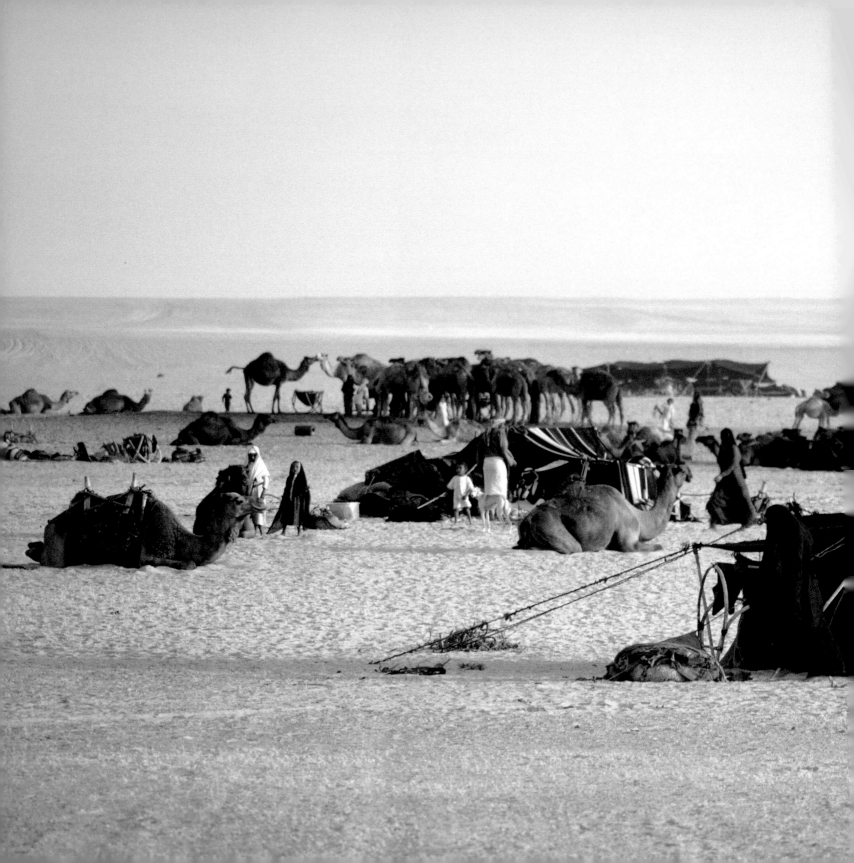

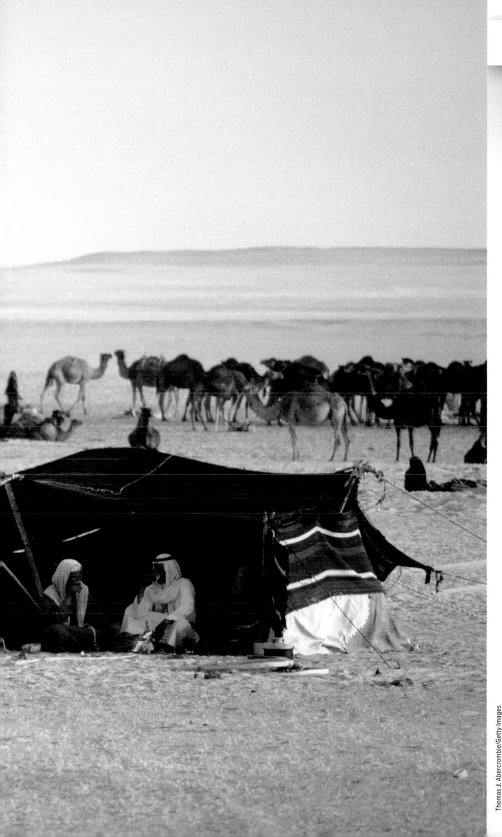

The Wind Creates Mars on Earth

Almost the size of Texas, the Empty Quarter is the largest uninterrupted sand sea in the world. Covering 251,000 square miles (650,000 square kilometers), it is one of the most extreme environments on the planet. Most of the desert is in Saudi Arabia, the rest in Yemen, Oman, and the United Arab Emirates.

For centuries, proud Bedouin communities have been the only people with the skills to survive in this vast wilderness. While some Bedouin have settled in towns, others continue a traditional nomadic life in tents, feeding on milk and meat from their stock of sheep, goats, and dromedaries and using their dromedaries for transport.

There is no permanent human habitation in the Empty Quarter, and few people have ever crossed the desert. In summer, temperatures can soar to above 120°F (50°C), making it one of the hottest and driest places on the planet. Over time, wind patterns have shaped the sand dunes, which reach heights of 1,000 feet (300 meters), creating a surreal landscape that resembles Mars on Earth.

Even in this harsh climate, life flourishes. The vegetation—mainly consisting of scattered herbs, shrubs, and weeds—feed the Bedouin's livestock. Recent scientific expeditions have discovered 31 new plant species and varieties and 24 species of bird, leading the scientists to nickname the Empty Quarter "The Valuable Quarter."

The sensitive ecosystem of the Arabian Desert is particularly vulnerable to climate change. Even a small rise in temperature will increase evaporation, reducing the surface moisture and putting even greater stress on water resources. By the end of this century, average annual temperatures are projected to increase by 7–9°F (4–5°C), which could wipe out the already scarce vegetation and endanger the remaining Bedouin societies.

A High-Cost Shortcut

After a previous unsuccessful attempt to construct a shortcut between the Atlantic and Pacific oceans, the United States succeeded in building a canal through Panama in the early 1900s. A total of 27,500 workers paid for it with their lives, dying in landslides and of diseases like malaria and yellow fever during one of the biggest and most difficult engineering projects in history.

The Panama Canal opened in 1914, revolutionizing shipping traffic by providing an alternative to the long, exhausting journey around Cape Horn at the southern tip of South America. The new waterway between the two oceans reduced the journey from New York to San Francisco from 14,000 to 5,900 miles (22,500 to 9,500 kilometers). Today, about 4% of all world trade passes through the canal, making shipping the most important industry in Panama.

The canal does not feed on ocean water but on freshwater, which pours in from 17 artificial, interconnected lakes. As the water flows into a series of locks, the ships are gradually raised almost 85 feet (26 meters) above sea level, meaning that the Panama Canal consumes three times more water in a day than the city of Los Angeles.

Shipping companies are deploying larger and larger ships nowadays, so a $5 billion expansion of the canal is scheduled for completion by 2014, the centenary of its opening. The expansion will require even more water. Water shortages have already forced Panama to close the canal on several occasions in recent years, and because the feeder lakes are dependent on rainfall, not enough may be available.

Increasingly frequent El Niño events, believed to be generated by global warming, may further reduce water resources in the future by changing rain patterns and causing extensive droughts. This will disrupt shipping traffic all over the world and have a huge impact on the economy and people of Panama.

Bruce Dale/Getty Images

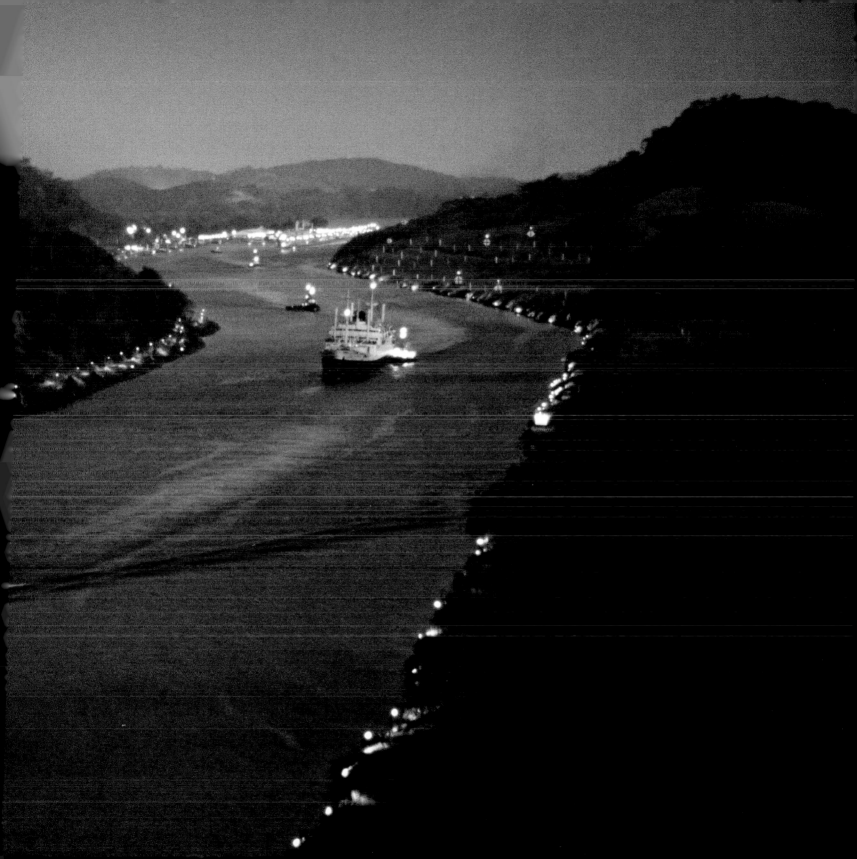

A Delicate Delta Home to 25 Million People

The Niger Delta stretches for 7,720 square miles (20,000 square kilometers) along Nigeria's southern Atlantic Coast. The second-largest delta in the world, it is home to around 25 million people, with rivers, creeks, estuaries, wetlands, and thousands of villages scattered throughout the largest mangrove swamp in Africa.

The delta's ecosystem has one of the highest concentrations of biodiversity on the planet, including numerous species of terrestrial and aquatic fauna and flora. It is also home to the widest range of butterfly species anywhere in the world.

Not far from its main city, Port Harcourt, the delta also holds some of the world's richest oil reserves, making Nigeria the world's seventh-largest oil producer. Extensive oil production has caused widespread pollution in parts of the delta.

Most of the laborers in the oilfields are migrant workers. The local people make their living from agriculture and fishing. They are some of the lowest-paid people in Nigeria, most of them living below the poverty line. To add to this, rivalries between a number of warlords and different ethnic groups frequently lead to outbreaks of violence.

Projected climate changes, including rising sea levels and extreme weather events, could lead to significantly increased flooding of the delta. The resulting intrusion of seawater into the sources of freshwater would threaten the whole ecosystem, destroying the mangroves and seriously affecting agriculture, fisheries, infrastructure, and the livelihood of the local communities.

To compound matters, the people of the region would become increasingly vulnerable to water-borne diseases such as malaria, dysentery, and cholera.

By the end of this century, large parts of the delta may have been destroyed, forcing millions of people, deprived of a basic income, to abandon their homes and relocate.

Jacob Silberberg/Getty Images

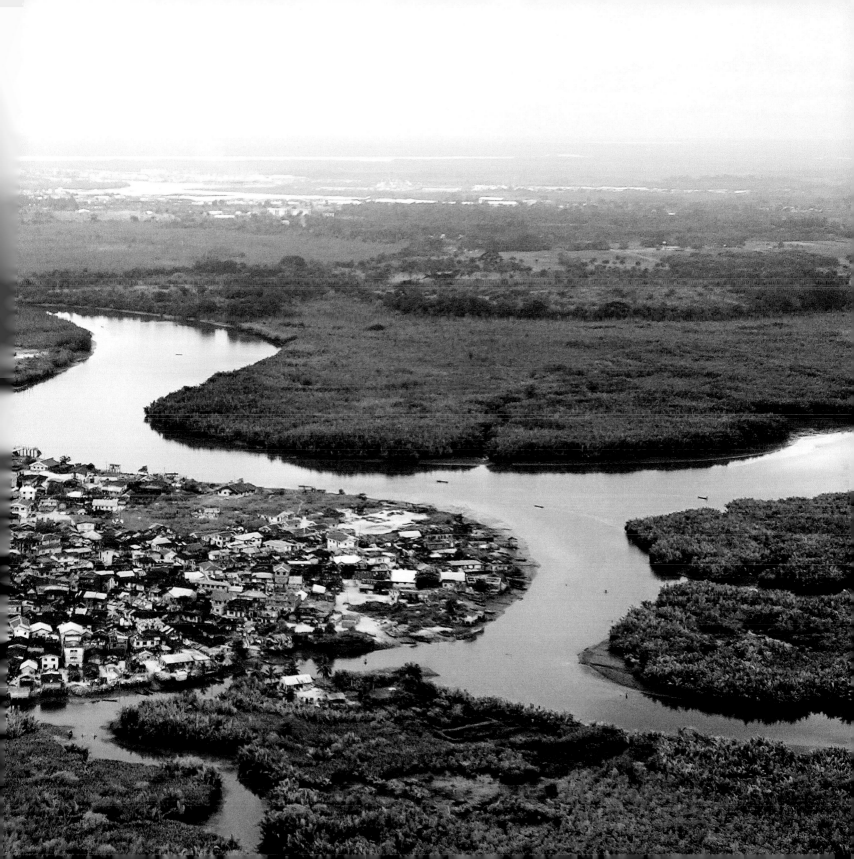

The Shallow Waters of the "Hungarian Sea"

Popularly called "The Hungarian Sea," Lake Balaton is the largest lake in central Europe. Famous for its shallow waters, this natural treasure stretches 48 miles (77 kilometers) between the low volcanic hills of western Hungary. Its average depth is just 10 feet (3 meters), and its name derives from the Slavic balaton, meaning "muddy lake."

Two thousand years ago, the Romans named it Lacus Pelso, or "shallow lake." It was the Romans who first produced wine in Hungary, establishing vineyards on the volcanic hillsides where the grapes receive twice the amount of sunlight thanks to the reflection of the sun's rays on the lake.

Since the downfall of the communist regimes in Eastern Europe 20 years ago, Lake Balaton has been a popular holiday resort for millions of tourists from all over Europe, giving the local economy a tremendous boost.

Rainfall decreased and temperatures rose substantially for four successive summers from 2000 to 2003. The famous lake began to shrink and the water level dropped even further than usual. Large muddy banks began to appear 100 yards (meters) offshore.

In summer 2003, temperatures were 7°F (4°C) above average. Scientists believe this is an early warning of climate change, indicating the sort of effects we can expect global warming to have later this century.

With summer precipitation projected to decrease by 30–70% in Central Europe, and temperatures expected to be substantially higher, the region around Lake Balaton could experience a 50% increase in heat waves and drought by the end of the century. This would dry up much of the lake and threaten the historic vineyards.

Mike Goldwater/Getty Images

A Blue Haze of Eucalyptus Vapor

This rugged sandstone plateau, with its steep mountainsides, deep gorges, and inaccessible valleys, rivers and lakes, takes its name from the blue haze that emanates from its eucalyptus forest.

Covering 3,860 square miles (10,000 square kilometers) west of Sydney, the Greater Blue Mountains are home to more than 100 eucalyptus genera, many of which are believed to be "evolutionary relict species" that have survived for almost 200 million years.

The blue haze is caused by vapor from highly flammable eucalyptus oil released into the atmosphere by the leaves in response to heat.

It has been this way for millions of years, and occasional wildfires caused by the heat and vapor are part of the ecosystem. Many of the eucalyptus and other native floral species are so adapted to fire that they only release their seeds to allow new plants to grow after fires.

This is a very delicately balanced system, and the projected rise in average annual temperature and decrease in rainfall due to climate change could lead to an increased risk of more frequent, intense and destructive wildfires within the next 20–60 years.

If the fires become too frequent, they could kill the plants before they have matured sufficiently to produce new seeds. This would lead to a significant decline in the diversity of eucalyptus species and other flora, and alter the fragile ecosystem of the Greater Blue Mountain area.

Adam Gault/Getty Images

Water, Not Oil, Is the World's Most Important Natural Resource

More than three million people—roughly half of Jordan's population—crowd into the capital, Amman. The city is ideally located on a series of hills between the desert and the fertile Jordan Valley below, where the Jordan River runs, supplying the city with drinking water.

The population of Amman has grown rapidly in recent decades. New buildings and districts have mushroomed, partly due to an influx of refugees from the disputed Palestinian territories and Iraq, partly due to inward migration from rural areas.

Although Jordan is one of the ten most arid nations in the world and 80% of it consists of desert, agriculture is the primary source of employment in the poorest rural areas, where vegetables, wheat, and barley are grown on small farms, usually run by families.

The Jordan River, which flows into the Dead Sea, is the only river system in the country and a vitally important resource. The expanding city needs drinking water. Farmers need to irrigate their crops. Water rights also fuel disputes between Jordan and Israel on opposite sides of the river, and with the Palestinians on the West Bank.

The substantial decrease in the flow of the Jordan River in recent decades, due to a combination of human exploitation and climate change, partly explains why the water level of the Dead Sea is plummeting by 3 feet (1 meter) a year. The soil in the Jordan Valley is becoming less fertile, forcing farmers to migrate to the city and turning farmland into desert. With temperatures projected to rise and precipitation to fall, water shortages will continue to fuel tension in the region, encourage migration to Amman and put further pressure on the city's water supply.

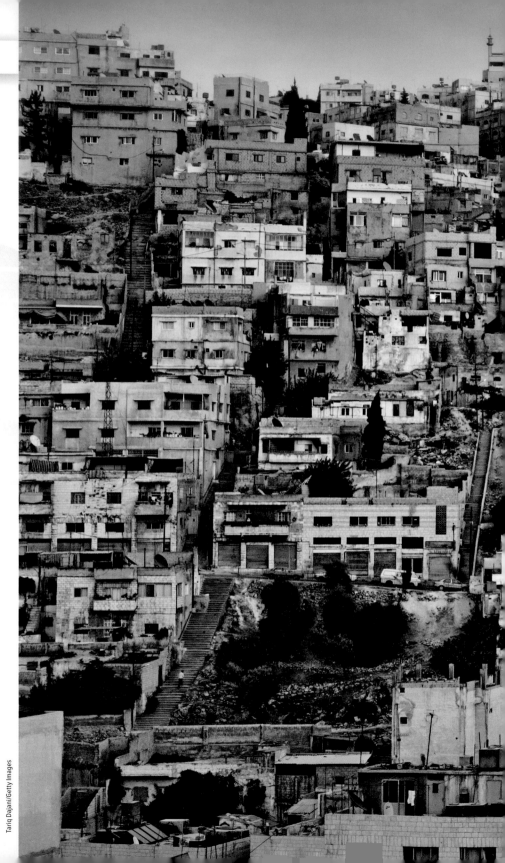

Tariq Dajani/Getty Images

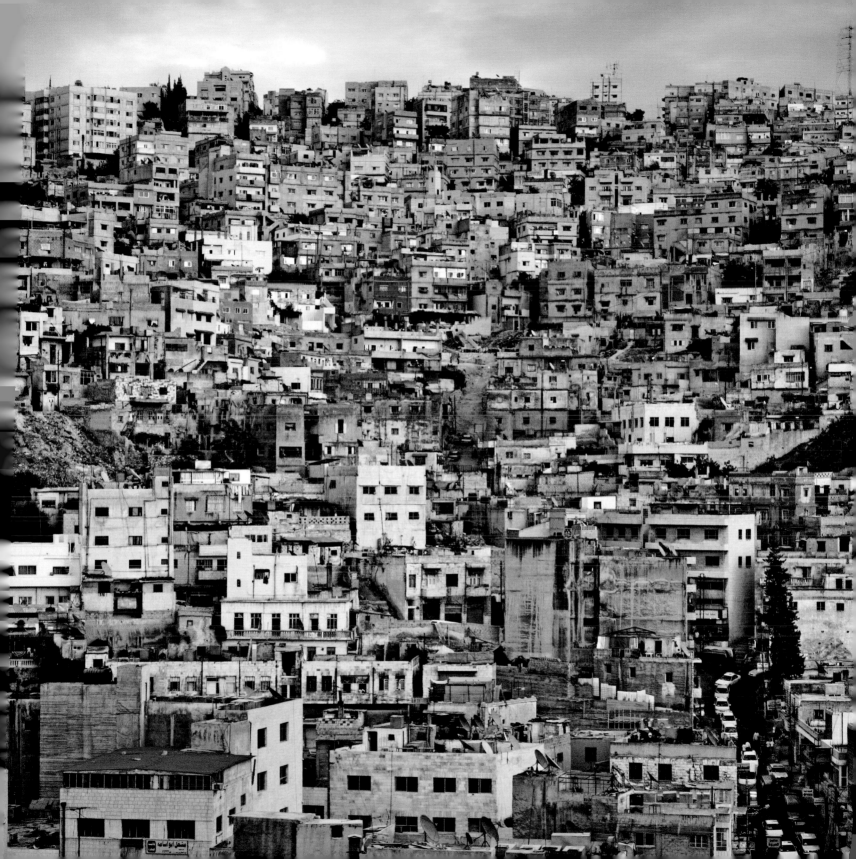

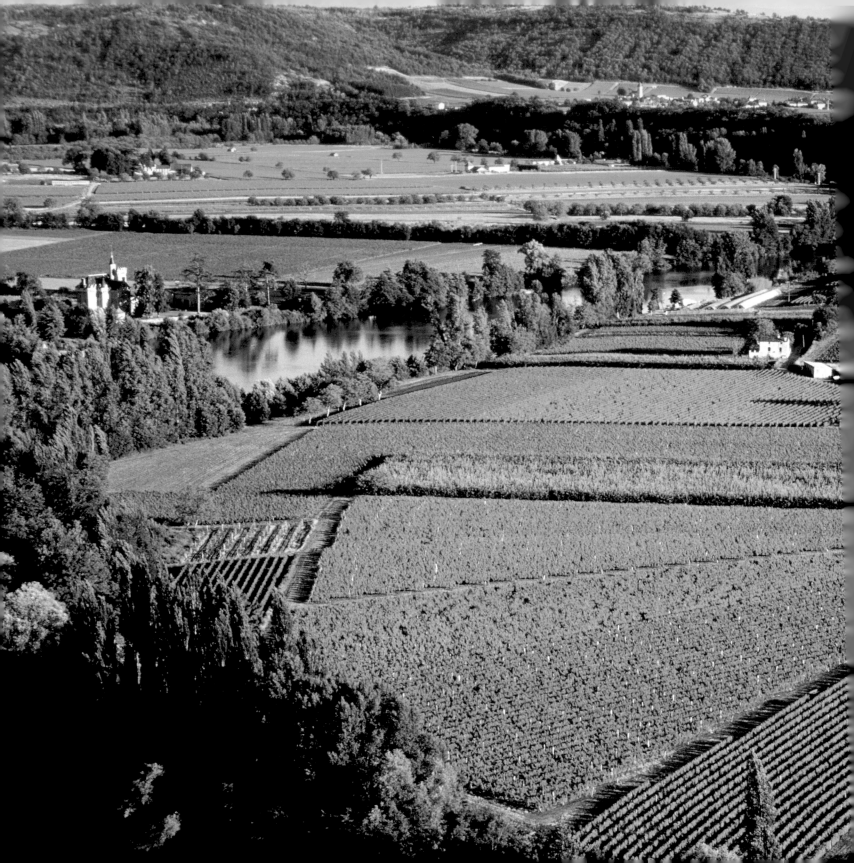

The Wine of Popes and Royalty

Winemaking along the River Lot near the town of Cahors in the south of France dates back to the Roman Empire. The first vines were planted here in about 50 BC, and the area has been known for its red wine ever since.

During the Middle Ages, Cahors wine was known as "the black wine of Lot." King Henry II of England drank it at his wedding in 1152 and when Pope John XXII, a shoemaker's son from Cahors, was enthroned in 1316 he used Cahors as both table wine and sacramental wine. Nearly 500 years later, it was the favorite wine of Emperor Peter the Great of Russia. Shortly afterwords, the Russian Orthodox Church adopted Cahors as its sacramental wine.

In recent times, Cahors has been overshadowed by the red wine of Bordeaux, but in 1971 it was awarded the important and prestigious Appellation d'Origine Contrôllée, or AOC, and has again become both appreciated and popular.

Today, the Cahors grape fields cover 4,200 hectares, which are shared by several wine producers. One of these is French-born Henrik, Prince Consort of Denmark, husband of the Queen of Denmark, Margrethe II, and owner of the Château de Cayx vineyard, 12 miles (20 kilometers) west of the town of Cahors.

In France, different types of grape are confined to certain areas, which makes each wine special and determines its AOC certification. The grapes are extremely sensitive to climate change, and a rise in temperature exceeding 2–4°F (1–2°C) could force production to move to cooler areas.

Summer temperatures are projected to rise by more than 11°F (6°C) in the south of France by 2070–2099, which could put an end to traditional wine production in Cahors and many other parts of the country.

Living on the Sea's Terms

The inhabitants of the ten small Halligen Islands off the north coast of Germany spent centuries adapting to the moods of the sea around them. The low-lying islands, which have been shaped by the rising tides of the North Sea, still retain their harsh, unspoiled nature.

The name Halligen comes from the Celtic word *Hal*, which means "salt." It refers to the occasional flooding of the islands when salty seawater penetrates far inland. This phenomenon has created a distinctive ecosystem, with fertile salty meadows where sea lavender blossoms in summer, and plants and animals that depend on the influx of saltwater.

The islanders' ancestors constructed mounds several yards high called *warften* and then built their dwellings and other buildings on top of the warften to protect them from storm tides. Sheep graze on the surrounding meadows, their hooves helping the ground that serves as the foundation for the warften to remain compact and solid.

When flooding occurs and parts of the islands are *Land unter* (flooded), the islanders flee to the warften with their livestock and wait for the sea to retreat.

Global warming is expected to raise sea levels, which would flood the Halligen Islands more frequently and make it difficult to farm there. Erosion caused by heavy storms and high tides would destabilize the foundations of the warften, putting the unique island habitat at risk.

The Halligen Islands are known as "the atolls of the north." Like the low-lying coral islands and atolls of the Pacific Ocean, they are at the mercy of the sea and are in danger of disappearing as sea levels rise.

Karl Johaentges/Getty Images

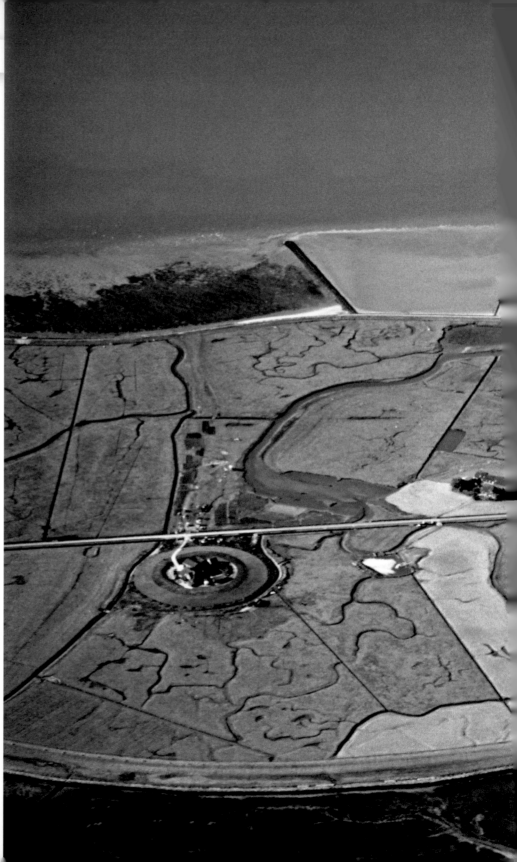

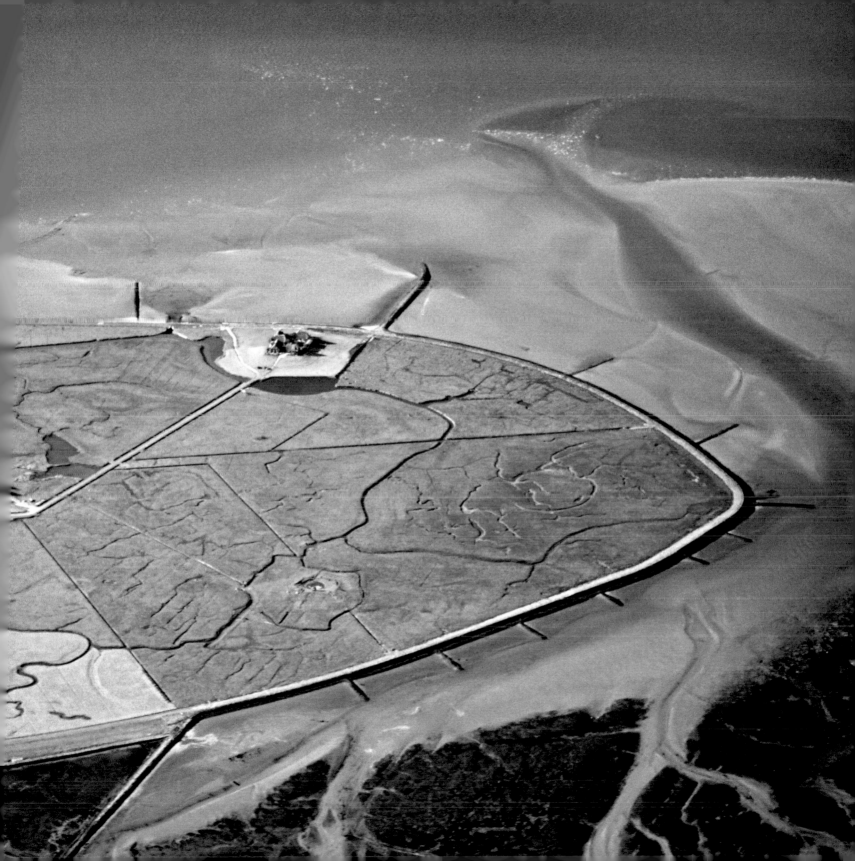

Dwindling Ice at the Top of the Andes

The Quelccaya Ice Cap is an awe-inspiring sight, with its massive ice fields and blue-white glaciers. Spanning 17 square miles (44 square kilometers) in the Cordillera Oriental Mountain Range in southern Peru, it is the largest body of ice in the tropics.

The ice has claimed these Andean peaks and fed the streams and rivers below for thousands of years. The vast quantities of ice have provided scientists with data about precipitation and temperatures going back 1,500 years, enabling them to calculate annual snowfall since the time of the early Andean civilizations.

Glacial runoff from the Quelccaya Ice Cap is vital for much of the Peruvian population. Farmers use it for irrigation and dams, and hydroelectricity plants supply drinking water and power to major cities such as Cuzco and Lima.

An estimated two million people out of the capital's population of almost nine million have no access to free and freshwater. They are forced to pay high prices for it and will be the first to feel the effects of shortages.

The Quelccaya Ice Cap is no longer an inexhaustible resource. Since 1978, it has lost 20% of its area, and the rate of the decrease is accelerating. The once steady flow of water is now intermittent, and within 30–50 years the Quelccaya Ice Cap is expected to have disappeared as a consequence of global warming, leaving millions of Peruvians without a reliable source of water and the Andean peaks without cover.

Bobby Haas/Getty Images

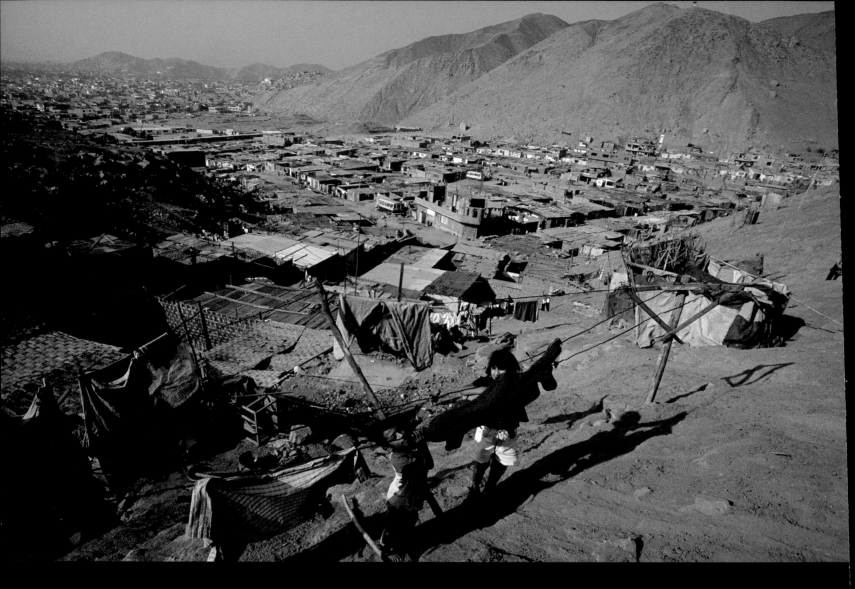

LIMA, 9 MILES (15 KILOMETERS) FROM THE PACIFIC COAST, is the second-largest desert city in the world after Cairo in Egypt. On the outskirts of Lima, shantytowns stretch far along the plains, eventually climbing the barren mountainsides. Many impoverished inhabitants of the mountain regions, mainly indigenous Aymara and Quechua people, move to the coastal cities in search of better lives.

When a shantytown house is first built, it is fashioned from bamboo mats, which are eventually replaced by wood and corrugated iron. Depending on the fortunes of the family, the wooden house may one day be converted into bricks and mortar.

Ira Block/Getty Images

The Amazing Full Circle of Life

Forming much of the border between the states of Oregon and Washington, the Columbia River is the largest river flowing into the Pacific Ocean from North America in terms of volume.

For more than 15,000 years, Native American groups have occupied the territories along the Columbia River and its tributaries, their livelihood based mainly on fishing from the bountiful river. Today, the river is fished more intensely, and sustains large commercial fishing activities as well as subsistence fishing.

The river is home to several species of salmon, which are typically anadromous. Born in the freshwater of the Columbia River, the salmon migrate to the Pacific Ocean before, at the end of their life cycle, swimming hundreds of miles upstream against strong currents to return to the river system and spawn. Pacific salmon only make this amazing journey upriver once, and die shortly after spawning.

The heavy flow of the Columbia River—the average flow at its mouth moves at around 265,000 cubic feet (7,500 cubic meters) per second—combined with its large drop in elevation endow the river with enormous potential for electricity generation. However, the construction of a large number of dams in the Columbia River system is preventing salmon from reaching their spawning grounds. The dams also slow the current, so young salmon now take several months to make their journey downstream to the ocean, rather than two to three weeks.

The salmon stock in the Columbia River system has declined significantly in recent decades. Global warming will exacerbate the situation. Higher water temperatures will accelerate the development of salmon eggs, leading to a smaller average size of juvenile fish, making them an easy target for predators and lowering the overall survival rate. By 2090, the habitat suitable for the salmon is expected to decrease by more than 40% in Oregon and Idaho.

Cotton Coulson/Getty Images

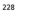

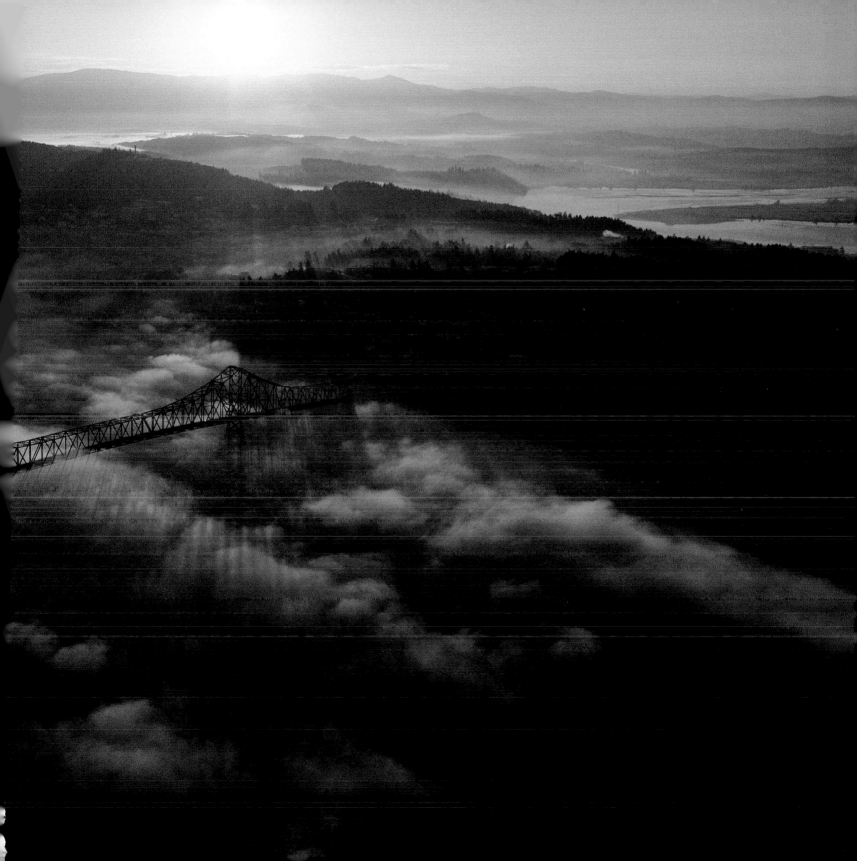

One of the Oldest Species on Earth

Sea turtles have been around for tens of millions of years. The males spend their entire lives in the ocean. The females venture onto beaches for a few hours once or twice every second year, lay their eggs in holes 15–20 inches (40–50 centimeters) deep and cover them with sand before promptly returning to the sea.

Despite living in most of the tropical and subtropical waters around the world, several types of sea turtle are registered as endangered species. Four of these—one of them the hawksbill turtle—live in the Caribbean, where they feed and mate among the corals and nestle on the sandy beaches around the rim of the sea, from Barbados in the east to Mexico in the west, from Florida in the north to Colombia in the south.

At about 1 yard (meter) long and weighing up to 265 pounds (120 kilograms), the hawksbill is one of the smaller sea turtles. Considered a delicacy, it has been hunted for centuries. Now, global warming poses a new threat to its survival.

Rising sea levels and temperatures, acidification of the oceans, and more extreme weather events could start to destroy the coral reefs where the turtles live, forage, and mate, and erode the beaches where the females nest. This would pose a serious threat to them. Although capable of migrating for thousands of miles and taking up to 30 years to mature, sea turtles always return to the beach where they were born to mate and nest.

Higher sand temperature presents another threat. The turtles have no sex chromosomes, so the ambient temperature of the sand determines whether hatchlings are born male or female. The hotter the sand, the shorter the incubation and the more likely the hatchling will be female. In other words, hotter sand might result in a drastic decline in the number of male turtles, which would pose a severe threat to the survival of one of the oldest living animal species on the planet.

A European Winter Playground

Every winter, from December to April, tens of millions of tourists make the pilgrimage to the Alps, the largest mountain range in Europe, to ski, snowboard, breathe clean mountain air, and enjoy the spectacular sight of snow-covered Alpine summits.

Any Austrian who lacks skiing ambitions is not considered to be a true Austrian. Two-thirds of the country consists of mountains and, with 13,600-mile (22,000-kilometer) pistes, 10,000 miles (16,000 kilometers) of cross-country skiing tracks, and a countless supply of cottages, skiing is an essential part of Austrian culture. Innsbruck, the venue for the Olympic Winter Games in 1964 and 1976, is known as the snowboarding capital of Europe.

Skiing tourism dates back 140 years and has become an important part of the Austrian economy, accounting for 4% of GNP.

Due to the low altitudinal range of its skiing regions, Austria is extremely vulnerable to any rise in temperature. The Alpine glaciers have been retreating for the past century but lately the melting has escalated dramatically, with glaciers losing 20% of their size since the 1980s. The four warmest recorded years of the last 500 were 1994, 2000, 2002, and 2003.

Less snow, if any, is falling on low-lying slopes, and higher up in the mountains the permafrost is melting. Warm weather is destabilizing what used to be reliable skiing areas, causing avalanches and rock falls that endanger roads, traffic, settlements and people.

To prevent the ice from melting and to protect the tourism industry, ski resorts across the Alps now cover glaciers with enormous white blankets during the summer. Blankets are a short-term solution, however, and cannot halt global warming in the long term. If temperatures rise 5°F (3°C) by the end of the century, the Alpine glaciers will shrink by 80%, leaving ski resorts abandoned.

Don Fuchs/Getty Images

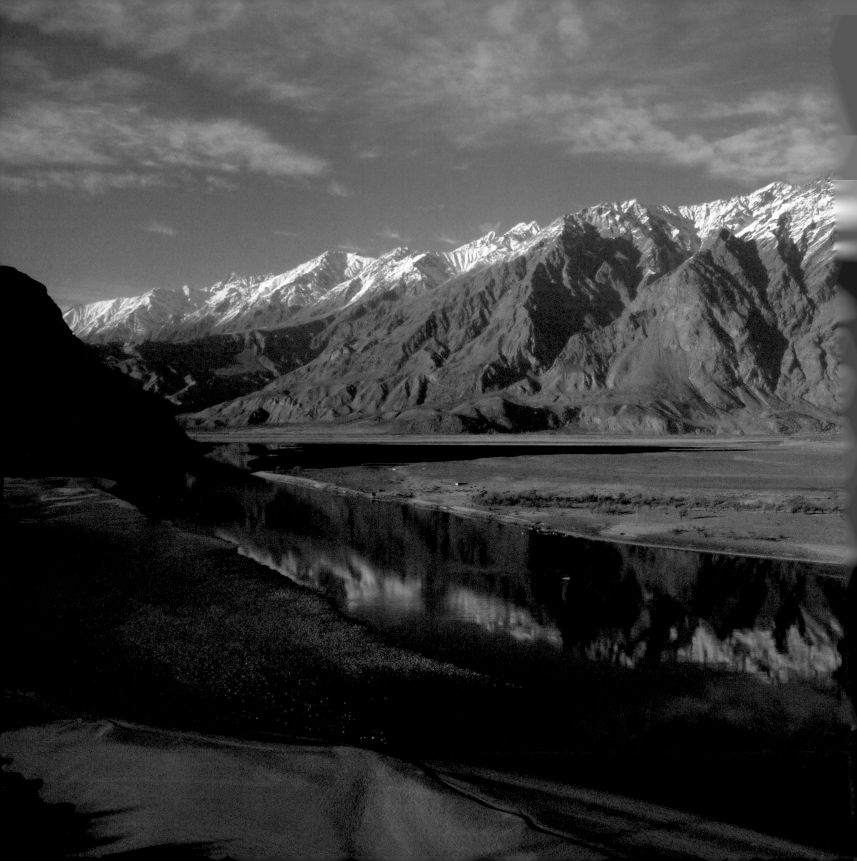

Pakistan's Lifeline

The Indus is a river of many names. In Tibet, it is known as the Lion River; between the Himalaya and Karakoram ranges, it flows from the direction of the rising sun and people call it the Eastern River; in Pashto the name is Abasin— Father of Rivers.

The source of the Indus River is the Tibetan plateau. Fed by glaciers on the mountains of Himalaya, Karakoram, and Hindu Kush, the river runs 1,860 miles (3,000 kilometers) through hills and gigantic gorges before it reaches the flat plains of the Indus Valley in Pakistan and flows into the Arabian Sea.

The Indus serves as a lifeline for the people of Pakistan. As it winds its way through the country, it nourishes temperate forests, plains, and countryside. As the only major river system in one of the world's most arid countries, it supplies water for irrigation in rural areas as well as for use in towns and cities.

For years, Pakistan has used the river as part of the biggest irrigation system in the world, turning 35.7 million acres (144,500 square kilometers) of desert plain into cultivated farmland that accounts for two-thirds of the nation's jobs and 80% of its exports.

Climate change, and the melting of the Tibetan glaciers, could turn the Indus into a seasonal river. Pakistan already suffers from water shortages but melting glaciers and a more irregular precipitation pattern could disrupt water supplies throughout the region.

In the absence of any other source of water, this would have a devastating effect on the Pakistani people. Eventually, the lack of water may lead to mass migration and imperil the very foundations of the national economy.

The Golden Gateway between East and West

If you haven't traveled up the mighty Yangtze, you haven't been anywhere.
—Chinese saying

The Yangtze River snakes its way from the Tibetan plateau through several of China's provinces before it flows into the East China Sea. Stretching for 3,900 miles (6,300 kilometers), it is the longest river in Asia, and is surpassed only by the Amazon in South America and the Nile in northeast Africa.

The winding Yangtze River has created some of China's most impressive landscapes. The deep valleys, hills densely covered in greenery, and steep walls slicing into the muddy water of the Yangtze are a compelling sight. The famous Three Gorges are particularly renowned for their dramatic beauty.

In the middle and lower regions of the Yangtze, where the climate is warm and humid, the earliest cultivation of rice on Earth began some 8,000 years ago. Today, the agricultural areas of the Yangtze generate almost half the total crop production in China—in total, China accounts for about a third of the world's rice production.

Roughly 500 million people depend on the Yangtze for freshwater, and the river sustains cities like Shanghai and Nanjing. Known as the "Golden Gateway" linking eastern and western China, the Yangtze has served as a transportation highway for millennia.

Due to the diminishing of the Tibetan glaciers, the flow of the once mighty Yangtze River will dwindle during the dry season in the future. By the end of the 21st century, the glaciers that feed the Yangtze will have decreased by more than 60%. This will reduce the availability of freshwater in large parts of China all year round, with immense human, ecological, and economic costs. Rice yields are expected to drop considerably, not only affecting the Chinese people but also making serious inroads into the world's food supply.

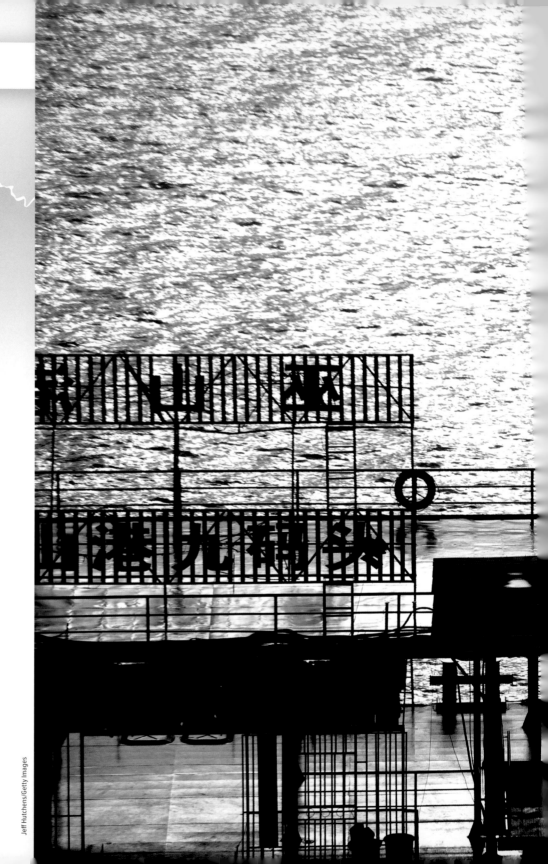

Jeff Hutchens/Getty Images

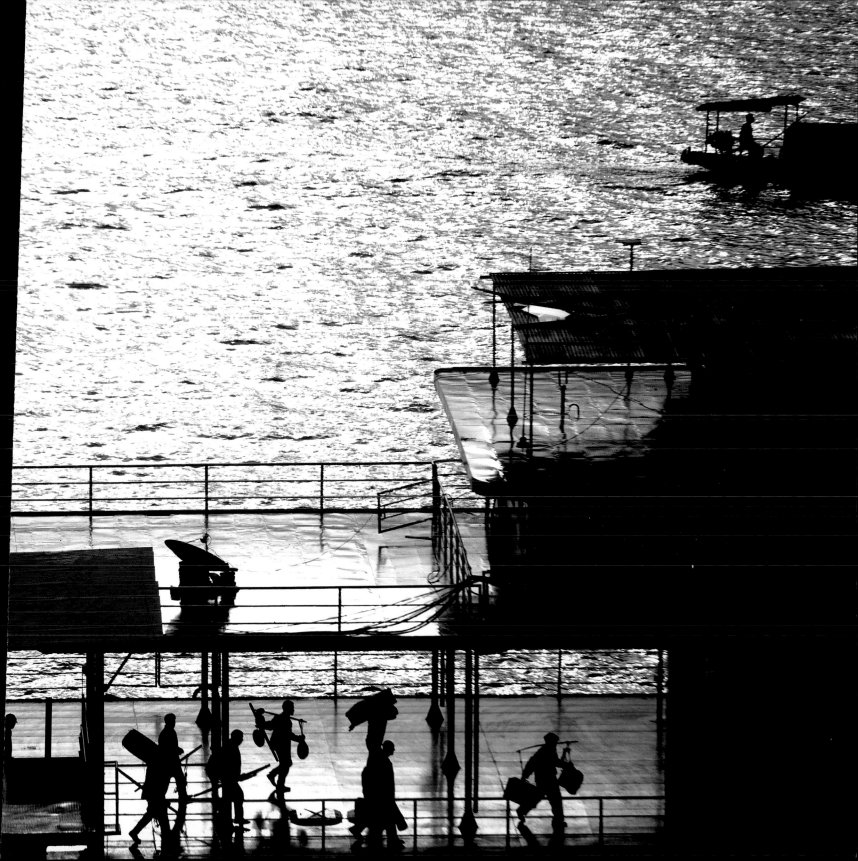

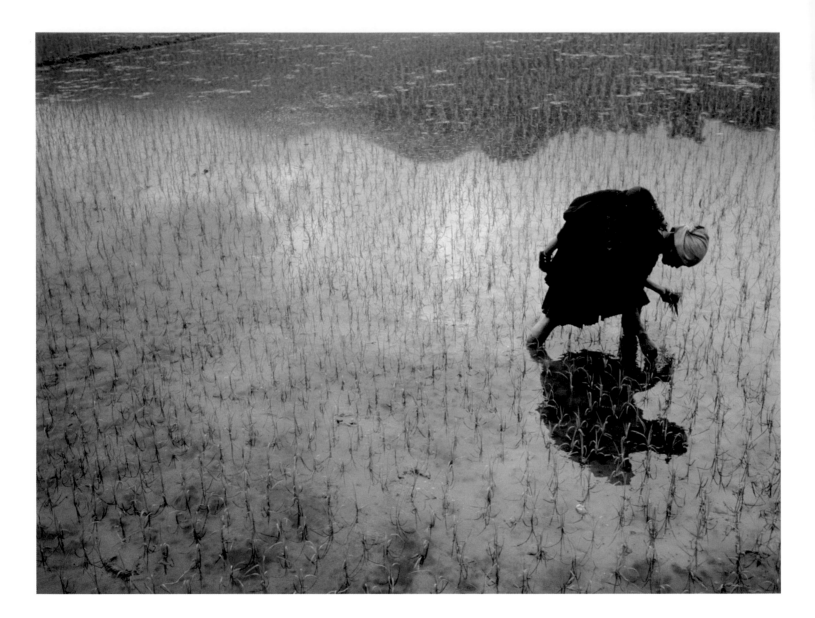

FED BY THE FERTILE SOIL, terraced paddy fields cover the Yangtze plains. Rice is indispensable in Chinese culture—in classical Chinese, the same character is used for rice and agriculture—and the subject is steeped in ritual and myth.

Farmers along the Yangtze still cultivate rice by hand, using traditional methods. The seed rice is pre-germinated in trays, and after 30–50 days the young rice plants are planted in the soft muddy soil of the rice paddies, which have been flooded by rain or river water. The fields are regularly irrigated by dyke-controlled canals or by hand, and finally drained before being harvested.

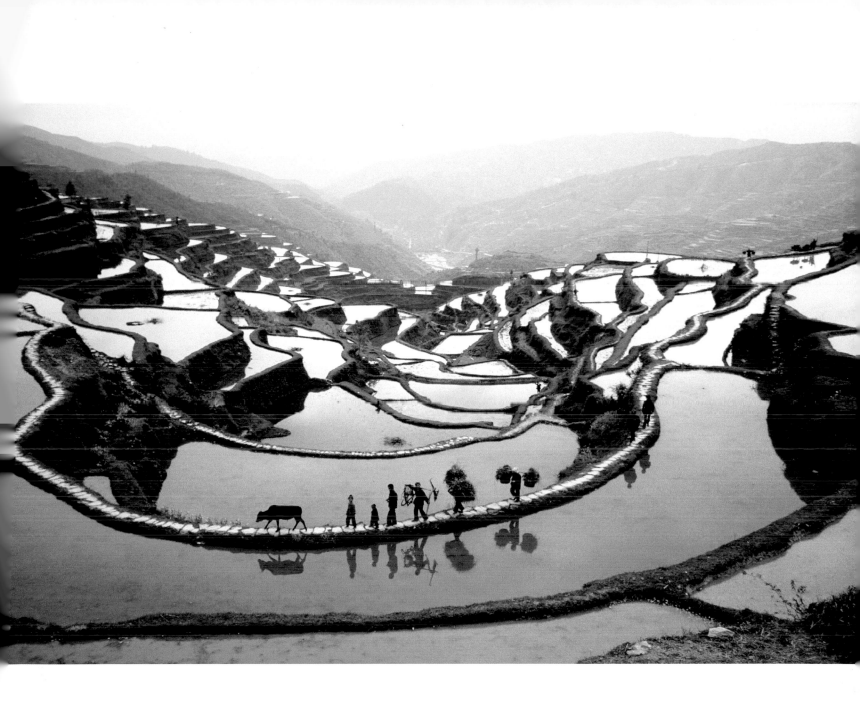

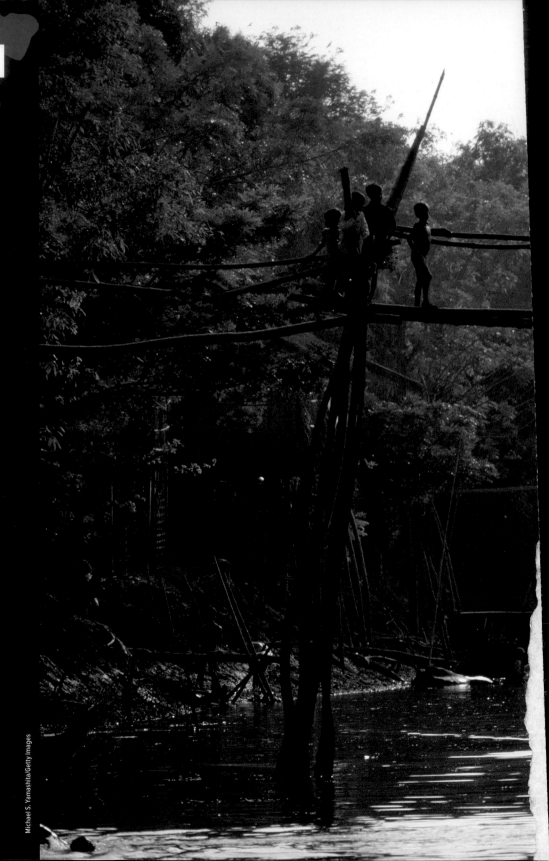

A Place Where Life Thrives Above and Below Water

In Southern Vietnam, the Mekong River forms a network of tributaries and canals that crisscross the land before flowing into the South China Sea. Deposits from the river and its tributaries have made the Mekong Delta a lush area of vast plantations and one of Vietnam's largest rice, vegetable, and fruit producing regions.

Most of the 17 million people who live in the delta belong to the rural poor, making their living by farming and fishing. The green waterways are at the center of daily life, and hum with activity from floating markets, restaurants, gas stations, and occasional tourist boats. Lining the banks are fish and snake farms and houses built on stilts. Some families construct cages below their houses to breed fish to sell at the market. The people of Southern Vietnam are proud of their vast, fertile land. They call it *co bay thang canh*, or the land that is vast enough for the cranes to stretch their wings as they fly.

The Mekong River makes its way through China's Yunnan province, Myanmar, Thailand, Laos, and Cambodia before it reaches Southern Vietnam. Being downstream, both Cambodia and Vietnam are heavily affected by pollution from the runoff of pesticides and heavy industry that takes place in the Upper Mekong regions. They are also suffering from the side effects of dams, mainly in China, which are reducing the water flow.

Dams and pollution are not the only threats to the vibrant water-world of the Mekong Delta. The projected global rise in sea level will increase saltwater intrusion into freshwater ponds and rice fields. It will also cause flooding, leading to a loss of cropland, mangroves, and marine species. By the end of this century, much of the Mekong Delta could be completely submerged for parts of the year, damaging the livelihoods of millions of families.

Michael S. Yamashita/Getty Images

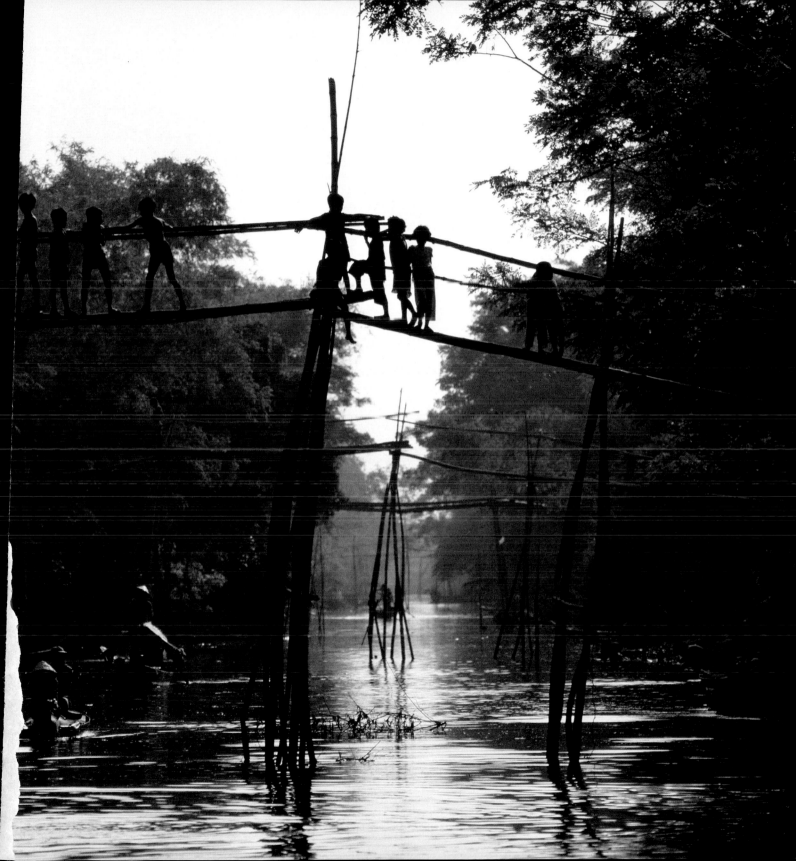

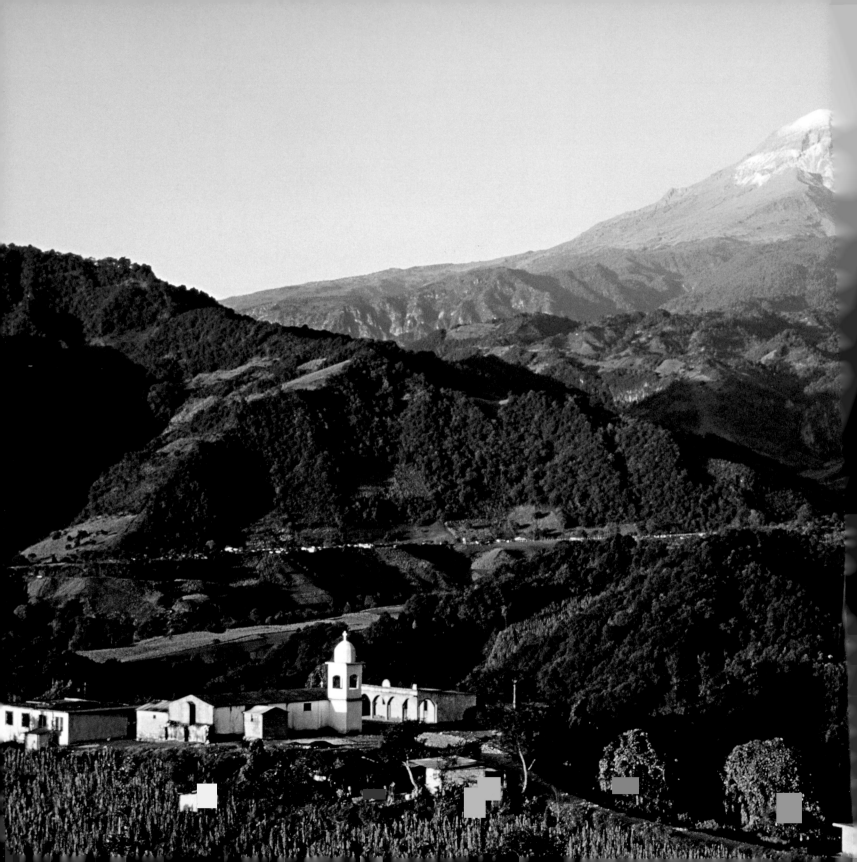

They Need Coffee More Than You Do

Coffee is not just one of the most popular beverages in the world—for some countries it is also a crucial export. One such country is Mexico, where most of the coffee is produced by 100,000 small farms. The state of Veracruz in east-central Mexico is the country's second-largest coffee producer, accounting for around 20% of total production.

In the highlands of Veracruz, many of the small farmers produce organic shade coffee in the traditional manner, by growing coffee plants under specific trees, preferably ones with pods. As well as shade, these trees also provide nourishment for the soil when their leaves and pods fall to the ground, which helps make the coffee plants strong and healthy.

The farmers hand-pick the red coffee berries once they are ripe. They either wet-process them in water baths or dry-process them on large patios in the sun, turning them by hand frequently to remove the pulp. Inside are the coffee beans—the seed of the fruit—two beans to each berry.

Compared to modern production methods, traditional coffee cultivation is time-consuming, and the yields are small. On the other hand, neither fertilizers nor pesticides are needed, so the traditional method is environmentally friendly. The coffee is also renowned for its intense flavour.

The small-scale organic farmers of Veracruz have suffered from many years of low coffee prices. Now they face another severe problem. In the near future it is projected that climate change will lead to both droughts and floods during the summer and unusually cold-weather events in the winter, rendering many areas of Veracruz unsuitable for organic coffee growing. By 2020, production in Veracruz may be economically unviable, forcing many smallholders out of coffee farming.

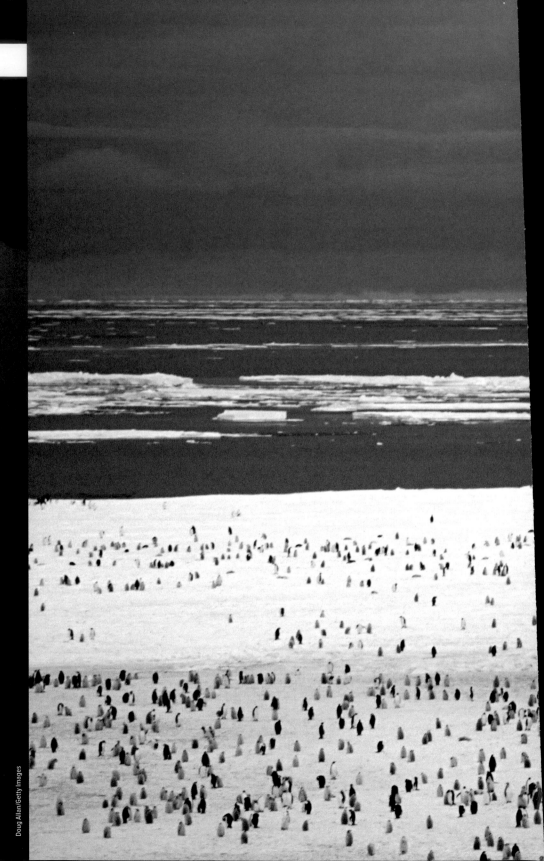

Where Penguins Fly in the Sea

Antarctica has no permanent human settlements; instead this vast land, which is covered with ice and surrounded by sea-ice, is the domain of another two-legged creature. Millions of penguins, that great icon of the continent, inhabit Antarctica, many of them on the Antarctic Peninsula at the northernmost tip.

The Emperor Penguin, the largest of all the species, is endemic to Antarctica. Every year, the Emperor Penguins make an amazing journey. Coupled in mating pairs, they trek 30–75 miles (50–120 kilometers) across the Antarctic wasteland to their ancestral breeding grounds. Here, each female lays a single egg.

The penguins look somewhat awkward on land, where they either waddle or "toboggan," sliding over the ice on their bellies, but they are agile and elegant underwater. Early Antarctic explorers actually mistook them for fish and classified them accordingly. With their streamlined bodies and wings that have evolved into strong, stiff flippers, penguins are perfectly shaped to fly through the water. The Emperor Penguin can dive for up to 22 minutes at a time, and to a depth of more than 1,650 feet (500 meters).

Like its smaller cousin, the Adélie Penguin, the Emperor depends on sea-ice to breed. The amount of sea-ice also influences the abundance of krill, a shrimplike crustacean that is a vital food source for the penguins and for the fish they eat.

Studies show that in the Antarctic Peninsula, temperatures are rising at one of the fastest rates anywhere on Earth. It has probably been 10,000 years since the ice shelves in this area have been as small as they are today. When the sea-ice disappears, so will the colonies of penguins. The rapid rate of warming is expected to continue, and large numbers of Emperor and Adélie penguins will be under threat by 2050, making the penguin an ominous symbol of global warming.

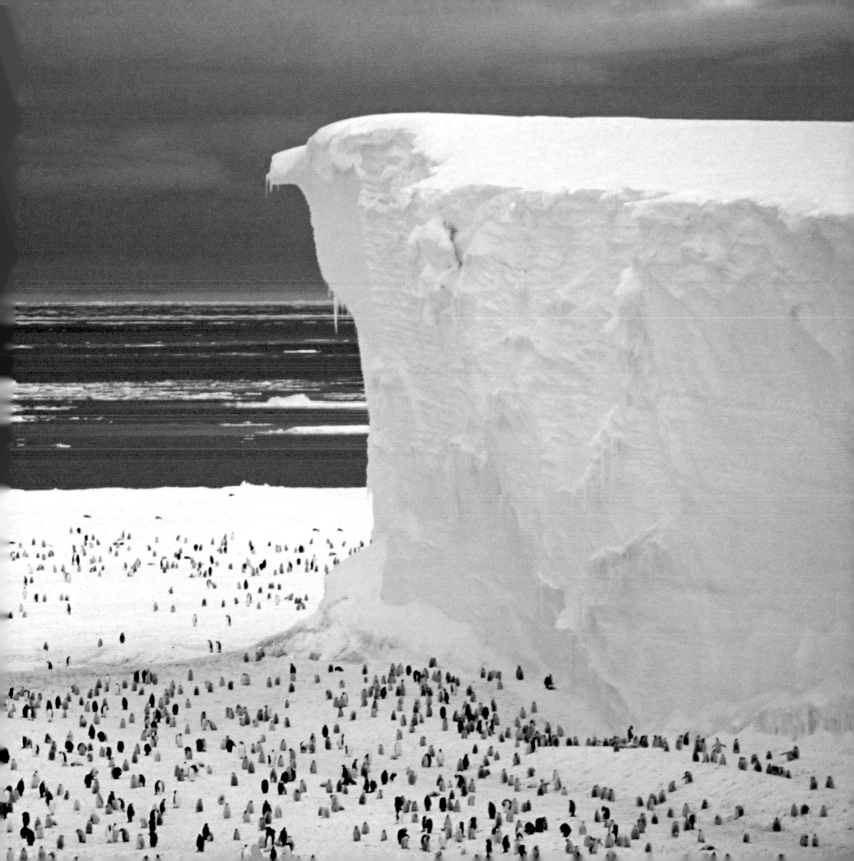

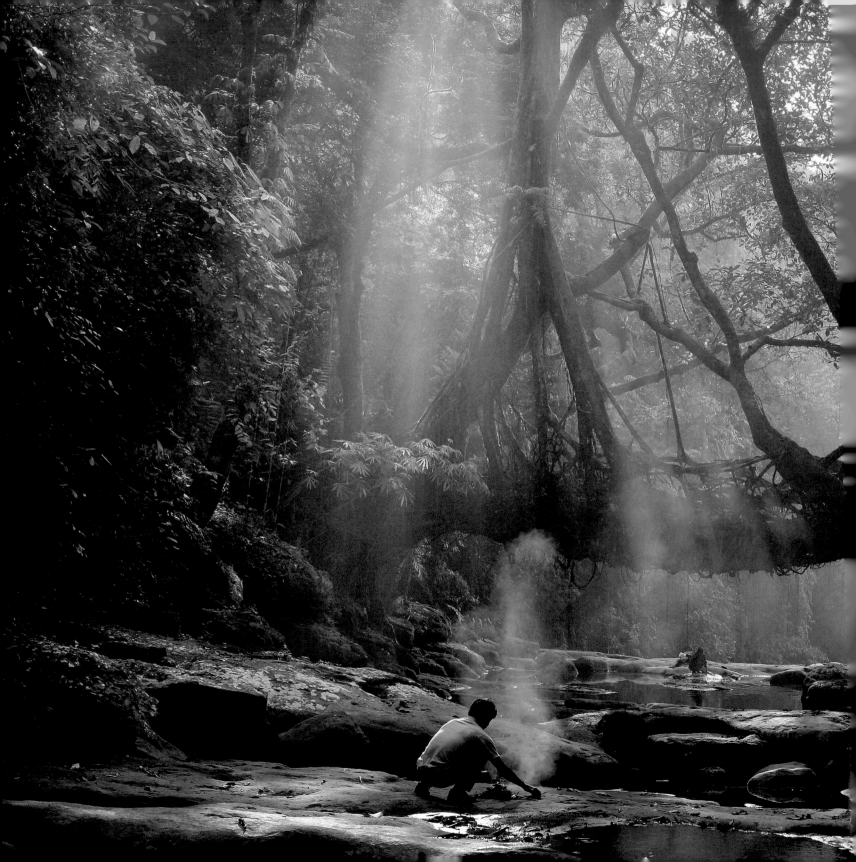

Monsoon Raindrops Sculpt the Earth

The Khasis, who inhabit the remote town of Cherrapunji in northeastern India, use the expression hynniew-miat *to describe rain that lasts for nine solid days and nights.* Khadsaw-miat *is fourteen days of persistent downpour.*

Shrouded in clouds and surrounded by misty valleys and waterfalls, Cherrapunji is one of the wettest places on Earth, with average annual rainfall of 450 inches (11,430 millimeters). Monsoon clouds sweep in from the Bay of Bengal, cross the flat Bangladesh plains, and finally rupture as they collide with the Khasi hills, where Cherrapunji is located.

From June to September, rain drums incessantly on rooftops and treetops, sculpting rock formations and cliffs and turning Cherrapunji into a sea of tiny rivulets. Villagers use body-length carapaces of woven bamboo for shelter.

Paradoxically, the residents of one of the wettest places on Earth do not have enough water. The town dries up completely for nearly eight months of the year, causing shortages of water and electricity. During the last century, annual rainfall decreased and became less predictable, probably due to climate change. This trend has accelerated in the last 50 years. During the dry season, which is now longer and drier, the rain stops almost completely and wells dry up.

Rampant deforestation in the surrounding region aggravates the problem by causing erosion. Once the topsoil has been washed away, the ground is incapable of storing rainwater. Combined with predicted rises in temperature and even more unpredictable rainfall patterns in the future, the peculiar predicament of the Cherrapunji townspeople—paying high prices for water or walking miles to collect it—seems set to worsen.

A Central City Once Again

Copenhagen, or København, is Danish for "merchants' harbor." Its prime waterside location made the city a center of commerce in the 12th century, when it was the seat of Bishop Absalon. The bishop built a castle on the site of the modern-day Danish Parliament, Christiansborg, and the city grew from there.

Copenhagen experienced massive development from the second half of the 19th century onward, with new residential areas spreading beyond the inner city to house people arriving from the countryside. Construction of a local railway network in the 1930s connected most parts of the city and contributed to its growth as a metropolis.

Today, another boom in urban development is taking place. A bridge connecting Denmark to Sweden opened in 2000, allowing a new urban area, Ørestaden, to emerge. Its innovative modern architecture contrasts dramatically with the low horizontal skyline of inner-city Copenhagen, which is interrupted only by the spires of castles and churches.

Today, Copenhagen's position by the water poses a threat to its landmarks, particularly in the old parts of the city. Other low-lying districts are at risk as well, including the old harbors, Nyhavn, which is renowned for its 300-year-old houses, and Christianshavn.

It is estimated that a rise in global sea level combined with an increased risk of storm surges could lead to damage costing more than $5 billion. The risk of flooding has been addressed in recent building projects like the new Metro in Ørestaden, but further coastal protection will be needed if the historic areas of Copenhagen are to be spared.

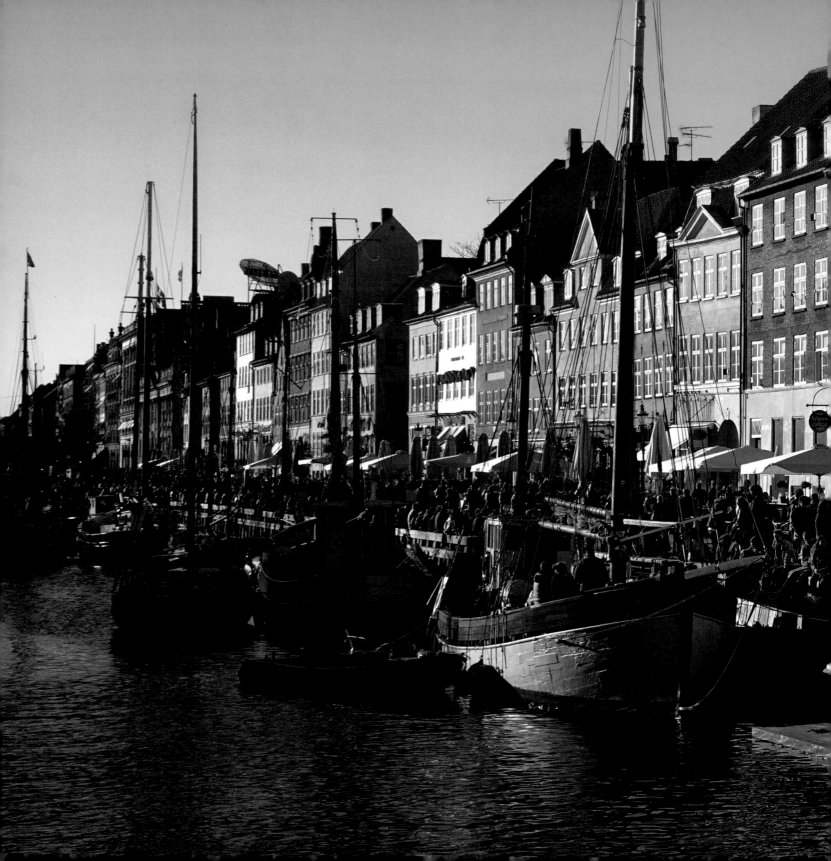

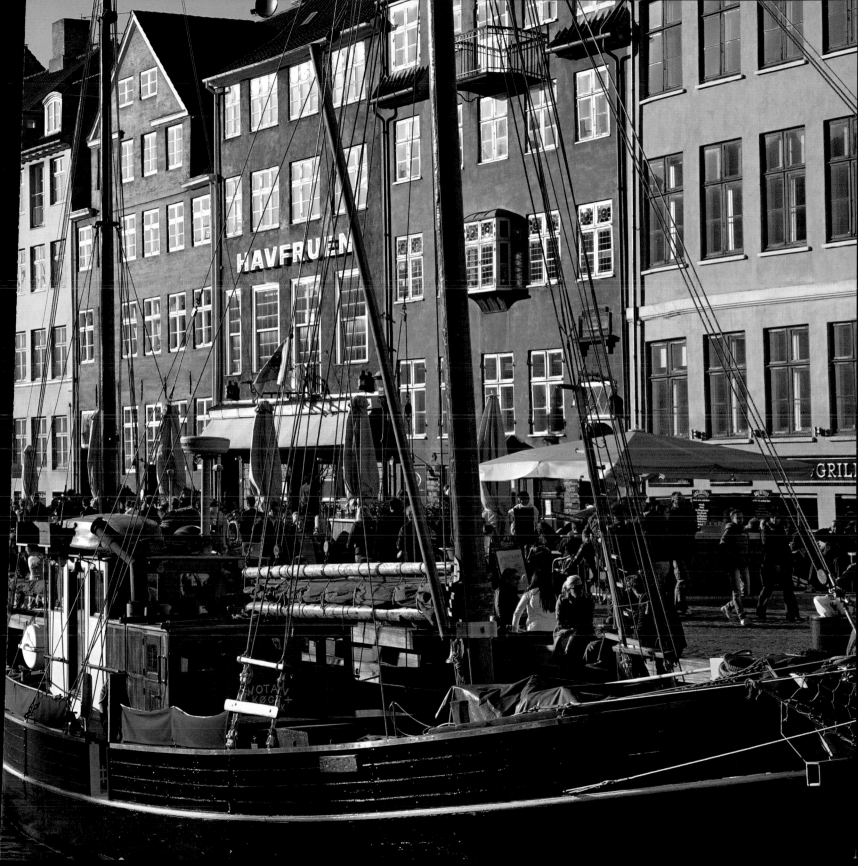

Turning Solutions Into Actions

THE COMMENTS, ARTICLES, AND ILLUSTRATIONS contained in this book convey a clear message: Climate change is a threat to our way of life and to Earth as we know it. The sheer enormity of global warming can be somewhat overwhelming and dispiriting. Is there really anything a single person—or even a single nation—can do to adapt to, slow down, or even reverse climate change?

Yes, there is!

Across the world, individuals, communities, businesses, nations, and the international community are beginning to take action to counter climate change, and potential solutions are emerging from every corner of the globe.

The most important single challenge facing us is how to stop burning coal, oil, and natural gas, all of which contribute significantly to global warming. It is also the challenge that will have the greatest impact on people throughout the world; coal, oil, and natural gas are integral to the economy and fundamental for production, energy, and transport.

Small changes have already been made. In some countries, plastics are now being produced from plants instead of oil, wind and solar power are replacing coal-fired energy, and clean electricity and biodiesel are increasingly common in the transport sector. Ridding the world of fossil fuels will be a long, hard struggle—they are backed by powerful business and political interests, after all—and we will remain dependent on them for some time. Solutions do exist, however, and are becoming more efficient and competitive every day. Most governments now acknowledge the harsh consequences of climate change. It is time for politicians to take action, to fund research, and to facilitate the implementation of alternatives to fossil fuels. Bold decisions taken now would transform the otherwise somber outlook for the climate.

The effects of climate change are already being felt in many places all over Earth. Droughts, floods, and extreme weather events such as cyclones are devastating lives, livelihoods, and whole ecosystems. The most dramatic changes are in developing countries already facing severe economic, political, and social problems. People in these countries have no choice but to adapt to the changing climate. Coastal cities in the Netherlands, Great Britain, and Italy are strengthening dykes and dams to cope with rising sea levels and fiercer storms. In Perth, Australia, a wind-driven desalination plant supplies drinking water to a growing population in an area where rising temperatures and lack of rain are eating into natural reserves. In the developing world, alternative energy sources such as solar panels and biofuels are providing electricity for remote villages.

The Editorial Team of
100 Places to Go Before They Disappear

The project "100 Places to Go Before They Disappear" has collected 100 solutions designed to point the way forward and alleviate the effects of climate change. You can read about them on our website at

100PLACES.COM

These solutions remind us that something can be done about the apparently bleak future of our Earth—if we turn the solutions into actions.

PLACE INDEX

COUNTRY INDEX

REFERENCES

Berlingske Tidende:
www.berlingske.dk

British Broadcasting Corperation (BBC):
www.bbc.co.uk

Cable News Network (CNN):
www.cnn.com

CARE Denmark/International:
www.care.dk

Central Intelligence Agency (CIA)
—The World Factbook:
www.cia.gov/library/publications/the-world-
factbook/index.html

Greenpeace International:
www.greenpeace.org/international

Information:
www.information.dk

Department of Geography and Geology,
University of Copenhagen:
www.geo.ku.dk

Intergovernmental Panel on Climate Change (IPCC):
Fourth Assessment Report
(Reports from Working Group I, II and III):
www.gtp89.dial.pipex.com
Klimadebat.dk:
www.klimadebat.dk

National Geographic:
www.nationalgeographic.com

Politiken:
www.politiken.dk

United Nations Development Programme (UNDP):
Human Development Report 2007/2008—Fighting
climate change: Human solidarity in a divided world,
United Nations Environmental Programme (UNEP):
www.unep.org

United Nations Educational, Scientific and Cultural
Organization (UNESCO):
www.unesco.org

World Bank:
www.worldbank.org

World Wildlife Foundation (WWF):
www.worldwildlife.org

Conceived, designed, and produced by Co+Life A/S
Editorial supervision and picture research: Stine Trier Norden
and Søren Rud
Writers: Poul Arnedal and Ulla Kayano Hoff
Scientific research: Dr. Michael Helt Knudsen
English editing: Camryn Thomas, Tam McTurk and Grace Fairley

Scientific review: Department of Geography and Geology, University
of Copenhagen by Associate Professor Kjeld Rasmussen, Associate
Professor Ole Mertz, and Professor Anette Reenberg
CARE Denmark by Dr. Charles Ehrhart

Photos: Getty Images Ltd.

Layout, final art, and production planning: Co+Høgh A/S

Cover photo: Peter Hendrie/Getty Images

Abrams edition cover and layout design: Shawn Dahl, dahlimama inc

Cataloging-in-Publication Data has been applied for and may be
obtained from the Library of Congress.

ISBN 978-1-4197-0003-3

Copyright © 2011 Co+Life
First published in Denmark in 2009 by Co+Life

Printed and bound in China
10 9 8 7 6 5 4 3 2

Abrams Books are available at special discounts when
purchased in quantity for premiums and promotions as
well as fundraising or educational use. Special editions
can also be created to specification. For details, contact
specialmarkets@abramsbooks.com or the address below.

THE ART OF BOOKS SINCE 1949

115 West 18th Street
New York, NY 10011
www.abramsbooks.com